❀ TEXTILES ❀

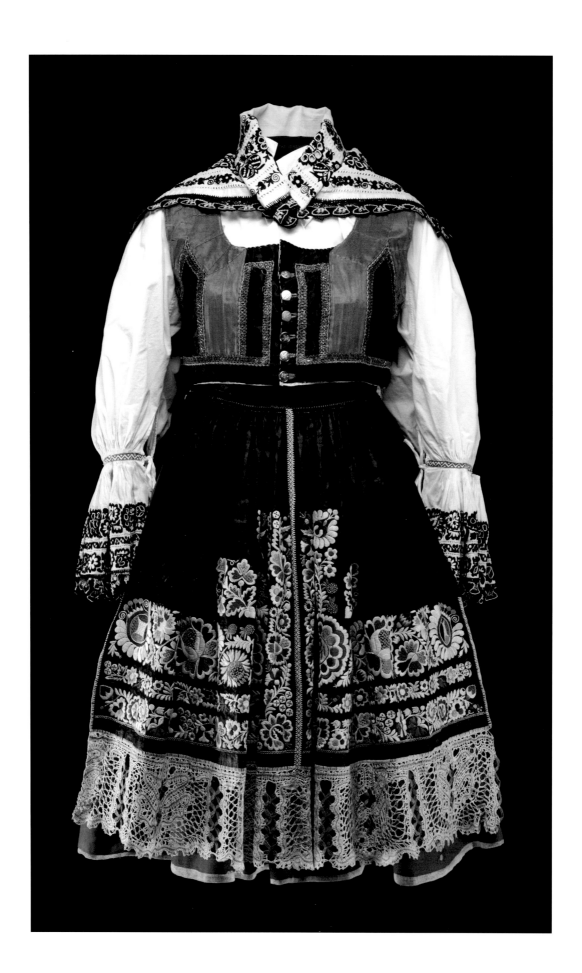

TEXTILES

COLLECTION OF THE MUSEUM OF INTERNATIONAL FOLK ART

BOBBIE SUMBERG

Photographs by Addison Doty

GIBBS SMITH
TO ENRICH AND INSPIRE HUMANKIND
Salt Lake City | Charleston | Santa Fe | Santa Barbara

First Edition
14 13 12 11 10 5 4 3 2 1

Published by
Gibbs Smith
P.O. Box 667
Layton, Utah 84041

1.800.835.4993 orders
www.gibbs-smith.com

Designed by Glyph Publishing Arts
Printed and bound in China
Gibbs Smith books are printed on either recycled, 100% post-consumer
waste, FSC-certified papers or on paper produced from a 100% certified
sustainable forest/controlled wood source.

Library of Congress Cataloging-in-Publication Data

International Museum of Folk Art.
 Textiles : collection of the International Museum of Folk Art / Bobbie
Sumberg ; photographs by Addison Doty. — 1st ed.
 p. cm.
 Includes bibliographical references.
 ISBN-13: 978-1-4236-0650-5
 ISBN-10: 1-4236-0650-7
 1. Textile fabrics—Catalogs. 2. Ethnic costume—Catalogs. 3. International
Museum of Folk Art—Catalogs. I. Sumberg, Bobbie. II. Doty, Addison. III.
Title.
 NK8802.S261588 2010
 746.074'78956--dc22
 2009028797

Abbreviations

A note on acronyms: Most pieces donated to the museum are owned by
the state of New Mexico, represented in the past by the Museum of New
Mexico or MNM. In the captions the donor is credited. The Museum of
New Mexico Foundation, or MNMF, is the nonprofit organization set up
to raise funds for the state museums in Santa Fe. It provides some funds
for collections acquisitions. Funds for most collections purchases are pro-
vided by the International Folk Art Foundation, noted in captions as IFAF.

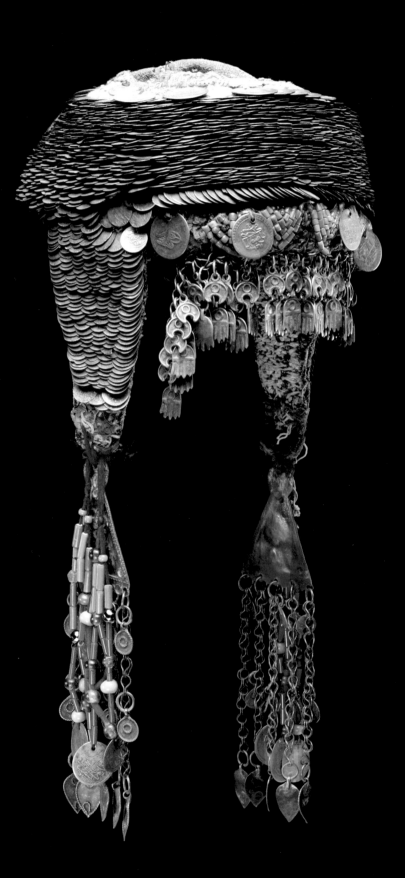

Contents

❀ Acknowledgments ❀

THIS BOOK COULDN'T HAVE BEEN DONE without the help of several people. John Stafford, Director of the Museum of New Mexico Foundation Shops, provided the inspiration and investment to realize photography and production of the book. Susannah Dourmashkin was essential to the smooth progress of the project, from setting up a spreadsheet to modifying mannequins during the photography. Volunteers put in significant amounts of time during the photography. Susan Handelsman, Nancy Looney, Barbara Forslund, Kate Healey, and Gary Carlson contributed their time and expertise. I especially want to thank Ava Fullerton and Pat Harlow, longtime volunteers who are dedicated to the collection and without whom I couldn't accomplish my work. Working with Addison Doty was a pleasure; the wonderful images are proof of his art and craft. As always, my heartfelt thanks go to David Morgan for his careful reading, suggestions, and support.

❀ Introduction ❀

Textiles and Dress in the Museum of International Folk Art

The Museum of International Folk Art was founded and given to the state of New Mexico by Florence Dibell Bartlett and opened to the public in 1953. Over the door was engraved the motto "The art of the craftsman is a bond between the peoples of the world." What better art to demonstrate the universality and particularity of human culture than textile art? When Bartlett gave her personal collection of nearly three thousand pieces to New Mexico, approximately 75 percent of the collection was textiles and items of dress, including garments, hats, shoes, and jewelry.

Many museums collect textiles and dress, but these materials rarely take center stage. The Museum of International Folk Art prioritizes these materials, realizing they are the art of a people in a profound sense, making concrete a culture's values, aesthetics, and ideas about the cosmos as well as where humans, collectively and individually, fit in the world.

Numerous aspects of history and culture are studied through the production and use of textiles, one of the fascinating characteristics of this material. Gender roles within a family and within a society or culture are usually played out when cloth is made and worn, beginning with the planting of a seed or the raising of an animal. It's easy to look at a woman spinning or embroidering and think that textile production is exclusively women's work, but there is so much more to the topic of gender and the production of textiles than that. Each piece in the museum's collection tells a complex story of the people who made and used it.

Take, for instance, the tie-dyed cotton cloth from Côte d'Ivoire, at right as well as on page 122. It was collected in the mid-nineteenth century and provides an excellent example of pre-colonial gender roles related to textile production. In central Côte d'Ivoire, where this cloth might have been made, young men cleared the fields of brush; women then planted the cotton seeds among the other crops. When the cotton was ready, everyone harvested the white or naturally brown bolls. Then it was up to the females of the household to deseed, card, and spin the fiber into yarn and dye it if desired. The yarn was given to a male member of the family to weave into long strips that were sewn together to make a cloth. The size of the cloth was determined by the number and length of strips; cloths for men were bigger than cloths for women. The cloth was then

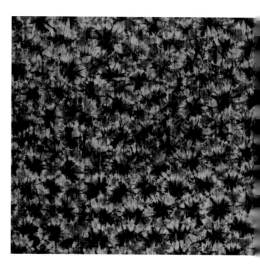

Tie-dyed cotton cloth from Côte d'Ivoire.

given back to the female head of the household. She decided who received it or if it was to be sold or used for a funeral gift. Men and women worked together and were expected to each do their parts of the process, which were equally important but not the same.[1]

Where women are secluded inside the household, the needle arts have often flourished. A needle, a hoop or frame, and a selection of colored threads are all that is needed to create something beautiful that not only demonstrates a woman's skill but also implies the correctness of her upbringing. Portable embroidery has often constituted a primary social activity for unmarried girls preparing their trousseaus and who are prohibited from contact with the world of men.

Making and embellishing textiles can be a powerful tool of socialization and a reflection of cultural values. The sight of men and women in the Andes spinning with a drop spindle while walking sends a strong message about being productive and not wasting a moment. Young girls learning to weave at a back strap loom in southern Mexico kneel quietly at the loom. They are not only learning a skill but are also learning that to be a woman is to be patient, still, and calm in comportment.

As with gender roles, economic roles are not always so straightforward. There is some—but only limited—truth to the assumption that women produced textiles in the home for use in the home while men labored in commercial workshops making textile products for sale. Like the chef/cook—male/female dichotomy, there is limited truth in this generalization. Female spinners, weavers, and needleworkers have always participated in the market economy, whether working inside or outside of the home. Young New England farm women, who had been weaving cotton cloth at home on contract, were recruited to work in the textile mills in Massachusetts at the start of the Industrial Revolution around 1815.[2] Even when the cultural ideal insists that women are isolated from the marketplace, their earning ability has helped sustain their families. What might be true for wealthy and upper-class women doesn't necessarily apply to families struggling to keep body and soul together.

On the other hand, some types of textile work were considered too heavy or difficult for a woman to manage. In the countries of Central and Eastern Europe, embroidery on sheepskin, leather, and fulled wool garments, such as those at right as well as on pages 120, 178, and 179, was the domain of professional male embroiderers. These garments were produced entirely in a workshop or professional setting as the materials used required more technical skills and equipment than was found in the home. The irony is that the weight of the clothing worn by women in this part of Europe and the physicality and repetitiveness of the household chores and farming activities women were expected to do ensured that they were very strong!

Different fibers originated in specific parts of the world—cotton in India, Africa, and Mesoamerica; silk in China; wool in the Eastern Mediterranean; and flax for linen in Northern Europe and Egypt. Trade in these fibers, in dyes, and in materials such as shells and feathers for decorating cloth and the body is perhaps the earliest example of global trade in history. Tomb paintings from the

Facing:
Embroidery on sheepskin, leather, and fulled wool garments was the domain of male embroiderers.

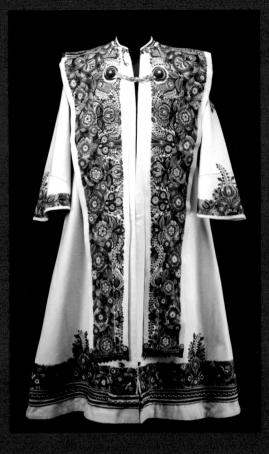

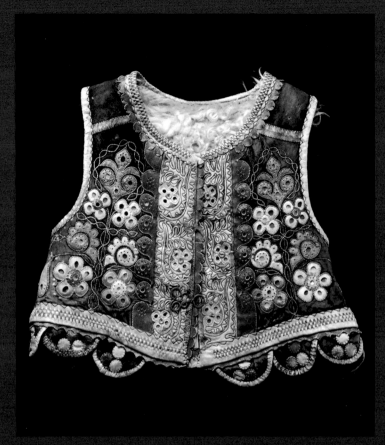

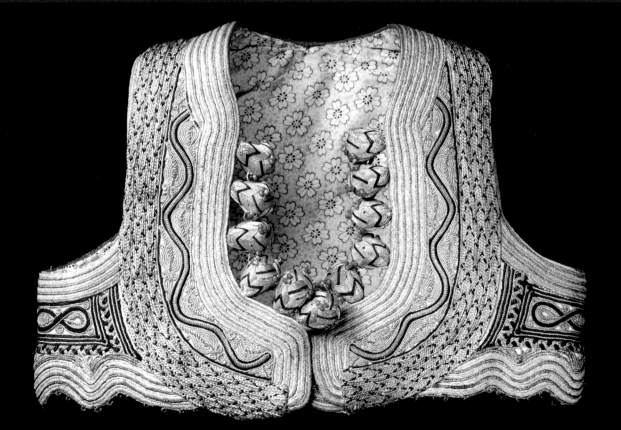

reign of Queen Hatshepsut (c. 1500 BCE) show Minoan traders from Crete carrying patterned textiles destined for the royal court,[3] while the Silk Road, popularly named for its most important trade good, brought textiles from China through Central Asia and into Europe beginning in the second century BCE.[4] Until textile manufacture was fully industrialized in Europe and North America, trade in cloth was limited to high-value luxury items like silk and cloth of gold. Everyday fabrics used by ordinary people were still made locally and in the home.

There was ancient trade in materials for decoration and jewelry as well. Cowry shells gathered on beaches on the east coast of Africa were carried thousands of miles along trade routes to West Africa, where they were highly valued both as currency and as jewelry. Cowries are still used today for symbolic transactions and jewelry, and as a motif on contemporary printed cloth. Parrot feathers used by the Hopi in ceremonial dance dress and on prayer sticks highlight the importance of prehistoric trade from Western Mexico to the mesas of Arizona.[5]

The majority, though not all, of the pieces in the museum were made by rural people around the world who intended to use them, people whose customs have been transformed drastically through the nineteenth and twentieth centuries and into the present. Ethnic textiles and dress provide important evidence of how people's lives change with increasing globalization. Where locally produced materials once were the norm and imported materials signified access to rare and expensive things, a whole array of possibilities have opened up with increased access to information, such as through television and the Internet, and to goods produced elsewhere. These possibilities range from simple substitution to incorporation of new ideas, from major changes in patterns of production and use to abandonment of ethnic dress and textiles entirely.

Frequently, cheaper factory-woven cloth is substituted for handwoven cloth while the form and use of a garment remains the same. The same holds true for some embellishments; where coins were sewn onto a garment, buttons can be substituted, machine-made lace replaces handmade lace, and purchased ribbons take the place of embroidery or other labor-intensive trims. While traveling in southwest China in 2007, I saw for sale in the villages the heavily pleated skirts worn by some Miao women, pre-made and printed with patterns mimicking the batik work and embroidery normally done by the women themselves.

Access to new ideas and goods brought by trade can encourage new forms of dress or use of textiles. The Ijo people of the Niger Delta in Nigeria did not grow cotton or weave much cloth other than small amounts of raphia fiber for small things such as hats and bands. But when the Portuguese arrived in the area in the fifteenth century, they brought handwoven cotton cloth from India. This cloth was initially traded for ivory, pepper, and dye woods, and later for slaves and palm oil. Madras plaid, woven to the color preferences of various peoples on the coast of West Africa, was adopted and incorporated into ceremonial life, where it was used as dress for special occasions and given as a gift during life-cycle ceremonies marking significant moments such as birth, puberty, marriage, and death. Something that had been virtually unknown in the Niger Delta became essential over time.[6]

The painted cloth pictured at right as well as on page 66 is another example of how traded textiles are incorporated into a culture. It was made in India for trade to the outer islands of Indonesia, Sulawesi in this case, where it was kept and treasured, brought out to display for only the most important occasions. Trade and access to imported goods such as this cloth did not diminish the need or desire for ordinary people on Sulawesi to elaborate a local style of dress and to assign profound meaning to textiles incorporated into rites and ceremonies. The colonization of Africa, Latin America, and Asia by Europe, as well as the industrialization of the textile sector in Europe and North America in the nineteenth century, wrought far more changes than the trade in luxury goods.

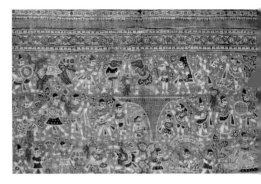

Another example of how traded textiles are incorporated into a culture.

When commercially produced cloth replaces a locally woven product, a cascade of economic effects may occur. Less handwoven cloth is generally needed for everyday purposes and fewer weavers are needed. What was a common household activity becomes a specialized professional activity. In some cases change may be rapid and radical—the purchase of ready-made garments may entirely supplant local production. In other cases, commercially made cloth or clothing may replace only some of the prior handmade products, making some occupations obsolete but leaving others intact. For instance, industrially woven fabric can be sewn into familiar garments by local tailors.

In still other instances, some part of the production process may be industrialized while others are not. An example of this can be found in the weaving of Harris Tweeds in the Outer Hebrides of Scotland. Hand-spun wool from island sheep was woven for home use and local trade in the islands until the mid-nineteenth century. By recognizing the value of the original product at a point when it was likely to disappear, one woman promoted and developed the concept of a high-value fabric produced to rigorous standards and marketed to the world. Over almost 150 years, the industry has adapted new methods and definitions but has retained some aspects of hand production. Today, locally raised wool is sent to mills to be commercially spun and dyed and then returned to be woven on human-powered looms and marketed as the only product that can legally be called Harris Tweed.

Sometimes the highest-value types of cloth used in ceremonial situations are still made, supporting a specialized weaver group. Local styles of dress that are abandoned for everyday wear might remain in use for special occasions such as weddings and holidays. An individual might add a part of their ethnic dress to their everyday ensemble when traveling to a distant market. I saw this repeatedly in China in 2007, where local traditions are changing at a phenomenal rate—a woman wearing plain pants and a sweater with elaborately embroidered head gear that identified her as a member of a particular minority group.

When rural dwellers move to the city to pursue employment, they often change their dress to conform to city standards and look less "ethnic" if they want to succeed. Those who stay behind in the village, usually women and girls, maintain the dress traditions they grew up with and other important aspects of cultural tradition that the textile arts exemplify.

Social and economic change does not always ring the death knell of ethnic dress and textile production or use. Increased prosperity and participation in the money economy of the mid-nineteenth century by peasants in the Mesokovesd region of Hungary produced a florescence of elaborate embroidery on men's and women's garments, particularly aprons, as seen in the wedding outfit at right as well as on page 227. Earlier embroidery in this region was quite sedate, using only red and blue thread, compared to the pieces shown. The availability of yarns brightly colored with chemical dyes developed in the mid-nineteenth century was essential to this expression of artistry.

When commercially woven and printed fabrics were introduced to West Africa, the use of hand-spun and woven cloth dropped off drastically in some areas. This new cloth was lighter weight and thus more comfortable to wear and more easily washed than the locally produced fabrics. At first it was used in the same way as handwoven cloth; a piece of fabric was simply wrapped around the body. With the increased availability of sewing machines, tailored garments using these new fabrics appeared. Ultimately, a fashion system unique to West Africa developed, with recognizable variations in specific locales and replete with rapid change in styles and details. For the visitor to Abidjan, Lagos, or Accra, the exuberance of color and shape worn by urban Africans is immediately registered.

In other situations, weaving itself has developed into a money-making activity, but for a new clientele—international tourists. This kind of weaving may be a sideline for people who also weave for themselves, or it may be pursued only in the context of outside buyers. Often, pieces made for the tourist market are recognizable by their "quick and dirty" aspect—loose weaving, large embroidery stitches, simplified patterning. When potential customers value a product as a souvenir, they are not often willing to pay a high price for that product, inducing the maker to invest less time and effort into that piece. Development projects aimed at providing women with employment often focus on the textile arts, reasoning that it's efficient to develop existing skills, especially those that can be used at home while engaged in all the other aspects of family life women are responsible for.

Revival and romanticizing of rural or peasant handwork has been a feature of urban society for centuries. The art of piecing and quilting, originally highly utilitarian techniques used in the United States to make bedding, and secondarily seen as a canvas for a quilter's creativity, has enjoyed a tremendous growth in popularity since the late twentieth century. Recently a lace bureau scarf was donated to the museum. It was handmade in an Italian workshop established in the 1920s to help the urban poor and features a Renaissance style design. Revivals of this type do not usually last very long but have been instrumental in maintaining the knowledge and appreciation of textile techniques no longer widely used.

Immigrant communities also contribute to the continued use of ethnic dress and textiles, sometimes when that use has disappeared entirely from the home place. In the United States, folk dance ensembles representing countries and cultures from all over the world look to long-abandoned historic

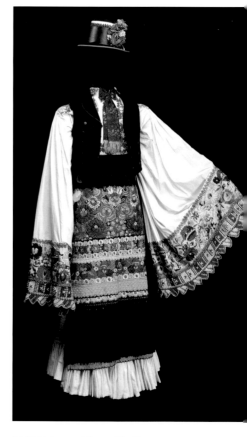

A Hungarian wedding outfit with apron.

ethnic festival dress for their own performance costume. National and ethnic pride and political consciousness also play their part in the contemporary use of ethnic dress. Palestinian women living in the U.S. and Australia commission embroidered dresses based on historic village styles from Palestinian refugees living in camps in Syria and Lebanon to wear at their weddings. The reinvigoration of traditional non-Christian religion in Lithuania is accompanied by a companion revival of hand-weaving for use in religious practice.

Many people in the U.S. lament the loss of handwork, specifically the textile arts practiced in other places, equating this loss with the lack of cultural connection they feel in their own lives. Many complicated questions arise when this attitude is examined critically. Is it better for a girl to spend her childhood learning to embroider or going to school? How can we in the rich nations have any objections to the ways in which people try to better their lives? What are the human costs occurred in maintaining a particular way of life? Are we willing, when we travel to exotic places and want to bring something back, to pay the actual price to support the continuation of quality textile production by skilled artisans? Is it a bad thing when a rug-weaving project in Turkey is so successful that the children of the weavers have attended school and are no longer employed in what is considered menial labor, ensuring the disappearance of this particular rug-weaving tradition? Can we deny anyone their desire to participate in a larger world, demonstrated by how they dress and the work they do?

Coupled with these questions is the current revival of textile arts in the United States. The recent popularity of knitting, crocheting, needlework, and sewing among a younger crowd points to a renaissance of interest in the handmade garment. Personal aesthetic expression that is embedded in the culture and society of the times is a universal human impulse. In twenty-first century North America, the urge to make something flies in the face of the mainstream consumer culture, signaling a renewed understanding of the human connection wrought by the work of the hands—an outward manifestation of the soul.

Collections of dress and textiles, such as those in the Museum of International Folk Art, chronicle the results of cultural and social change by illustrating the solutions people have devised to address their changing circumstances and needs.

The museum has many one-of-a-kind pieces as well as significant groups of items that represent the depth of a textile tradition. The collection includes more than seventy-six embroidered dresses dating from 1840 to 1970 from Palestine. Veils, jackets, hats, and bags as well as more than 150 amulets and pieces of jewelry collected in about 1910 round out this extraordinary collection. We also hold the second-largest group of Swedish textiles from before 1850 in the United States. It's rare to even find quality like this outside of Sweden and a few private collections. Nearly five hundred samplers, with more than forty on permanent display, represent Italy, Germany, the Netherlands, Latin America, and other Northern European countries, while only ten come from the United States. Other strong areas for both dress and textiles include Japan, Guatemala, Turkey, Mexico, India, and New Mexico.

The textile collection in the museum now numbers about twenty thousand

pieces. Collection acquisition can be characterized as emphasizing items made by people for their own use. This criterion is not exclusive but does guide collecting today. As an example, the museum has Chinese court robes that exhibit fine embroidery and weaving. These pieces were commissioned by members of the Chinese upper class. Recently, dress and textiles of minority nationalities in China demonstrating ethnic identity and fast-disappearing skills such as batik, embroidery, weaving, and complex needle techniques have been added. This type of material is more pertinent to the collection of Chinese dress than pieces produced by workshops for use in the Han or Manchurian courts.

Although it is somewhat arbitrary, we have divided this book into two sections—Textiles and Dress.

History of the Collection

Florence Dibell Bartlett, a citizen of Chicago and a summer resident of New Mexico, donated her collection of art to create the museum. Belonging to a wealthy family, she traveled extensively, often with her sister, Maie Bartlett Heard, who, with her husband, founded the Heard Museum in Phoenix, Arizona. When Bartlett traveled, she also purchased. Although we don't have very much information about where and when she bought things, we do know that she acquired the core of the Palestinian dress collection in Jerusalem in 1921 from the American Colony Store with the help of John and Grace Whiting. In 1981, the museum purchased a group of amulets the Whitings had collected around 1910. Some of these amulets came with handwritten notes by Grace Whiting explaining how they were used and where they were bought. Most of the Swedish textiles were purchased by Bartlett in Sweden, and the Moroccan textiles and jewelry were acquired in North Africa. The entire group of Plains Indian dress came from her as well. Florence Dibell Bartlett was concerned with collecting art that represented vanishing traditions.

In the 1960s and 1970s, collections in the museum were built through donation and purchase. More Palestinian dresses and jewelry were bought from a collector in Jordan. Hundreds of pieces from Mexico, and the Shook collection from Guatemala that was collected in the late 1930s and 1940s, were acquired by the museum in the 1970s. The second major gift came in 1980 when Alexander Girard donated about 110,000 objects. About 3 percent of these were textiles and some costume pieces. Of these three thousand or so things, some three hundred are on permanent display in the Girard Gallery, while the rest are in storage and are brought out for exhibit. As a collector, Girard was more interested in the visual attributes of textiles and dress than in the historic value of a particular piece. Thus, what we have with his African textiles, for instance, are a set of pieces from the 1960s, very representative of what was happening then but without any historical depth. The samplers collected in Europe by his grandfather Marshall Cutler gave the museum the best sampler collection west of the Mississippi. The samplers are unique in U.S. museum collections because they were stitched in Northern and Southern Europe, Latin America, and Mexico. Very few are from the United States.

The next concentrated influx of textiles came in 1995 with the Neutrogena Collection, donated by Lloyd Cotsen. Of his gift of about 2,500 pieces, there are approximately 1,500 textiles and costume parts. Lloyd Cotsen generously gave money to build a gallery that primarily shows textiles and costume; he also donated funds for a storage area in the basement and for staff salary and acquisitions.

Curators guide the formation of a collection by their research interests and through exhibit needs. Some of the textiles shown in the bedding section of this book were acquired for exhibit in "Dream On Beds from Asia to Europe," while Chinese minority nationality costumes are currently sought to fill a gap. Curators at the Museum of International Folk Art continue to solicit and select donations as well as make judicious purchases to develop the collections.

A collection as broad as this one, spanning centuries and acquired over time, poses some problems to the curator when it comes time to classify and catalog. Geographic boundaries change regularly with the advent of empires, the spoils of war, and the emergence of new political entities. For example, the present day Republic of Macedonia, also known as the Former Yugoslav Republic of Macedonia, has belonged at different epochs to the Byzantine Empire, the Ottoman Empire, The Kingdom of Bulgaria, Greater Serbia, and Yugoslavia. These political boundaries have an effect on what people have worn, where their influences come from, and how strongly they retain their local customs and traditions. Do we say that a dress made and worn in Bethlehem in 1890 comes from Palestine, where Bethlehem was in 1890, or from Israel, where Bethlehem was located when the dress was given to us, or from the Palestinian National Authority governing the city in 2009? I have usually chosen to use the place name associated with the time the piece was made and used, trying to ascertain what the people would have called the place where they lived. In the rare case where there wasn't a nation-state associated with a place, I have used the contemporary name for the reader's ease. Although I make an attempt, I make no claim to consistency or to a definitive geographic terminology.

The words "folk" and "traditional" are not often used in this book, nor is "costume." Instead, the term ethnic or local dress distinguishes the kinds of things shown in this book from cosmopolitan fashion items. Costume is used to describe garments that are put on to disguise or change the identity of the wearer, as in the theater. These pieces are in the Ceremonial Dress section. I prefer the word "dress" to describe what people put on every day and on special occasions to show the world who they are, what they do, their economic status, and their level of personal taste.

The mission of the museum is to present its collections to educate the public. Along with exhibits, a book such as this is one way the museum collections are made available to the public. With about twenty thousand pieces in the textile and costume collection, it was a difficult decision when it came to choosing representative examples for this book. There is so much that deserves to be included but couldn't be. I invite you to turn these pages to discover a small selection of the wonders, both from the world of ethnic dress and textiles and at the Museum of International Folk Art, that await you.

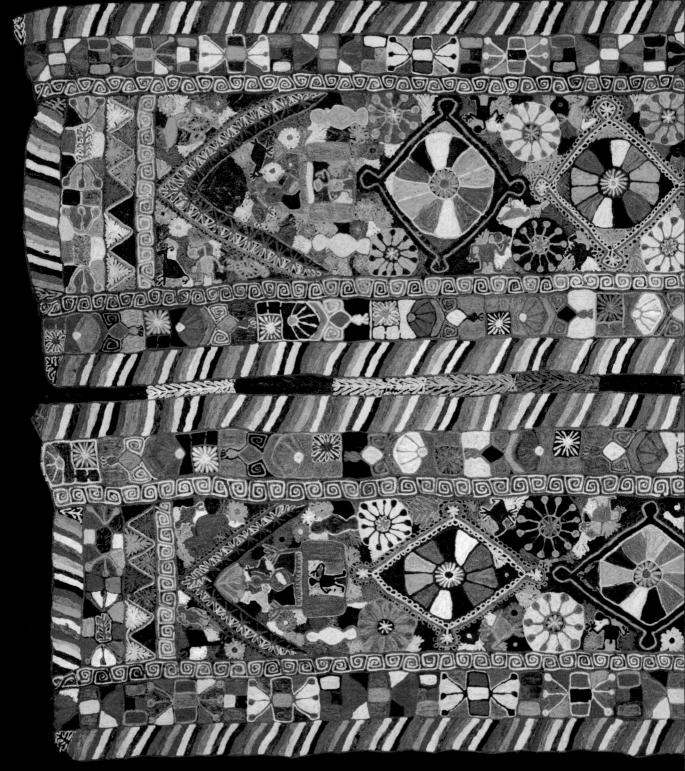

Textiles

Textiles can be woven, felted, knit, crocheted, or made by a number of other methods. The base fabric or ground can then be decorated with dyeing techniques, embroidery and other stitchery such as quilting or appliqué, and by attaching ribbon, beads, lace, metal, and other trim. Cloth can also be patterned using weaving techniques, while color can be added before weaving and even before spinning the yarn. Textiles are used flat, not sewn to make a three-dimensional shape such as a garment. This is not to say that flat textiles aren't worn. In many parts of the world a piece of cloth is wrapped around the body as a garment, held in place with a belt or a pin or tucked into itself. When a flat textile is primarily used as a garment it is shown in the Dress section of this book.

Many flat textiles have multiple uses. What is worn as an outer garment during the day can be used as a blanket at night. Small pieces can be used on a table, to wrap a gift, or to cover a plate of food. Function can be a function of the moment; a floor covering can also be a bedding textile when someone lies down on it to sleep at night. Although this multi-functionality can make it difficult to assign a piece to one category, it also makes for richness in ethnographic use.

Textiles and dress are part of the material of culture. Culture defined at its most

basic level is the ideas and standards a group of people hold in common. This includes standards of beauty and comfort as well as propriety. The use of textiles, particularly those that are handmade by members of the group or culture, conform to accepted patterns. Mats plaited from local plant fibers were made all over Polynesia and used as floor coverings, bedding, seating, and even mosquito nets. For the most part, handmade mats have been replaced by commercial cloth and plastic mats for quotidian use. But the fine mat pictured on page 67 is distinguished from everyday mats by its softness and sheen, by the skill involved in plaiting the pandanus leaves so finely, and, most importantly, by its historic associations, and would never be used on the floor or to sleep on. It is far too valuable as a bearer of culture. A fine mat not only demonstrates the skill and care of the women who made it, but also embodies history as a record of the gift giving and exchange that is essential to Samoan society. Function can be strictly controlled, like the fine mat, or it can be more informal. Who hasn't thrown a quilt or blanket on the grass for a picnic or wrapped a towel around themselves to keep warm when it was the only thing at hand? The pieces in this section are grouped by function—bedding, household, sacred and ceremonial, and decorative.

❀ Bedding ❀

TEXTILES HAVE BEEN AN INTEGRAL PART OF SLEEPING FOR A LONG TIME, beginning with animal skins used both for padding and warmth. Sometimes a bed is nothing but textiles; a woven mat on the floor is the bed. And even where the bedstead is a furniture framework, sheets, blankets, coverlets, curtains, and other hangings have defined the bed for centuries. Although all people sleep, humans have developed myriad styles and have put a lot of time and artistry into beautifying their sleeping arrangements.

Bedding illustrates not only aesthetic principles, but also cultural ideas of comfort. In the ancient world, beds raised off the floor were used by the Chinese, Egyptians, Etruscans, Romans, and Greeks. For reasons that are impossible to discern now, the Chinese and Egyptians preferred head rests—small curved wood or stone pieces that supported the neck—while the Greeks, Romans, and Etruscans found soft pillows to be the thing.[1] A friend told me a story about a Vietnamese exchange student who lived with her family for a year. One night her mother entered the student's room and found him sleeping on the floor. When the horrified hostess asked why, he explained that he wasn't used to a soft mattress, and sleeping on the floor made him feel less homesick. How we sleep, whether on a hard or soft surface, or in the open or enclosed by cloth, is a learned behavior.

The museum has a wonderful collection of bedding textiles from all over the world, from African string hammocks to French quilts; Guatemalan blankets to Southeast Asian mats; and Iraqi to American coverlets. Particular strengths are Japanese *yogi* (kimono-shaped coverlets) and futon covers, bed coverings from Scandinavia, and quilts from France, the United States, India, and Turkey.

Blanket

Wool, bast, tapestry technique
203 cm x 128 cm; 80 in x 50½ in
1825–1850, Skåne, Sweden
Gift of Florence Dibell Bartlett
A.1955.86.162

The province of Skåne, or Scania, is renowned for the artistry of hand-weaving practiced by rural women until the mid-nineteenth century. Interlocked tapestry weave, the technique used in this blanket, is called *rolakan* in Swedish, and it is used here to create the vivid, crisp geometric designs. Sixteen ducks are also found in this blanket. The museum has the second largest collection of Swedish handwoven textiles in the United States.

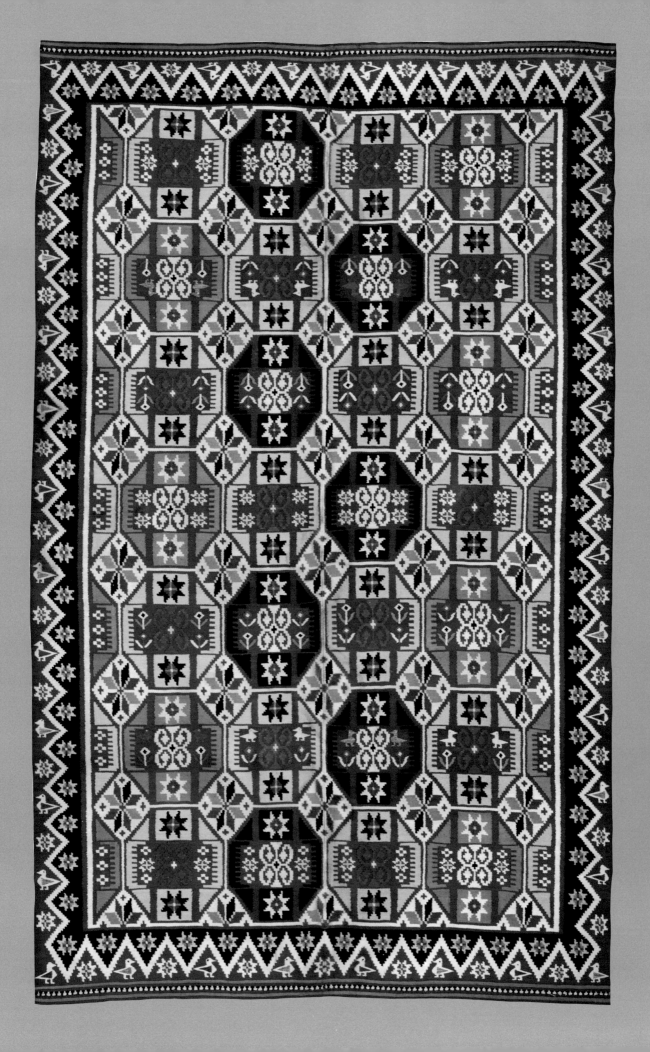

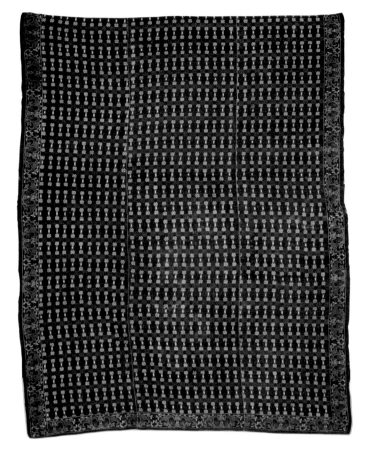

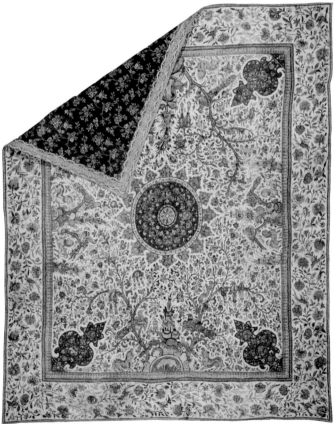

Above, left:

Coverlet

Linen, resist print
243 cm x 174 cm, 95¹¹⁄₁₆ in x 68½ in
Early nineteenth century, Ticino, Switzerland
Acquired through trade with the Kulturen Museum, Basel, Switzerland
A.1963.12.1

The flax plant, from which linen is processed, has grown in Northern Europe since the Neolithic period—3000 BCE. This coverlet is made from three panels and is block printed with two different blocks. The delicate floral and vine border contrasts with the chunkier floral barbells in the center. Block printing with imported indigo on both linen and cotton fabrics flourished in central Europe from the seventeenth to nineteenth centuries.

Below, left:

Palimpore quilt

Cotton, painted, printed, quilted
238.8 cm x 198 cm, 94 in x 78 in
Eighteenth century

Top made in India, quilted and used in the Netherlands

Gift of Paul and Elissa Kahn, MNM Art Acquisition Fund, Barbara H. Lidral Estate Bequest, Connie Thrasher Jaquith, Folk Art Committee, Textile Gift Fund

A.2004.40.1

Hand-painted and block-printed cottons made on the southeast or Coromandel Coast of India were highly prized in the European market from the mid-seventeenth century. Though many of these fabrics were used for hangings, some survived as quilted bedding. Stuffed with cotton wadding and backed with a European-made block print, the piece features a quilting pattern with a combination of parallel intersecting lines and curvilinear patterns. It is not densely stitched.

Facing:

Bed rug, *ryiji*

Wool, bast, knotted
178 cm x 136 cm, 70 in x 53½ in
Late eighteenth century, Finland, Western region, IFAF FA.1959.1.1

Heavy bed rugs were made to use during the long, cold winters of Scandinavia. The knotted wool pile, by creating air pockets, created more warmth for weight. Sometimes bed rugs were used with the pile on the inside when it was especially cold. Called *rya* in Sweden, *ryer* in Norway, and *ryiji* in Finland, bed rugs evolved into floor rugs and wall hangings beginning at the end of the nineteenth century.

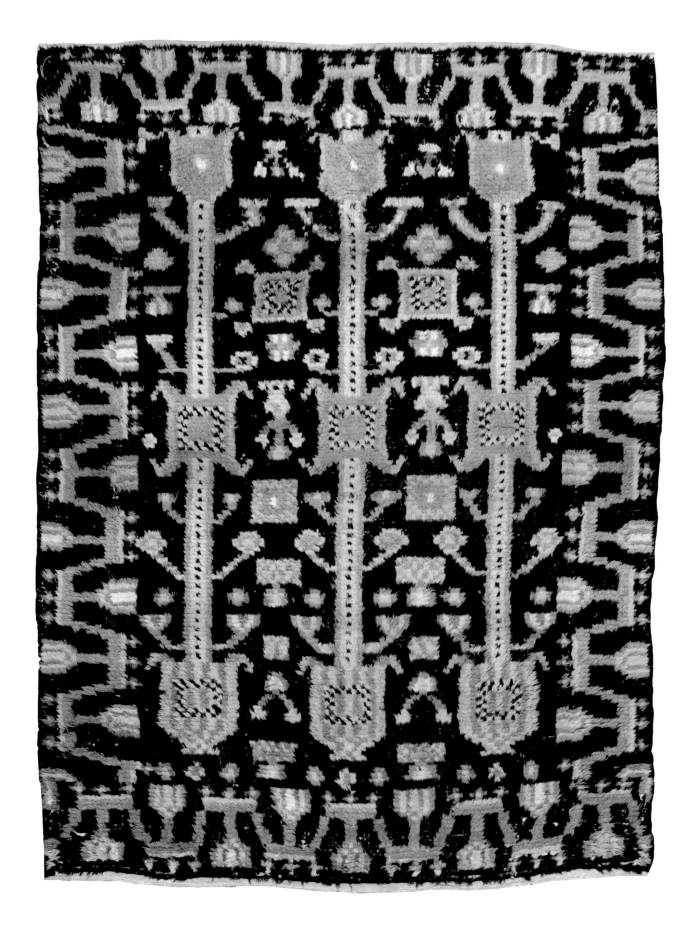

Quilt

Cotton, silk, metallic thread,
sequins, quilted
181 cm x 152 cm, 71¼ in x 59¹³⁄₁₆ in
c. 1900, Turkey
Textile Fund Purchase, MNMF
A.2004.12.1

The center of this quilt was made from an embroidered velvet coat. Looking closely, the seams of the coat construction are visible. The yellow cotton cloth of the inner border covers a silk border, also yellow and in poor condition. The quilt is stuffed and backed with cotton and is quilted with large stitches in a concentric diamond pattern. When it was in use, printed cotton fabric would have covered the white muslin back extending to the yellow inner border. This extra cover could be removed for cleaning and replaced when worn out.

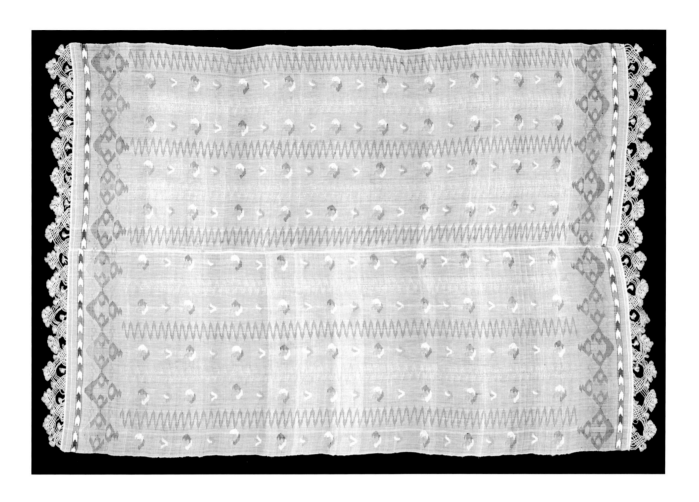

Cradle cover

Cotton, supplementary weft pattern,
tapestry weave, needle lace
155.2 cm x 101.6 cm, 61⅛ in x 40 in
c. 1910, Turkey, IFAF
FA.1988.3.5

Woven with very fine cotton yarn, the colored motifs in the
body of the cloth were made by inserting extra yarn while
the arrow-shaped color blocks on the ends are tapestry
woven. The scalloped trim on either end is needle lace.
The cloth would have been draped over the center bar of
a cradle to protect the occupant from insects.

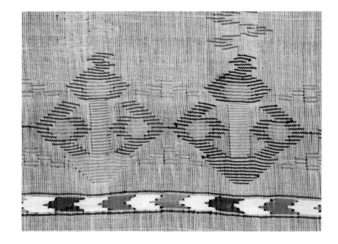

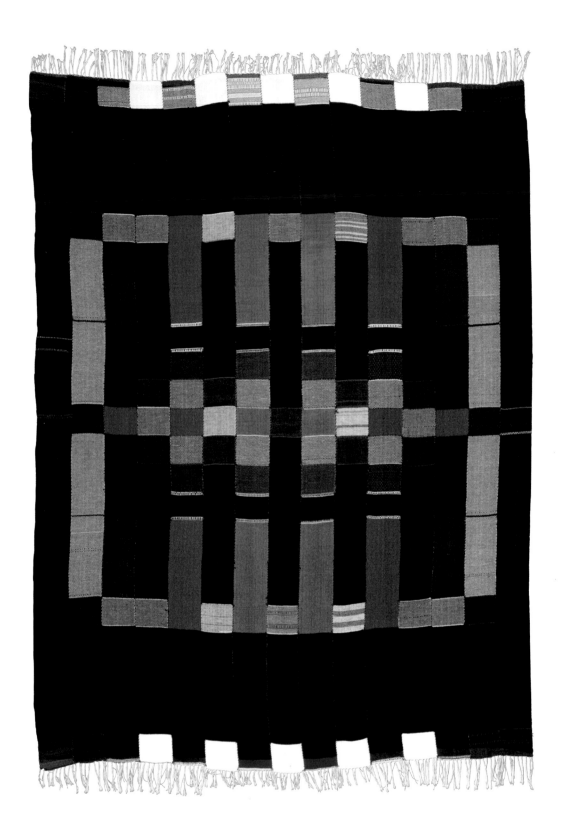

Coverlet

Cotton

236.2 cm x 165.1 cm, 93 in x 65 in
c. 1960, Liberia, Gift of Lloyd E.
Cotsen and the Neutrogena Group
A.1995.93.54

Woven in narrow strips that are then sewn together to make the cloth, this textile is typical of cloth woven on the West African narrow loom. It has often been called a cover cloth in the literature on African textiles and was probably used for sleeping.

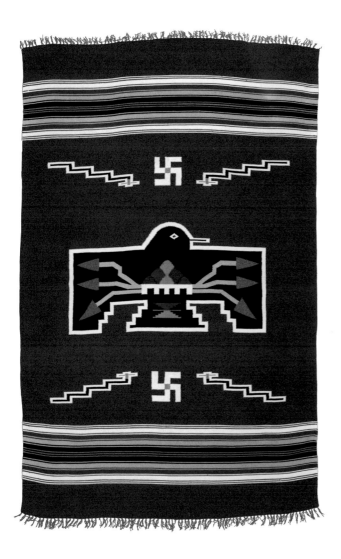

Blanket

Wool, tapestry technique
202 cm x 130.5 cm, 79½ in x 51⅜ in
c. 1930, Chimayo, New Mexico, IFAF
FA.1993.53.1

Hispanic weavers in the town of Chimayo, in northern New Mexico, developed a distinctive visual style grown out of the Rio Grande blanket tradition. A deep red ground was commonly used, as were motifs associated with American Indians such as arrowheads, eagles, and the pinwheel or swastika. During the early 1900s, Chimayo weaving was sold as an Indian-made product. This weaving tradition continues to this day.

Below:

Blanket

Wool, tapestry technique
201 cm x 117 cm, 79⅛ in x 46 1/16 in
Before 1865, Northern New Mexico, IFAF
FA.1969.15.1

Rio Grande blankets from New Mexico were often woven in two sections and sewn together, which required great care and skill during weaving if the patterns were to match up nicely. The white and brown yarns are natural sheep colors while the blue yarn was dyed with indigo and the red with cochineal, both imported from Mexico. This blanket has many similarities to the Saltillo serape style with a central medallion, zigzag motifs and four borders. For more illustrations of the museum's Rio Grande weavings, see *Rio Grande Textiles* by Nora Fisher.

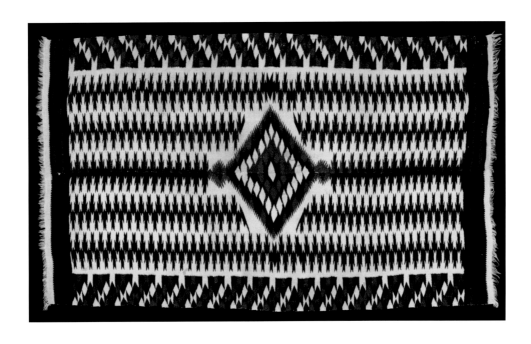

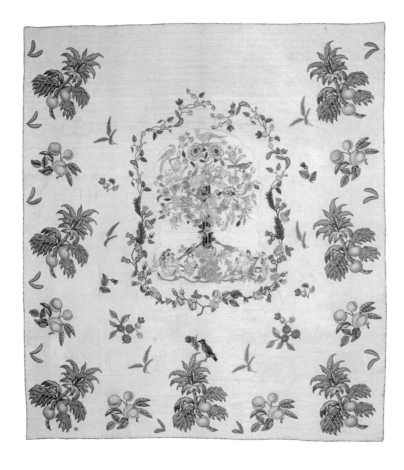

Quilt

Cotton, silk, appliquéd, embroidered, quilted
242 cm x 219.5 cm, 95¼ in x 86⁷⁄₁₆ in
1790–1820, Lynchburg, Virginia, IFAF
FA.1974.41.1

Made by Esther Austin, this is a broderie perse or chintz quilt. Printed cotton motifs were cut out and appliquéd to the quilt top to create a luxury bed covering. Like many broderie perse quilts, this one is decorated with a tree of life in the center and floral motifs creating the borders. The unhemmed motifs are sewn down with blanket and stem stitch and many are embroidered over with cotton and silk threads in varying stitches. The center medallion is filled with an exuberance of motifs, some layered. The quilting is minimal— around the appliquéd designs, some quilted shapes in the white spaces, and horizontal and diagonal lines at the top of the piece. The quilt has a ¼ inch printed cotton binding all around.

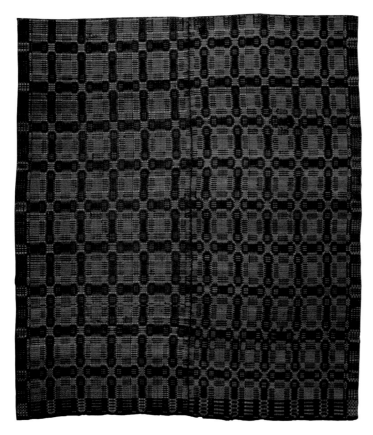

Below, left:

Coverlet

Wool, overshot
220 cm x 190 cm, 86⁵⁄₈ in x 74¹³⁄₁₆ in
c. 1880, Somerset Co., Pennsylvania
Gift of Mr. and Mrs. Van Meter
A.1987.276.4

Overshot coverlets were made both at home and by professional weavers. The peak period of production was from 1810 to the Civil War. This coverlet was made from hand-spun single ply wool and is said to have been made by Sally Flickinger Van Meter in Somerset County, a member of the Brethren, a sect of Anabaptists. Overshot coverlets were out of fashion by this late date, but home production by someone in a religious community such as the Anabaptists is very possible. Features of home-woven coverlets seen in this piece are the side edges finished simply as the selvedge and the inexact matching of the center seam as well as some flaws in the weaving. Wear on the top comes from the sleeper pulling up the coverlet.

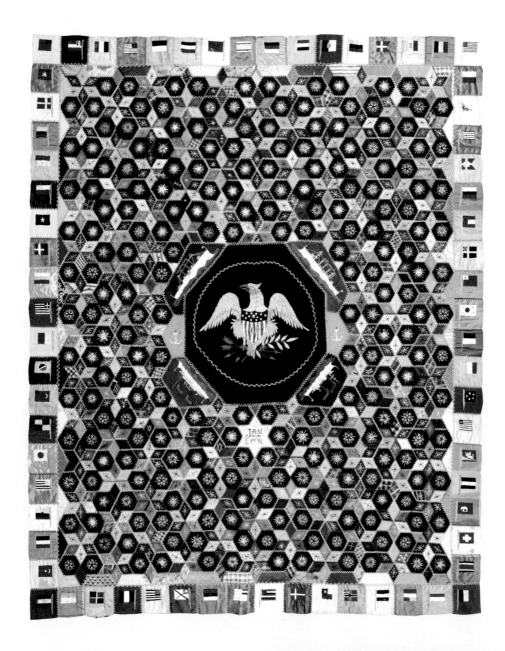

Quilt top

Silk, cotton, pieced, embroidered
184 cm x 148 cm, 72⁷⁄₁₆ in x 58¼ in
January 29, 1896, Maryland, Gift of Dr. and Mrs. Gerald Greene
A.1987.481.1

This quilt top came to the museum with an intriguing story. It was said to have been made in the Baltimore area for presentation to U.S. President Benjamin Harrison. The four ships represent the Great White Fleet of the American navy and the flags show the countries the fleet visited. The only problem is the Great White Fleet was sent on its round-the-world mission by President Theodore Roosevelt in 1907, at the conclusion of the Spanish-American War. The quilt top is clearly dated 1896. Despite the incongruence of the story, it is a magnificent piece of work with its hexagon, diamond, and parallelogram patches fitted neatly together, each embroidered with a starburst and outlined with herringbone stitch. The ships and eagle, executed in straight, seed, and feather stitches, indicate a masterful hand with the needle.

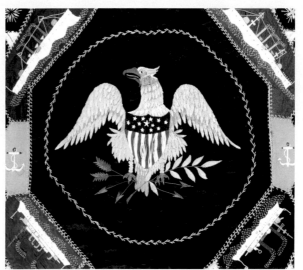

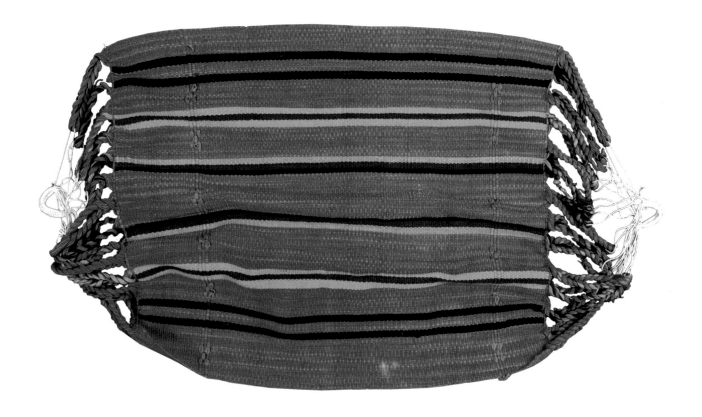

Above:

Child's hammock

Cotton
75 cm x 41 cm, 29½ in x 16⅛ in
Twentieth century, Colombia, Gift of Elizabeth King Black
A.1996.5.1

In many parts of the world, hammocks are used to keep infants out of harm's way. Although not always used for night-time sleeping, a suspended hammock provides a safe place for napping away from dangerous animals, dirt, and insects on the floor or ground, and the clumsy feet of adults. This hammock might have been made in Bolivar province.

Facing:

Blanket

Wool, ikat
202 cm x 142 cm, 79.5 in x 56 in
c. 1910, Momostenango, Guatemala, IFAF
FA.1998.26.14

Using primarily natural color wool with dyed red accent, this blanket was woven in two sections stitched together to make the finished piece. Wool blankets have been woven in Momostenango since colonial times and are still one of the primary income-generating activities of the inhabitants. The blankets are woven on a floor loom and then fulled in a nearby hot spring to make them thick. This blanket shows a small repair on the right edge.

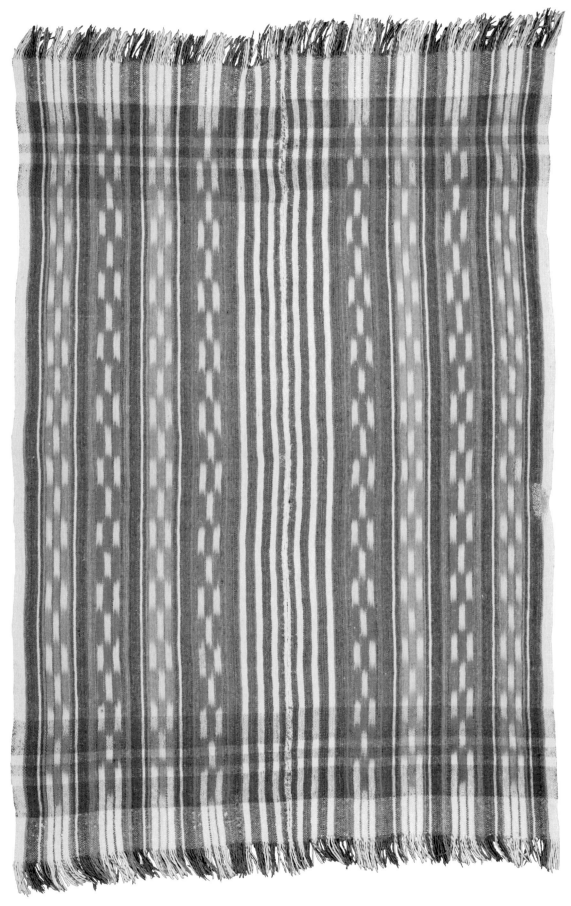

Left:

Futon cover, *futonji*

Cotton, tsutsugaki (hand-painted resist)
147 cm x 136.5 cm, 57⁷⁄₈ in x 53¾ in
c. 1860, Japan
Gift of Julia Meech and Andrew Pekarik
in honor of Nucy Meech
FA.1986.539.16

A futon cover was a quilt top; it would
have a backing and would be stuffed
with cotton batting and used as a blanket
when sleeping on a futon or cotton-
stuffed mattress. This futonji is made
from five panels of cloth sewn together;
the tabs at top were added by the donor.
A masterfully drawn phoenix is about to
alight on a paulownia branch. The three
center panels were sewn together before
dyeing, but it looks like the cover was
once longer and perhaps wider, as the
two tail feathers cascading on either side
panel are cut off.

Above:

Coverlet, *yogi*

Cotton, tsutsugaki (hand-painted resist)
144 cm x 152 cm, 56¹¹⁄₁₆ in x 59¹³⁄₁₆ in
1868–1912, Japan
Gift of Julia Meech and Andrew Pekarik
in honor of Nucy Meech
FA.1986.539.67

A *yogi* was usually given to a newly
married couple to use on their wedding
night. Thickly padded with cotton, it made
an especially warm cover for winter. The
"Three Friends of Winter" motif represents
longevity (pine), resilience (bamboo), and
happiness (plum). The motifs were drawn
with rice paste and then dyed the different
colors to make the design. The final dye-
ing with indigo produced the circular crest
and the deep blue of the coverlet. Along
with a substantial number of pieces col-
lected by Nucy Meech, the Cotsen collec-
tion contains many superb indigo-dyed
futon covers and yogis.

Mat

Rattan, plaited
184.15 cm x 82.55 cm, 72½ in x 32½ in
c. 1970
Central Kalimantan, Borneo, Ot Danum group
Gift of Lloyd E. Cotsen and the Neutrogena
Corporation
A.1995.93.1096

Ot Danum Dayak women living along the
rivers of Kalimantan Province plait mats with
geometric designs used for sitting and sleep-
ing. Weavers split the stems of the rotan palm
and dye some of the stems to make the
designs. Similar motifs appear on baskets,
weavings, and the human body as tattoos.
Each person living in a longhouse has a per-
sonal mat. Mats with elaborate designs of
human figures, houses, and the tree of life are
not for sleeping but are used in rituals.

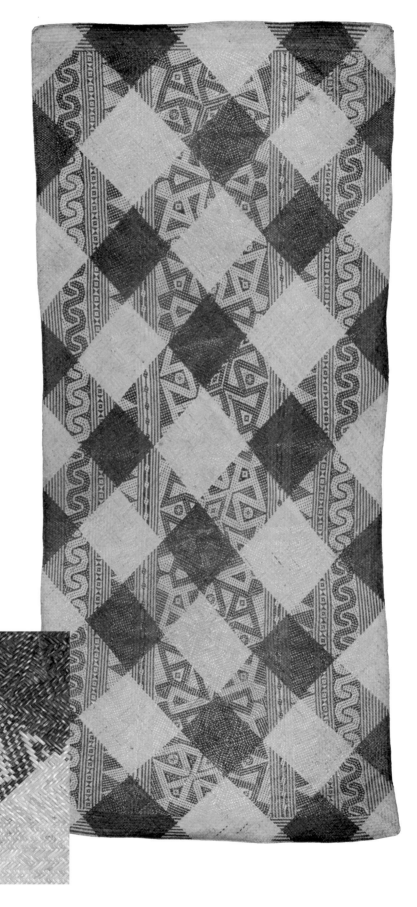

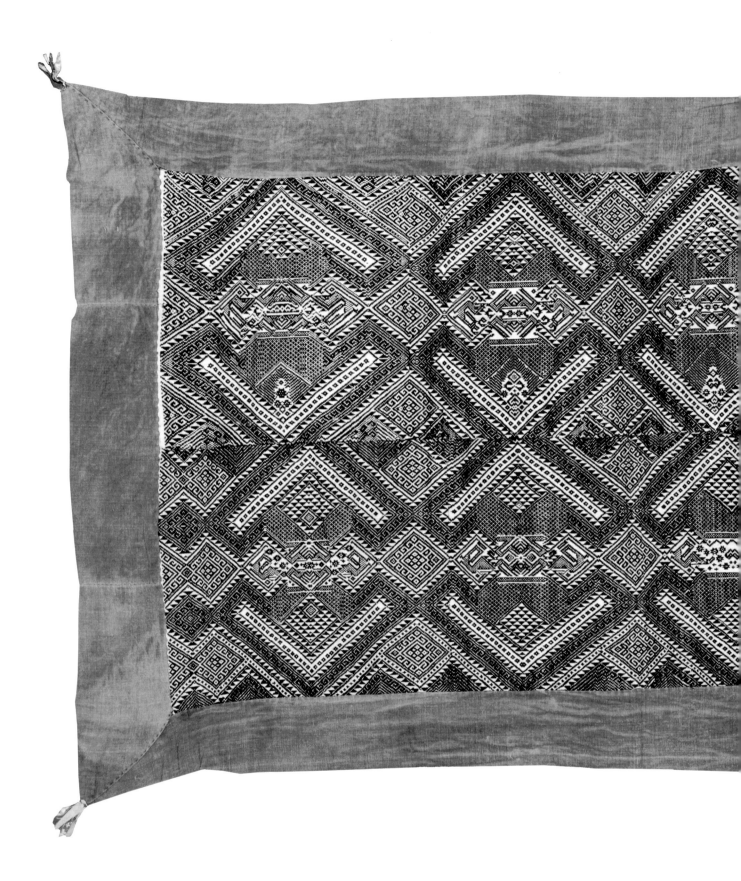

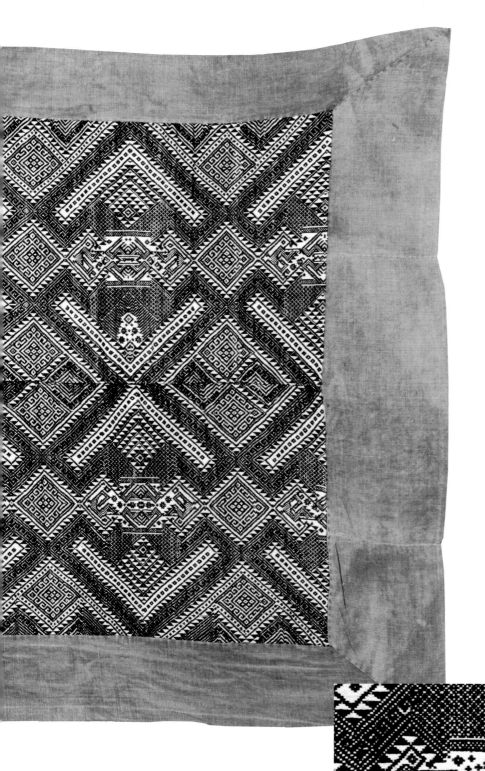

Mat

Cotton, supplementary weft patterning
182 cm x 103 cm, 71½ in x 40½ in
c. 1925, Vietnam, IFAF
FA.2005.2.1

Elaborate patterns of stylized snakes and ancestor figures embellish this sleeping mat from the northern mountains of Vietnam. Hand-spun natural and indigo-dyed cotton yarns create the strong contrast seen in these two panels backed and bound with brown cotton fabric.

✿ Home ✿

TEXTILES ARE ESSENTIAL IN ANY DWELLING, WHETHER IT'S A NOMADIC tent, a timber-frame house, or a tiled palace. They provide comfort and warmth to the inhabitants as well as a canvas for the skill of their makers. Textiles are used on the floor and on the table. They are also used to serve food, to pad hard furniture, to warm the walls, to protect other items from dirt and dust, and to decorate.

In some dwellings, textiles soften the hard surfaces of wood, plaster, and tile. In others, textiles are the dwelling itself. The woven goat hair tent has been used all over Central Asia, Turkey, and the Middle East for people who follow the grass for their livestock. Inside, the ground is covered with hardwearing cloth spun and woven from fiber produced by the family's flock. Quilts and pillows are stacked for use at night, woven bags hold the household's possessions, and cloth covers the bags to keep out dirt. All of these are made by the women of the family, whose weaving skills are on display to anyone who enters the tent. Stylized geometric and figurative motifs seen on storage bags and kilims may represent the animals that provide livelihood and the plant life seen all around.

In houses with seating furniture, cushion covers were woven and embroidered using patterns and techniques specific to a region. The earliest type of peasant house in rural Sweden had an open fire in the center of the single room with only a small hole in the ceiling for the smoke to escape. Rafter hangings were hung for special occasions such as holidays and weddings to create a contrast between the normally soot-covered walls and the white and colored linen of the hangings, creating a festive look. These long narrow cloths were adorned with embroidery or, more often, woven patterns. Rafter hangings were most commonly used in village houses until the eighteenth century when a fireplace with flue was adopted, but the practice of decorating a house with hangings persisted well into the nineteenth century in many parts of the country.[1] House design was practically dictated by the severe winter conditions and resulted in many characteristic features of the Swedish house, such as built-in cupboard beds and a wealth of bedding and household textiles.

Display towel
Elisa; linen, embroidered
140 cm x 43.2 cm, 55⅛ in x 17 in
1833, Lancaster County, Pennsylvania
IFAF
FA.1972.72.1
When Germans immigrated to Pennsylvania in the eighteenth century, they brought their needlework traditions with them. Display towels were made by young women as part of the trousseau. They were not functional but were decorative and were brought out when guests arrived. This towel displays the typical cross-stitched motifs of paired birds, trees of life, and a star. Only the name Elisa and date of 1833 are readable. The other letters might be initials or might refer to a saying, possibly in German.

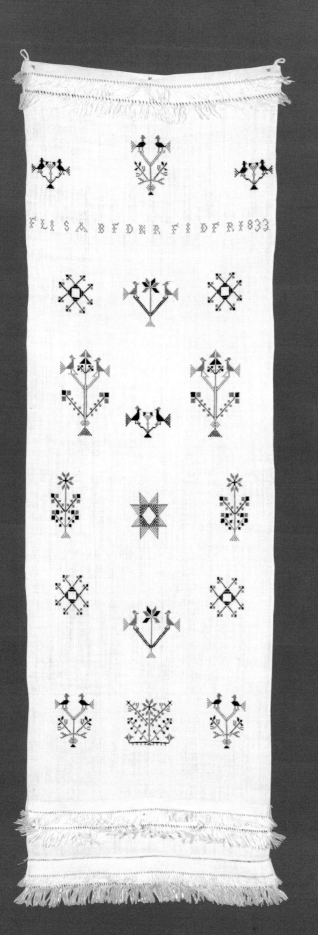

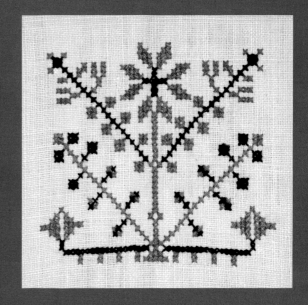

People in India, Guatemala, Mexico, and China, among others, covered food with cloth to keep it warm. All over the world, cloth has been used to carry food and other things. In Korea, pieced cloths known as *pojagi* are used to wrap things for storage in the house and as gift wrap as well. In Japan, the *furoshiki* is a square or rectangular cloth that was originally used to carry clean clothes to the public bath. Decorated with auspicious symbols, it was also widely used to carry gifts to a wedding. Today, the furoshiki is being revived as a "green" alternative to plastic shopping bags and paper gift wrap. The care taken with choosing an appropriate cloth design and wrapping a gift in an aesthetic way reflects the Japanese concern with presentation and correct behavior.

Where tables are used, it's common to cover them with a cloth, plain or fancy. In Europe and North America, dressing the table has gone from a white figured linen cloth primarily used as a napkin to printed, embroidered, and woven cloth that complements the crockery. Dressing the table developed out of banqueting habits of the upper classes in Europe. Farmers and laborers ate sitting around the hearth or from a bare wood table using fingers as utensils. As often happens, the customs of the upper classes slowly filtered down to the lower. By the nineteenth century, tablecloths became yet another canvas to display a woman's handiwork.

Tent hanging, *ilgitsh*
Wool, cotton, silk, embroidered
67.3 cm x 69.8 cm, 26½ in x 27½ in,
including fringe
1875–1900, Tajikistan,
Lakai Uzbek group
Gift of Lloyd E. Cotsen and
the Neutrogena Corporation
A.1995.93.374

Beautifully embroidered in chain stitch with silk thread on wool, this *ilgitsh* was made by a young woman to be hung in her tent after her marriage. Many bags, small and large, were needed for storage purposes, but were also, as this one shows, used purely for decoration. Backed with light-weight red printed cotton, it is not sturdy enough to hold anything even though it is bag shaped. The hanging is trimmed with warp twined tape, perhaps produced on a card loom. Separately woven fringe is attached.

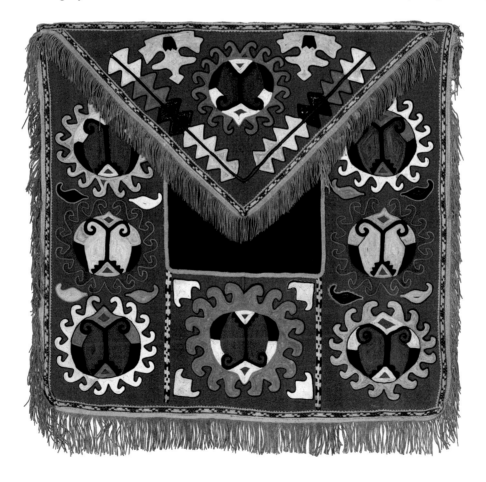

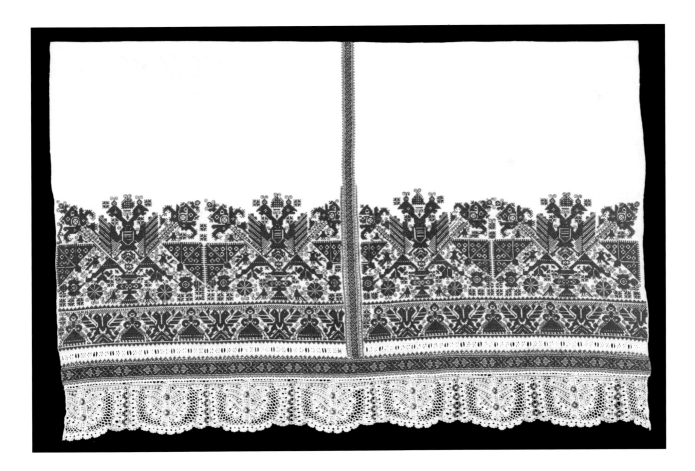

Hanging

Linen, embroidered, bobbin lace
145 cm x 96.5 cm, 57 1/16 in x 38 in
Late nineteenth century, Southwest Slovakia
Gift of the Heard Foundation
A.1951.2.1

The maker of this wall hanging or curtain from Southwest
Slovakia used many different techniques to decorate the piece.
Dense cross-stitch forms eight-legged goddess figures flanked
by double-headed eagles, single birds, and stylized floral motifs.
There is a band of white drawn work below the cross stitch, both
a horizontal and vertical woven tape with supplementary weft
repeat designs and, finally, a strip of bobbin lace is attached to
the bottom. Although the exact usage of this cloth isn't recorded,
it has all the hallmarks of a dowry cloth and appears to have
been made to hang as a curtain with a casing at the top. It could
have been a bed curtain used during childbirth. All the motifs are
symbolic of fertility and are of ancient origin. The goddess her-
self wears a very wide skirt, a two-dimensional representation of
pregnancy. Birds are magical beings that produce eggs, a very
potent fertility symbol, and are born from them. The triangles
with circles within symbolize the sown field that produces food
as a woman produces children. Other motifs of circles/solar
disks and flowers are part of the natural world associated with
pre-Christian religion. Their use on a curtain hung on the bed
while a woman gave birth helped ensure a healthy baby and
easy birth.[2]

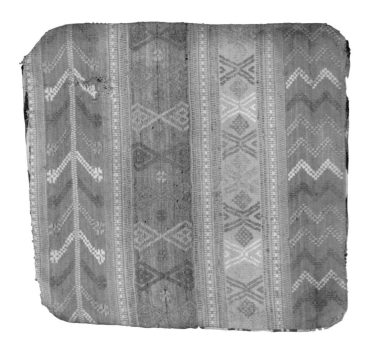

Cushion cover

Wool, bast, tapestry technique, supplementary
weft patterning
58.5 cm x 53.4 cm, 23 in x 21 in
1800–1850, Sweden
Gift of Florence Dibell Bartlett
A.1955.86.145

Tapestry technique, or *rölakan*, was used to make dazzling
geometric patterns such as this cushion cover. Handwoven
cushions stuffed with feathers and down, evident inside this
cover, were a common feature of Swedish houses. Many
such as this one were sewn together from two different types
of cloth. The back is patterned with the supplementary weft
technique called *krabbasnår*.

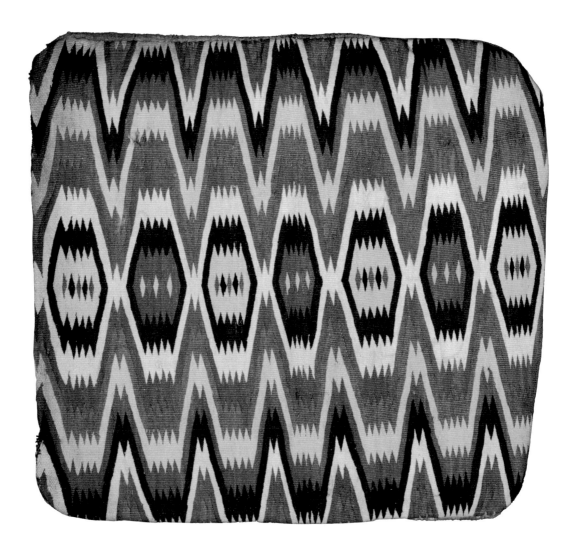

Tablecloth (detail)

Cotton, silk, metallic thread,
embroidered, crocheted
110 cm x 116 cm, 43⁵⁄₁₆ in x 45¹¹⁄₁₆ in
c. 1900, Turkey
From collection of Faizur R.
and Liselotte Khan
A.1988.57.8

In the Turkish house, most surfaces were covered with textiles of some type. Low tables were used to serve food and also as work surfaces for embroidery. This tablecloth is embroidered around the edges and in each corner, with crocheted metal lace around the entire cloth.

Towel

Silk, metallic thread, embroidered
117 cm x 32 cm, 46¹⁄₁₆ in x 12⁵⁄₈ in
c. 1900, Merzifon, Turkey
IFAF
FA.1988.3.4

Lengths of cloth with embroidered ends were used for many purposes around the house. Delicate towels were handed to guests after eating, were folded and displayed in a bedroom to celebrate the birth of a child or a boy's circumcision, and were hung around pictures and mirrors on the wall. The gauze-like cloth is embroidered with pomegranates, framed by columns of silver-wrapped white silk thread, and alternately filled with silver or gold. This piece was purchased in Merzifon, near the Black Sea.

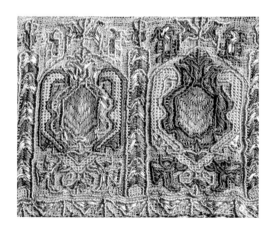

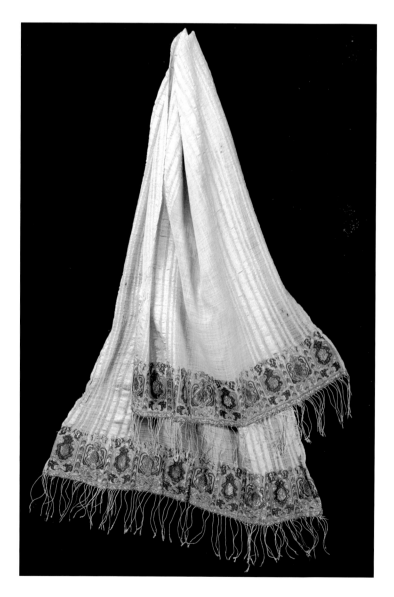

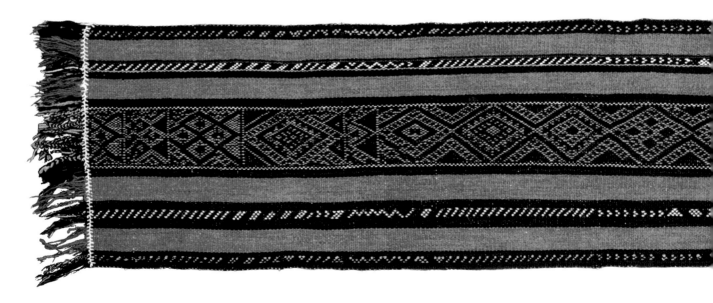

Facing:

Mat

Jute or similar fiber, straw, twined
137 cm x 134.5 cm, 53⁵⁄₁₆ in x 52¹⁵⁄₁₆ in
c. 1960, Ethiopia
Gift of the Girard Foundation
A.1980.1.963

Mats for use as floor coverings were made from locally available materials all over Africa and used for sitting, sleeping, or covering the floor, and as walls and roofs. Handmade mats for indoor use have been largely replaced by industrial plastic mats purchased in the marketplace. Using just two colors, this mat demonstrates the various textures and patterns that can be made with a simple material and a simple technique.

Right and below:

Cushion cover

Wool, supplementary warp patterning
277 cm x 49 cm, 109 in x 19¼ in
c. 1970, Libya
Gift of Mrs. Adele La Brecque
A.1999.38.2

Long strips of cloth woven on the horizontal ground loom were used in many ways by the nomadic Berbers of North Africa. This strip could have been folded over and sewn up on three sides to become a long pillow-cum-storage bag stuffed with clothing. It could also have been used as a wall decoration inside a goat-hair tent.

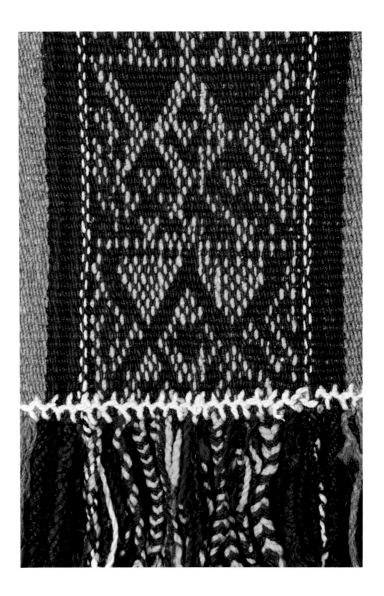

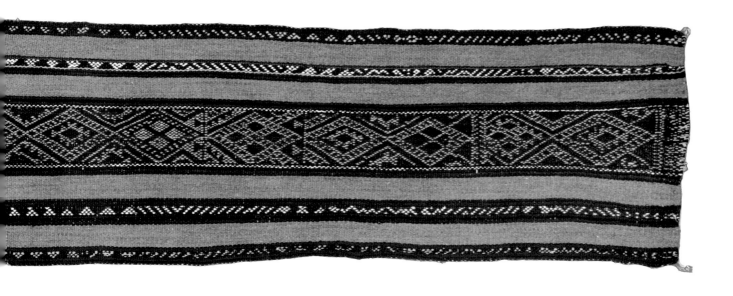

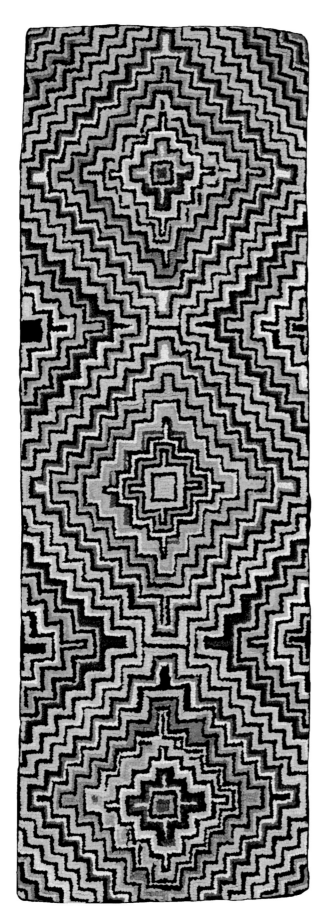

Rug

Cotton, jute, hooked
176.5 cm x 59.7 cm, 69½ in x 23½ in
c. 1895, Nova Scotia, Canada
Gift of Lloyd E. Cotsen and the Neutrogena Corporation
A.1995.93.892

The art of rug hooking developed in eastern North America in the mid-nineteenth century and flourished in eastern Canada in particular as a household art for one hundred years. Strips of fabric or yarn were pulled through burlap backing to create designs. Florals, geometrics, outdoor scenes, animals, and abstracts inspired by everyday life or from the imagination of the maker were all common.

Facing:

Rug

Cotton, wool, jute, hooked
110 cm x 75 cm, 43⁵⁄₁₆ in x 29½ in
c. 1890, Eastern United States, MNM
A.1978.73.1

Hooked rugs were often made from mixed fibers—whatever was at hand, if it was the right color, would do the trick. This eccentric rug combines recognizable flowers with shapes that might be trees, or perhaps corn plants, sprouting between semi-circular mounds.

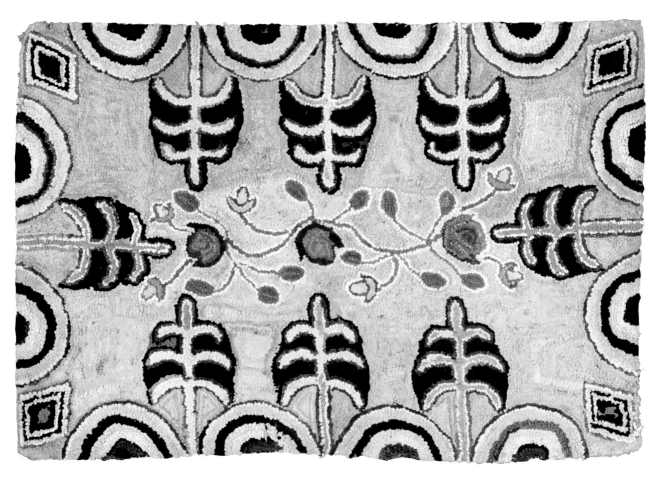

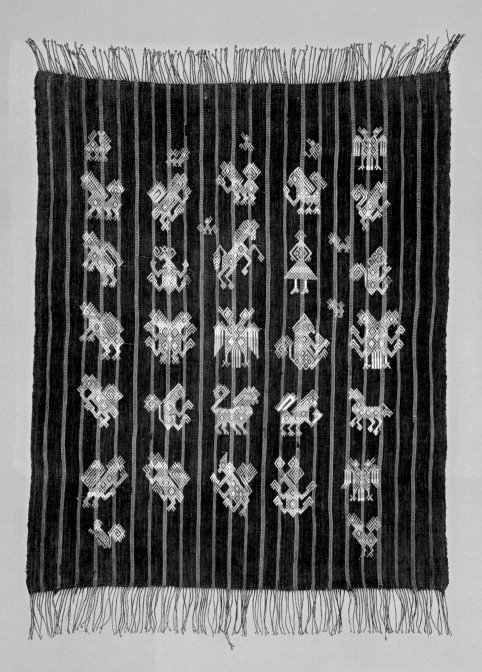

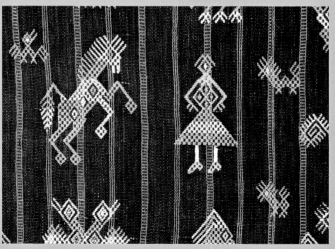

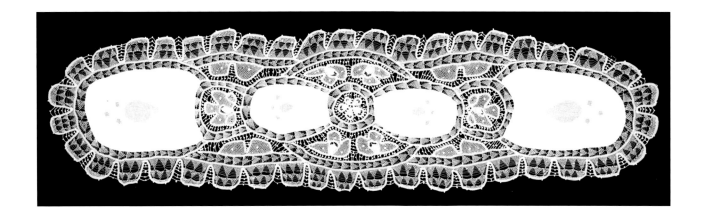

Facing:

Carrying cloth

Cotton, supplementary weft patterning
85 cm x 63.5 cm, 33$\frac{7}{16}$ in x 25 in
c. 1900, Nahuala, Guatemala, Quiche group
In memory of Jane Hall
FA.1982.39.1

All over Guatemala, square and rectangular cloths
are used to protect food and other things being
transported from place to place as well as at home.
All-purpose cloths, they are also folded and worn on
the head. Ceremonial types are used to cover altars
and are worn by *cofradia* members on the head or
over the shoulder. This single panel of hand-spun
cotton has brown warp stripes and diverse figures
woven in. It has a supple hand and feels like it was
well used and well loved. The warp fringe is twisted
and knotted.

Above and right:

Table runner

Linen, cotton, needle lace, embroidered
113 cm x 42 cm, 44$\frac{1}{2}$ in x 16$\frac{9}{16}$ in
1990, Passira, Pernambuco, Brazil
FA.1991.17.43

The techniques of lace making were brought to Brazil
in the seventeenth century by Portuguese settlers and
missionaries. Lace has been part of the dress and
household textiles of northeastern Brazil ever since.
This runner is made with a combination of techniques.
The solid centers are patterned with cut work, known
in Brazil as *renda labirinto*, and embroidery while the
borders are worked in a type of tape-based lace called
renda irelandesa or *renascança*, illustrated in the
detail. Woven tape is attached to a paper or cloth
pattern, filled in with needleworked brides and motifs,
and then sewn to the linen fabric. The origin of the
name "irelandesa" is a mystery, as it has no similari-
ties to Irish needlepoint or Carrickmacross lace. The
word *renascança* may refer to the curvilinear motifs.

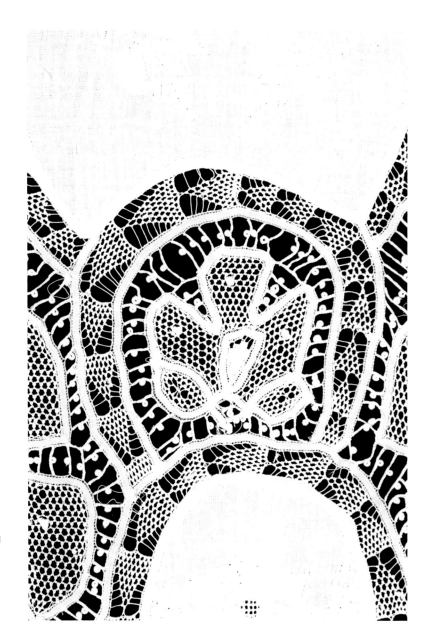

All-purpose cloth

Wool, embroidered
233 cm x 164 cm, 91¾ in x 64⁹⁄₁₆ in
c. 1950, Babylon region, Iraq
Gift of the Girard Foundation
A.1982.7.853

Pieced and patched from twill woven wool, the front of this multipurpose cloth is fully covered with freehand chain stitch embroidery using many fabulous shapes and colors. These embroidered cloths were made in villages along the length of the Euphrates River and used as room dividers, curtains, wall hangings, bed coverings, and occasionally as floor coverings. Men wove the cloth and women embroidered the motifs according to their own sensibilities. The detail shows two male figures, an orange sheep, and some gazelles that symbolize beauty and purity of heart.

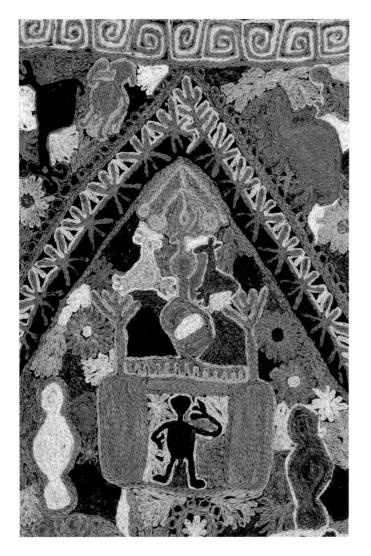

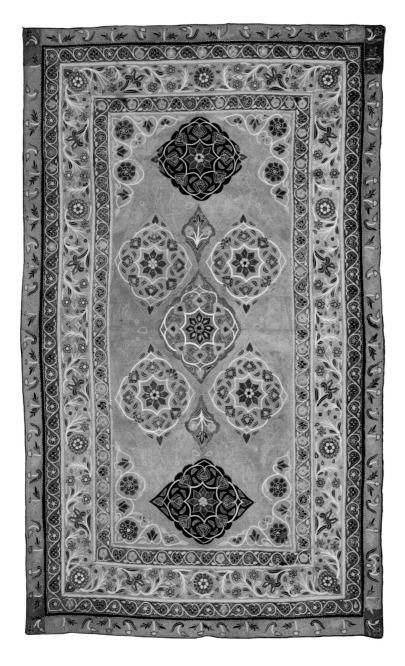

Hanging

Wool, silk, pieced, embroidered
191 cm x 116 cm, 75³⁄₁₆ in x 45¹¹⁄₁₆ in
c. 1850, Rasht, Iran
Gift of Cyrus Leroy Baldridge
A.1965.31.40

Pieced and embroidered wool textiles used for wall hangings, cushion covers, and saddle blankets are called *resht*, after the city in northwest Iran, known as either Resht or Rasht, where they are made. Although at first glance the motifs appear to be sewn onto an entire base cloth, this is not the case. Wool cloth is cut into small pieces that correspond exactly with cutouts in the base cloth. The edges are whipped together and chain stitched around. Other embroidery, both chain stitch and straight, is added. There is no backing on this piece; its construction is clearly visible. The museum has another, smaller resht that is appliquéd.

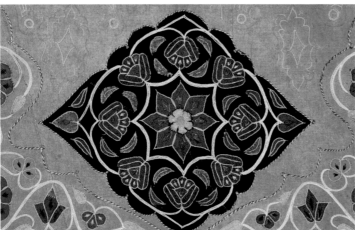

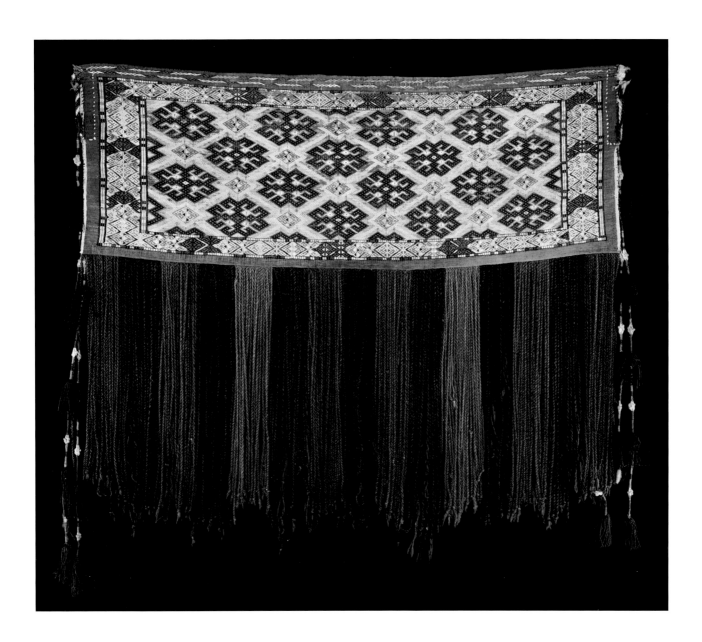

Tent bag

Wool, silk, supplementary weft patterning
119 cm x 127 cm, 46⅞ in x 50 in, including fringe
Twentieth century, Turkmenistan, Turkman group
Gift of Lloyd E. Cotsen and the Neutrogena Corporation
A.1995.93.346

Bags of this shape were hung on the back wall of the tent to store clothing and personal items. The Turkman tent is actually like a yurt—a frame covered with felt that can be taken apart and moved—that was filled with the products of women's looms. The nomadic life followed by the Turkman changed drastically in the twentieth century with forced settlement by the Soviets, who governed the area until the collapse of the USSR. It is difficult to assign a specific Turkman group to this piece. Similar pieces are attributed to both Ersari and Yomud groups.

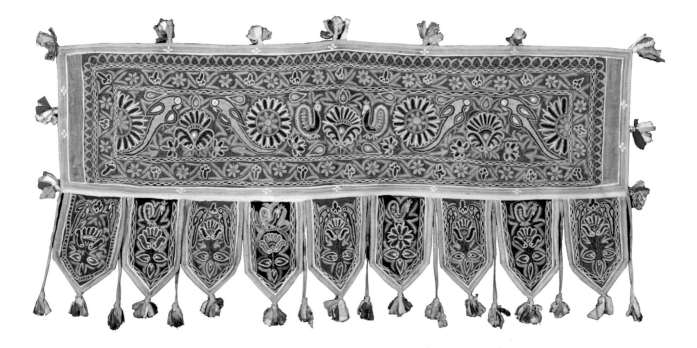

Above and right:

Door decoration, *toran*

Cotton, mirrors, embroidered
53 cm x 115 cm, 20¾ in x 45¼ in
c. 1920, Kutch, India
Gift of Nancy Bloch
A.1996.67.20

Hanging over a doorway in Gujarat State, a toran welcomes both human and divine visitors to the home. Multicolored chain, self-couching, feather, and running stitch motifs on primarily red and green ground cloth identifies this piece as made by an Ahir embroiderer (or in the Ahir style). In many torans the hanging "leaves" at the bottom have detached and been replaced. This entire piece is original, including the fabric tassels all around.

Facing, above and left:

Door hanging, *toran*

Cotton, silk, glass beads, mirrors, embroidered
77 cm x 131.2 cm, 30⁵⁄₁₆ in x 51⅝ in
c. 1945, Gujarat or Saurashtra, India
Gift of the Girard Foundation
A.1980.1.692

The top and flaps of this toran, although dissimilar, are original to the piece. They were made by two different groups of embroiderers, thus the different styles. The top rectangle was embroidered by a Mahajan stitcher using mirrors, herringbone, and satin stitches. The flaps are in the Mochi style, primarily mirror work and chain stitch done with a needle rather than a tambour hook. Small clusters of beads hang from each flap, a practice associated with the Mochi group.

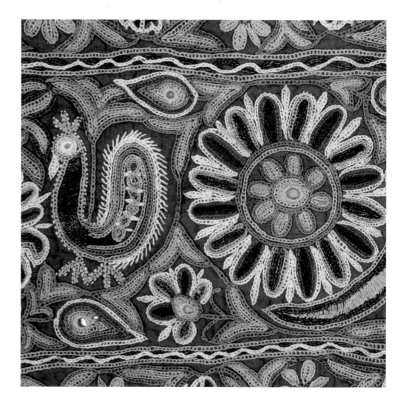

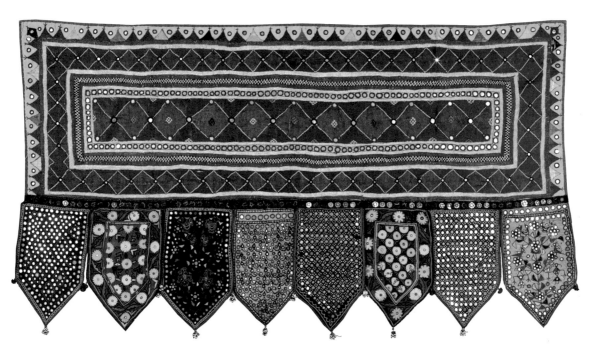

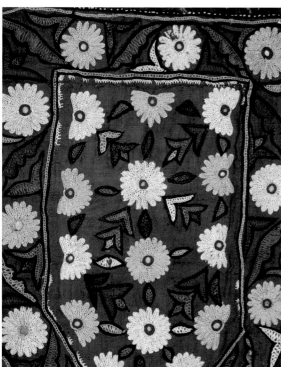

Below:

Cloth

Cotton, printed
59.2 cm x 59.2 cm, 23⁵⁄₁₆ in x 23⁵⁄₁₆ in
c. 1920, China
Estate of Caroline F. Bieber
FA.1984.227.12

Textile printing, thought to have been first developed in India, has a long history in China as well. This cloth could have been used as a mat on a table or to cover food. Soy bean paste was applied on the cloth through a stencil to create the white designs of phoenix, plum blossoms, bamboo branches, and floral meandering border. The motifs are all auspicious symbols in China. The phoenix represents good fortune, bamboo stands for longevity, and the plum blossom stands for resilience and perseverance—all qualities that are important to sustain a household.

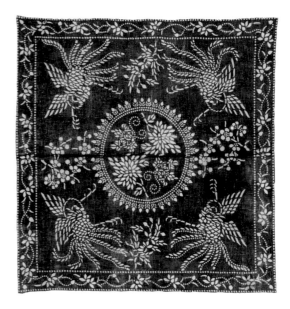

❁ Church & Temple ❁

THE USE OF TEXTILES IN A RELIGIOUS OR SACRED CONTEXT IS ALMOST universal, but the textiles used are very specific, from a Catholic priest's ecclesiastical wardrobe to hangings in a Buddhist temple in Thailand with myriad stops in between. Some textiles that fall into this broad category— here defined as pieces used in a place of worship, in the act of prayer, during ceremony and ritual apart from everyday life, and to magically affect one's destiny or fate—are made specifically for sacred use. In highland Madagascar the yarn from silk worms indigenous to the island is traditionally woven only into burial shrouds. Although it is acceptable for Europeans who are ignorant of the cultural connotations of the cloth to have it tailored into clothing, it is shocking when a Malagasy uses it this way. The ancestors play an important role in the life of the living and are believed to be able to manipulate the lives of their descendants and influence the course of events. Nontraditional use of the burial cloth would trivialize the important role of the ancestors so central to Malagasy life and belief.[1]

The sequined flags, or *drapo*, hung in Haitian *Vodou* shrines and used during ceremonies to call the spirits known as *lwa* are made by the priest himself. They feature sacred iconography garnered from the several religions that combined to form Vodou among the African slaves of the New World. Although they have been made for sale to collectors, they are still essential to the proper conduct of the ceremonies.

Other pieces are made sacred by intention and use. Many Catholic ecclesiastical garments were made from rich silks woven in the Muslim world. The fabric itself wasn't sacred or consecrated but was made so by the use it was put to. Worn garments or household cloths can be dedicated when refashioned into a ceremonial or sacred cloth. Beginning in the sixteenth century, garments made of rich fabrics were donated to a Buddhist temple when the wealthy owner died. These garments were cut up and made into altar cloths and temple banners. By making such a donation to the temple and toward the upkeep of its monks, a lay person gained merit. Buddhist banners also represent prayers for health and success in an endeavor, among other things.

Cushion cover top
Wool, embroidered
56 cm x 54.5 cm, 22 in x 21½ in
1827, Skåne, Sweden
Gift of Florence Dibell Bartlett
A.1955.86.155

Embroidered cushion covers were made for the bride and groom to kneel on during their wedding. They were done in pairs, one for the bride and one for the groom, and were part of the bride's trousseau. This cushion top shows the bride's initials, HKD, the year of the wedding, 1827, and a masterful hand at free embroidery using stem, surface satin, and cross couching stitches. A central wreath, corner motifs, and graceful floral sprays were all common motifs in southern Sweden but were used according to the taste and design sense of the maker. The ground fabric was handwoven at home using hand-spun, single-ply yarn. Feathers are apparent on the back.

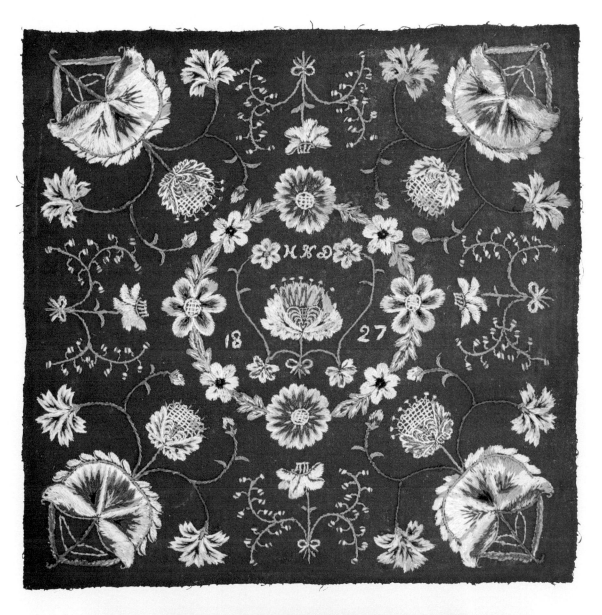

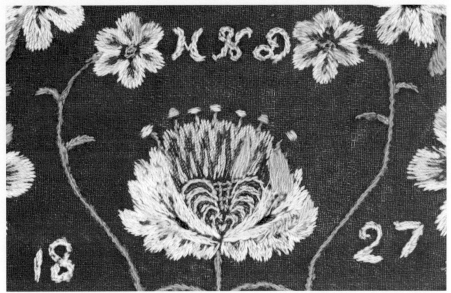

Textiles are used to decorate the space of prayer and are used by individuals while praying. Muslims put many kinds of mats on the floor when they prostrate themselves before God. The Torah curtain and mantle are used to protect the sacred scroll in a synagogue, and there are several types of small cloths such as the communion sets, pulpit falls, and altar frontals used in the celebration of Catholic Mass. Woven cloths also cover sacred books and hold them closed. In Southeast Asia, the process of making yantra cloths itself is ritualized to imbue the finished product with power and holiness that protects the person who carries it.

Ceremonial flags are carried into battle, while others are used during an initiation rite or wedding ceremony. Flags are also national symbols that evoke patriotic feeling; the rituals and strict rules that surround the raising and lowering of the American flag highlight its emotional and mystical value. Amulets made from cloth hang in the home or tent. Amulets can be very informal and appear to the outsider as a simple decoration only, while to the inhabitant the piece is charged with protective power by its colors and motifs.

Weddings provide another occasion for ceremonial textiles to be made and used. Changes in life status, such as getting married and thereby actively joining the adult community, are marked in some cultures by a change in dress and also by the presence of special articles such as cushion covers and dowry cloths. At either end of life, birth and death are also commemorated through the use of special cloths, such as the aforementioned case in Madagascar. Textiles visually honor a culture's ceremonial, sacred, and special occasions and places, proclaiming to those who see and recognize them their importance to the life of the community.

Flag, *asafo frankaa*
Nana Manso
Cotton, pieced, appliquéd
106.7 cm x 170.2 cm, 42 in x 67 in
c. 1945, Kormantine Saltpond area,
Ghana, Fante group
Gift of Lloyd E. Cotsen and the Neutrogena Corporation
A.1995.93.31

Flags were carried by Fante warrior groups called *asafo* in southern Ghana until the intervention of the British colonial and Ghanaian national governments curbed local wars and fighting. Flags employ a locally understood visual vocabulary to communicate the sentiments of the asafo company toward its rivals. The presence of the British flag in the upper corner dates this flag to before Ghanaian independence in 1957. A pole would be placed in the sleeve at the side so the flag could be carried during festivals.

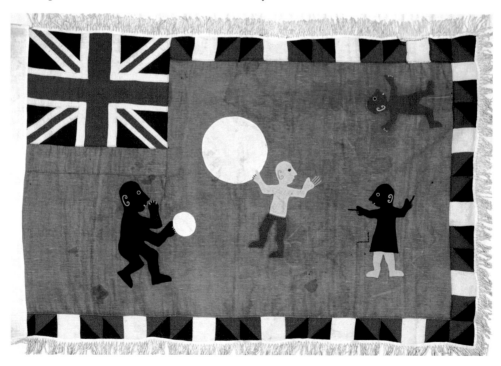

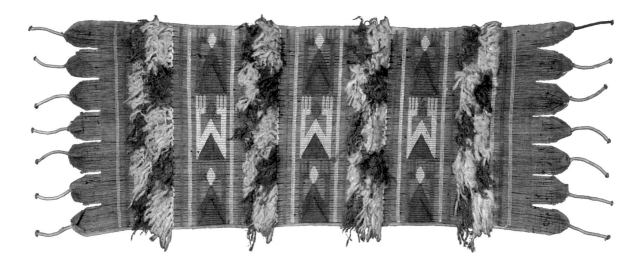

Above:

Shoulder cloth, *itagbe*

Cotton, silk or rayon, supplementary weft patterning
141.5 cm x 45.7 cm, 55¾ in x 18 in
Twentieth century, Nigeria, Ijebu Yoruba group
Gift of Lloyd E. Cotsen and the Neutrogena Corporation
A.1995.93.73

Itagbe are handwoven cloths made by female weavers on a vertical loom. They are used by members of Oshugbo, a group whose religious practice gives them moral authority to lead in the spiritual, judicial, and political realms of Yoruba society. All aspects of this cloth have symbolic significance—the shag is called *shaki* and refers to the innermost being of a person made visible; the number seven as the number of tabs woven at each end is a sacred number to the Yoruba; and the supplementary weft motifs are *opolo*, or frog, a water spirit sacred to the Yoruba. The cloth can be worn over the shoulder at Oshugbo ceremonies, but it can also be presented as an offering at a shrine to gain favor with the gods. Itagbe cloth is considered to be a visual form of prayer.

Right

Hammock

Cotton, supplementary weft patterning
309.5 cm x 61 cm, 121⅞ in x 24 in
c. 1930, Sierra Leone, Mende group
Gift of Mrs. Anna Kliene
A.1968.32.5

Although people in West Africa use hammocks for sleeping, this elaborately woven hammock was not for everyday use. It was used to carry Chief Brewa of the Mende during ceremonial occasions. A pole was threaded through the woven slits on each end and supported by two bearers. One very long piece of cloth woven on a narrow loom was cut into three pieces and sewn together to make the body of the hammock. Eight small flaps, each showing a different design, were attached to both sides. Tufts of unspun cotton were inserted into the warp in three sections. The ground cloth is composed of natural white and brown stripes with indigo-dyed motifs woven in. The expert weaver took special care to make sure the design sections would match perfectly when sewn, not an easy thing when making a complex cloth with multiple design elements. The hammock was given to the donor, a medical missionary in Sierra Leone and later head of nursing in a Santa Fe hospital, by Chief Brewa himself.

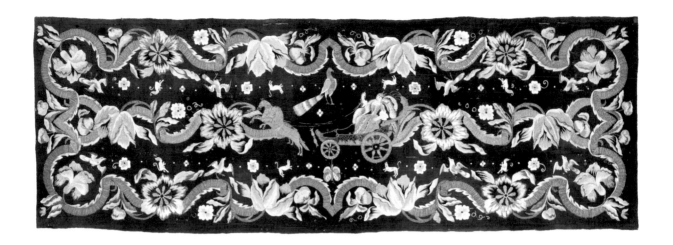

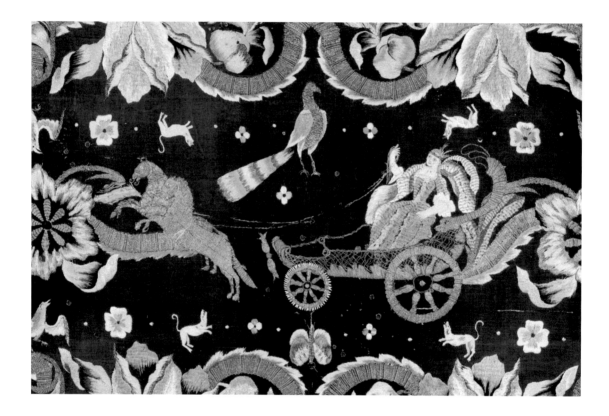

Altar frontal

Cotton, silk, metallic thread, embroidered
66.5 cm x 194 cm, 26³/₁₆ in x 76⅜ in
c. 1800, Mexico and New Mexico
Fred Harvey Collection of the International Folk
Art Foundation
FA.1979.64.30

This textile was purchased in Mexico in 1815 by Bernardo Abeyta, resident of Chimayo, New Mexico, for use in the new Santuario de Chimayo he was building. Its use as an altar cloth is evident from the candle wax spots in the center of the cloth. This piece is one of a set of four embroideries previously owned by Fred Harvey. They might have been stitched in Asia for sale in the New World. Alternatively, they could have been embroidered in Mexico, possibly in a convent, for local consumption. There is no relationship to indigenous Mexican embroidery either in style or in stitches used, which are primarily long and short satin and metal embroidery techniques. The figure in the cart is dressed in fashionable style of 1750–1770 with a corseted waist, large sleeve ruffles, and square neckline embellished with lace, illustrating a profound European influence on urban Mexican life.

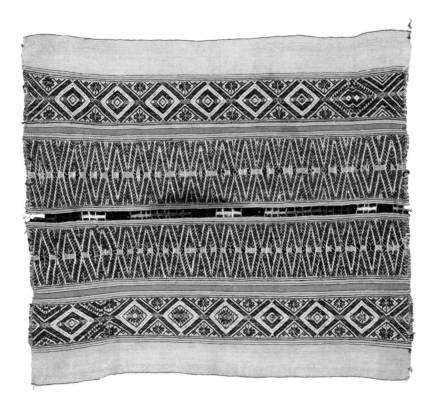

Above:

Ceremonial coca cloth

Wool, complementary warp weave, embroidery
60 cm x 50.5 cm, 23⅝ in x 19⅞ in
Twentieth century, Pisac, Peru
Gift of Florence Dibell Bartlett
A.1955.86.286

Small decorated cloths were used to wrap and carry all kinds of things in the Andes, including coca leaves. Coca leaves are offered to the gods as a form of tribute, perhaps creating the stain in the center of the cloth. This small cloth is made from two pieces, joined by embroidery.

Right:

Altar cloth

Cotton, supplementary weft patterning
79 cm x 78 cm, 31⅛ in x 30¹⁄₁₆ in
1931, San Mateo del Mar, Oaxaca, Mexico, Huave group
The Elizabeth Norman Collection
FA.1954.32.103

A very different kind of altar cloth is shown here, this one for use in an Huave Indian home. Some cloths of this shape and design are used by Huave Indians to cover food and to carry things, but again, the spots of wax point to use as an altar cloth, where candles would have been lit. Woven into the cloth are the date, Marzo 1 de 1931, and indecipherable lettering that might be a name. Before the availability of chemical dyes, the commercial red yarn would have been dyed shellfish purple. Huave huipils (upper garments) are made with the same patterning technique and motifs such as deer, birds, and geometric shapes.

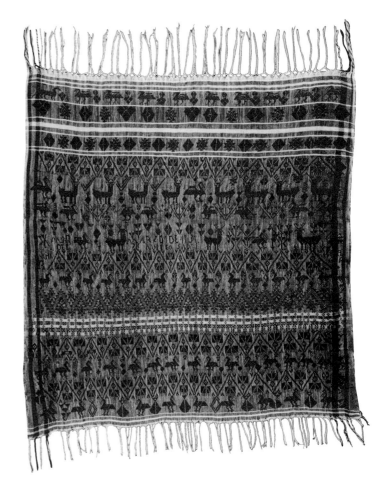

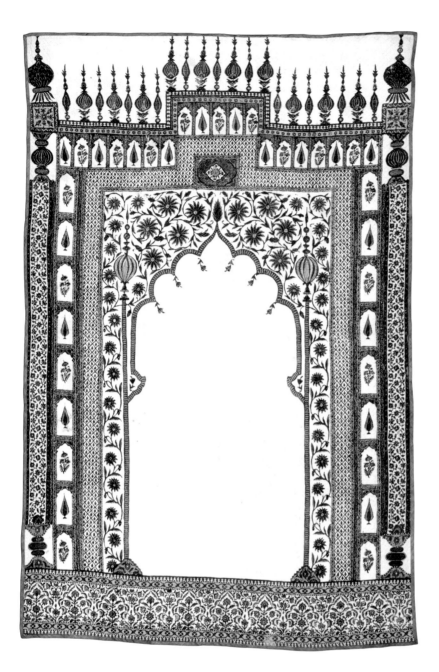

Prayer mat

Cotton, silk, painted, printed, quilted
132 cm x 89 cm, 51¹⁵⁄₁₆ in x 35¹⁄₁₆ in
Nineteenth century, Iran
Gift of Mrs. Dwight B. Heard
A.1949.1.65

Both the size and shape of this textile, as well as the decoration, make it likely this was used as a mat for prayer. The *mihrab*, or niche, shape symbolizes the wall in a mosque that faces Mecca, the direction of prayer. Other architectural elements include minarets or mosque spires with domes and pillars. Most of the motifs are hand-painted, but some of the narrow floral borders are probably block printed. The small quilting stitches are in an all-over chevron pattern. The natural dyes used are still bright, and the quality of the painting is very fine.

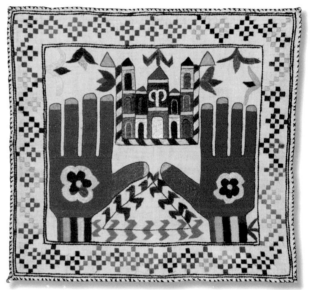

Above:

Tent hanging

Silk, cotton, pieced, appliquéd
55.2 cm x 35 cm, 21¾ in x 13¾ in
c. 1930, Pamir Mts., Kyrgyz group
Gift of Lloyd E. Cotsen and the Neutrogena Corporation
A.1995.93.356

This colorful piece was made by Kyrgyz nomads to hang inside the tent. As an amulet, its function is to protect the dwelling and its inhabitants from harm. Living in a harsh environment where there is very little control of the forces that affect them, the Kyrgyz use all means available to help them prosper. Patchwork, or *korak*, curtains and quilts are also made by Tajik and Uzbek women. The Pamir Mountains are primarily in Tajikistan, Kyrgyzstan, Afghanistan, and Pakistan.

Right:

Prayer stone wrappers

Cotton, embroidered
39.4 cm x 39.7 cm, 5½ in x 15⅝ in; 32.4 cm x 35 cm, 12¾ in x 13¾ in;
30.5 cm x 34.3 cm, 12 in x 13½ in
c. 1960, Afghanistan, Hazara group
Gift of Lloyd E. Cotsen and the Neutrogena Corporation
A.1995.93.334-6

These small cloths are used by Hazara Shia Muslims to protect the prayer stone on which they place their foreheads when they pray. They are embroidered by women in the home during the long winter months of central Afghanistan, using satin and surface satin stitch. The hands represent those of Hazrat Abbas, a Shia martyr killed in the battle of Karbala in 681 CE.

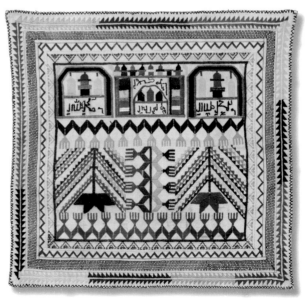

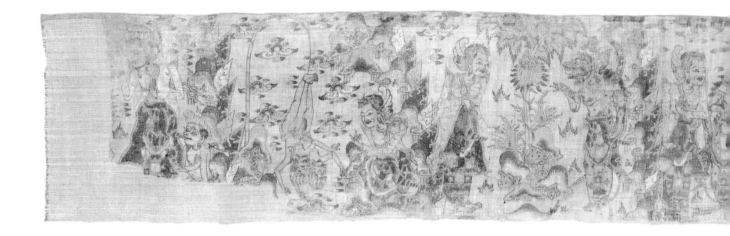

Above:

Temple hanging, *ider-ider*

Cotton, painted
160 cm x 36 cm, 63 in x 14³⁄₁₆ in
n.d., Bali
MNM
A.1958.30.4

This fragment of a temple hanging was sewn to a linen backing to preserve it. Narrow lengths of cloth painted with scenes from Hindu religious epic stories were hung around the roof of pavilions and shrines on festive occasions, then carefully folded and put away. The white cloth was boiled with rice and then polished to prepare the surface for painting. This piece is painted on hand-spun and woven cotton. Fine machine-woven cotton replaced this material around 1900.

Below:

Manuscript binders, *sazigyo*

Cotton
From 300–710 cm x 1.5–3 cm, 118–279½ in x ⁹⁄₁₆–1³⁄₁₆ in
Mid-nineteenth to early twentieth century, Burma
IFAF
FA.2005.48.2

Narrow tapes were woven by professional female weavers to hold the leaves of manuscripts together. The tapes were usually commissioned by a patron to present to a monastery, along with a monastic text written on palm leaf or cloth with carved wood covers. Upperclass women also wove *sazigyo* as an act of devotion. The inscriptions can include religious symbols, one of the animals representing a day of the week, and a prayer in verse. The oldest tape in this photo is wider, blue, and made of hand-spun yarn. The red style became popular in the 1870s, while in the 1890s, new colors and styles were introduced. Time-consuming to produce on a card loom, this painstaking work is no longer done in Burma.

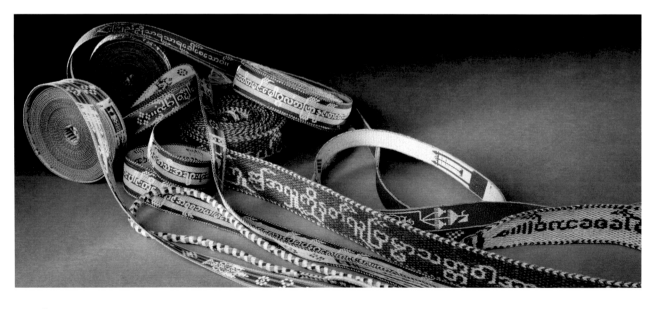

Below:

Yantra cloth
Cotton, painted
90.5 cm x 48 cm, 35⅝ in x 18⅞ in
Twentieth century, Burma
FA.2003.9.4

Yantra cloths are covered with magic squares and mystical writing as well as images of Buddha, seen here under a hat or canopy of many heads and what appear to be dancers or acrobats. Each symbol within the square is a key to a chant, thus the square can be read or chanted. This cloth could have been placed on an altar or carried, folded up, by someone desiring the protection from harm it promises. Yantra drawings on cloth are associated with Theravada Buddhism.

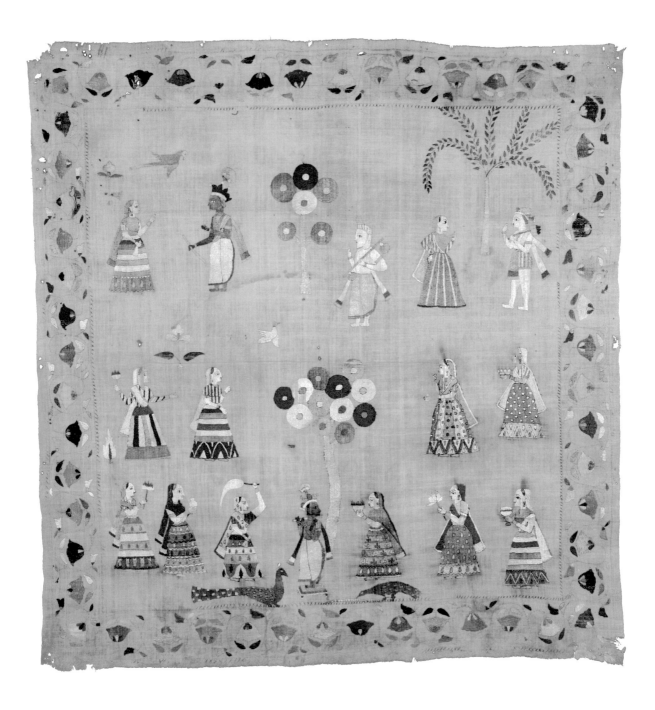

Gift cloth, *chamba rumal*

Cotton, silk, embroidered
77 cm x 76 cm, 30⁵⁄₁₆ in x 29¹⁵⁄₁₆ in
c. 1875, Chamba, Himachal Pradesh, India
Gift of the Girard Foundation
A.1980.1.717

The word *rumal* is used in India to indicate a small, usually square cloth with multiple uses—it can be worn on the head, used to cover food, or used to wrap something for presentation. It is also translated as "handkerchief."

Rumals embroidered in the districts of Chamba and Kangra were used to cover offerings as they were carried to the Hindu temple. This one is in the classical style, highly refined in both the embroidery and the figures, said to be based on the famous Pahari miniature painting style. Krishna, the blue god, and the milkmaids, or *gopis*, are shown along with a white bearded wise man, or *rishi*, and birds realized in satin stitch. The gopis are dressed in skirts, blouses, and veils all beautifully suggested in silk.

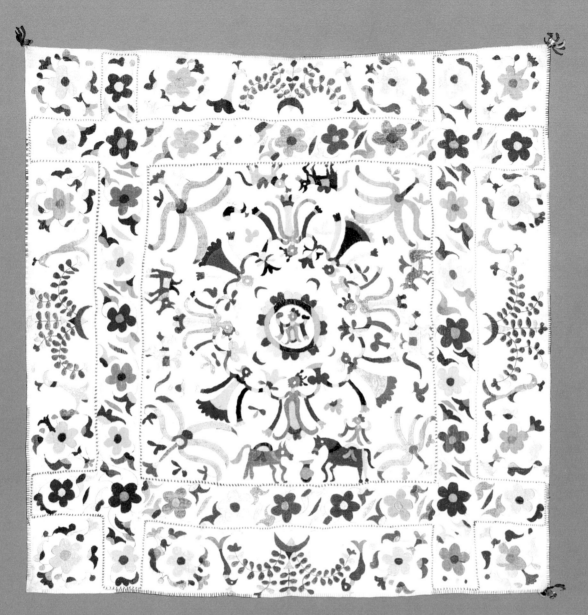

Gift cloth, *chamba rumal*

Cotton, silk, embroidered
88 cm x 88 cm; 34⅝ in x 34⅝ in
c. 1920, Chamba, Himachal Pradesh, India
Gift of the Girard Foundation
A.1980.1.718

Here is an example of the folk style of *chamba rumal,* executed by village women. Unlike the classical style, whose motifs were usually drawn by professional artists, this was more likely designed by the woman who made it, resulting in a far more exuberant expression using brighter colors to create bolder motifs. The stylized face of the figures, with pronounced nose and lips, is typical of the style. Flowers, birds, and horses with saddles fill three outer borders. A ring of dancing gopis, alternating with the blue god Krishna, surround a central figure of Krishna.

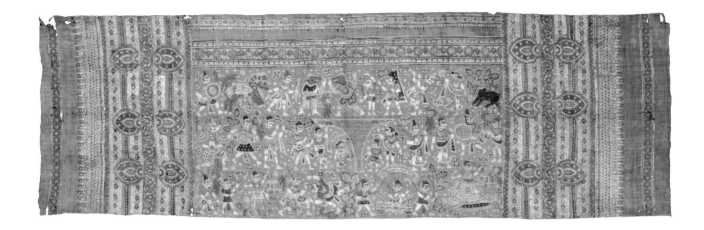

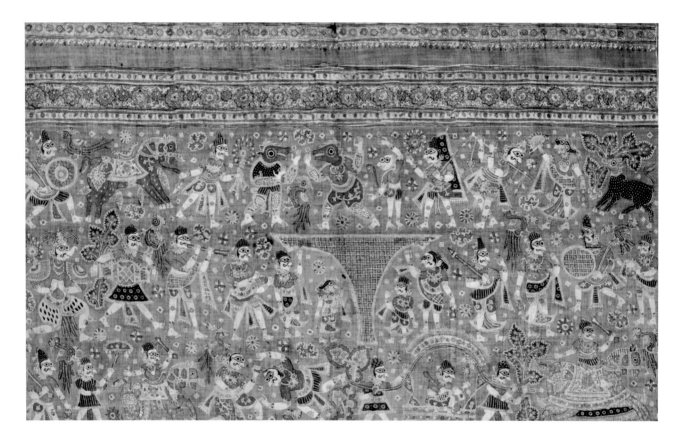

Ceremonial hanging

Cotton, painted, block printed
82.55 cm x 264.16 cm, 32½ in x 104 in
Seventeenth century, India for
the Sulawesi market
Gift of Lloyd E. Cotsen and the
Neutrogena Corporation
A.1995.93.432

This expertly painted and finely detailed cloth was found on the island of Sulawesi in Indonesia in the 1970s and became part of the museum collection in 1995. Since then, a small group of similar textiles have surfaced and more research has been published about the early trade in textiles between India and the islands of Southeast Asia. The figures in the center panel, although seemingly randomly placed, are meant to be read in groups as separate scenes. If there is an overall narrative, we don't know it at this point. The depiction of the faces, with a three-quarter profile and bulging eyes that look like goggles, relate most closely to shadow puppets from the state of Karnataka in southern India. What is most sure is that this cloth was treasured and preserved for centuries by its island owners, brought out to display on important state or ritual occasions, resulting in a surprisingly vivid condition for a cotton cloth almost four hundred years old.

Right:

Fine mat, *'ie toga*

Pandanus fiber, feathers, plaited
180.3 cm x 137.2 cm, 71 in x 54 in
c. 1930, Samoa
MNM
A.1958.17.4

Mats, both as everyday sitting and ceremonial textiles, played a very important role in Polynesian life. This particular fine mat, called *'ie toga* in Samoa, was never used on the floor but instead was a prestige item, exchanged and presented at weddings, funerals, and the blessing of a new house. They were also sometimes worn for a very special occasion. The entire process, from cutting the young leaves to soaking, drying, bleaching, splitting, and weaving a mat, was done by women. A fine mat could take years to complete.

❀ Decorative ❀

DECORATIVE TEXTILES ARE PRODUCED BY HAND IN MANY PARTS OF THE world. Although many household textiles are decorative as well, this category is reserved for pieces that have little more function than to decorate or to show the skill of the person who made them. Embroidered samplers have a long history: before they became a schoolgirl endeavor, samplers were made by professional embroiderers to show clients the variety and quality of their work as well as to provide a visual reference for technique. Schoolgirl samplers were a product of the educational system of Europe and the places it influenced. The ability to do fine needlework was considered an essential skill for a woman who was either running a household and supervising servants or sewing for a meager living. Before 1860 or so, bed linens were produced at home and were marked with initials and a number. The number was useful for rotating the sheets in use. Samplers that included different alphabets served as patterns for the marking. Needlework became less important as part of the school curriculum in the mid-nineteenth century, though it was still taught well into the twentieth century in some parts of the world.

Embroidered pictures were another domestic art form that flourished in the eighteenth and nineteenth centuries, particularly in northern Europe and North America. They were usually made by older girls of the upper class reaching the end of their schooling. Common subject matter for these pictures was stories from the Old Testament, classical themes, and allegories illustrating the values and morals of the time. The embroidered picture on page 74 shows a landscape, another popular theme. These works were usually very detailed and worked in several colors and types of stitches and threads, including metallic, that would create texture and reflect light to create an illusion of depth. Mourning or memorial pictures were also worked to commemorate the death of a family member or friend. Common motifs on these were tombs, weeping willow trees, and inscriptions.

In more recent times, traditional skills with a needle have been put to use for economic development. In places with limited job possibilities for women, individuals and outside agencies might create a project to sell

Hanging
Synthetic, silk, wool, embroidered, painted
78 cm x 55 cm, 30 $\frac{11}{16}$ in x 21 $\frac{5}{8}$ in
c. 1925, Megisti Island, Greece
Gift of Magdalene P. Singer
A.2006.54.1

This embroidered picture is immediately charming, showing a woman of the time spinning with a drop spindle, her sheep gathered around her. The entire background except for the sky is covered with stitching. Her hair and skin is painted. The sheep are made from bits of fleece. Not very reminiscent of Ottoman embroidery, this picture paints a portrait of island life in the early twentieth century.

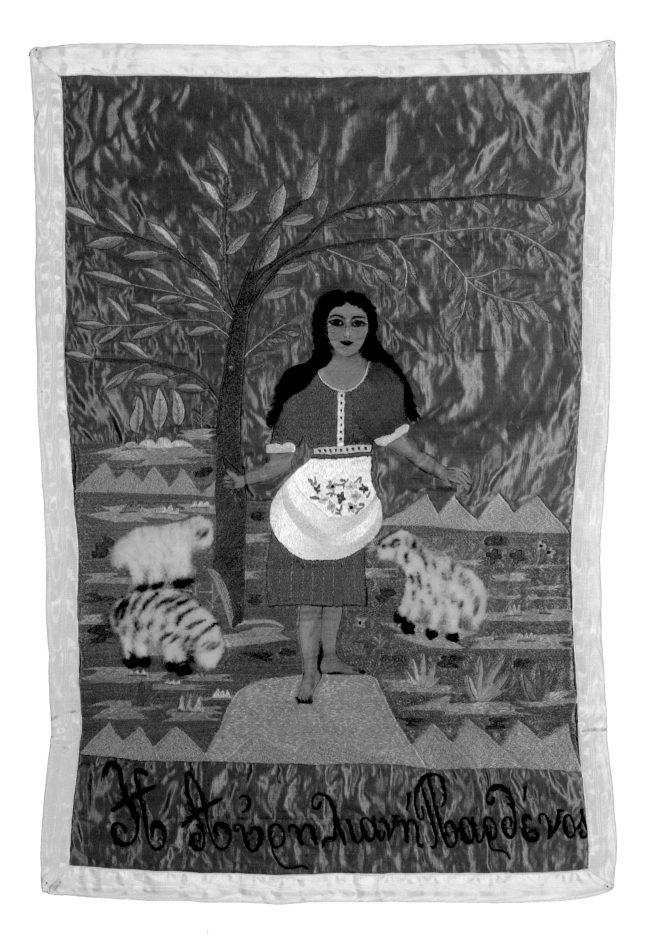

woven or embroidered products that use existing textile skills. Xhosa women of South Africa spin yarn to sell to knitters all over the world. Several cooperatives in Peru and Bolivia produce three-dimensional wall hangings called *arpilleras* for sale at home and abroad. These projects took inspiration from the Chilean women's organization discussed on page 81. New products are developed and put on the market to aid women who have few other ways to support their families.

The increasingly rapid disappearance of textile skills due to the availability of ready-made fabrics and garments, and the change in fashion in many parts of the world, has led to the salvage and revival of skills that once were used to decorate everyday life and now to make saleable goods for the market. In India in the late twentieth century, many ancient hand-weaving and embroidery techniques were revived by Indian fashion designers who designed clothing for the wealthy Indian consumer. Meanwhile, Kuna Indian women of the San Blas Islands create tourist textiles based on their dress tradition.

Sampler

Linen, embroidered
21.5 cm x 41.5 cm, 8^{7}/$_{16}$ in x 16^{5}/$_{16}$ in
1867, Tuscany, Italy
Gift of the Girard Foundation
A.1980.2.768

Samplers went from being a visual record of pattern production in the earliest known pieces to a record of schoolgirl achievement in the eighteenth and nineteenth centuries. Many of the forty-two Italian samplers in the museum's collection are red cross-stitch on white linen. Others include glass beads and other colors as well. The standard Italian alphabet does not include the letters J, W, X, or Y, thus the stitcher, E. S., didn't include them. The sampler is worked entirely in cross-stitch with linen thread.

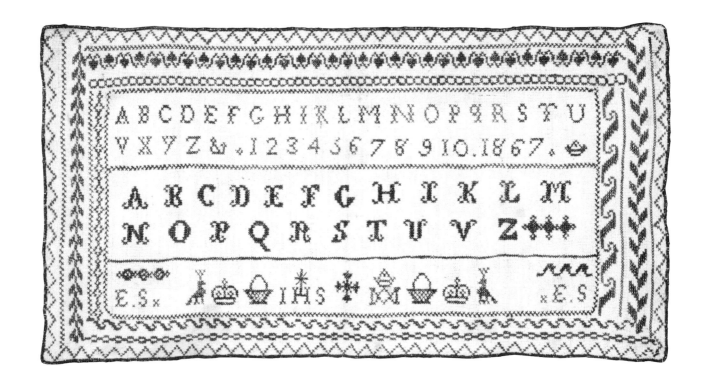

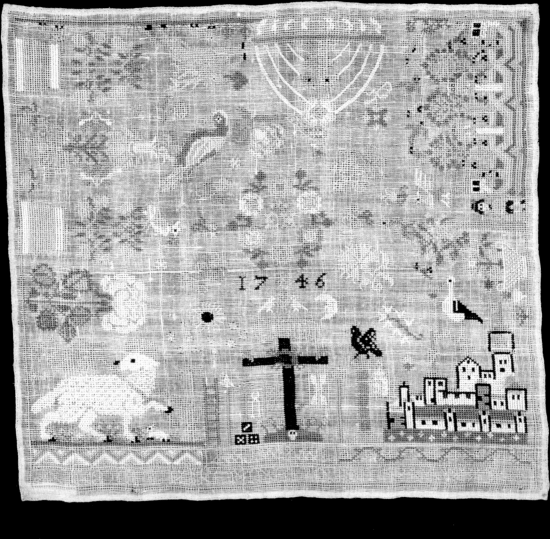

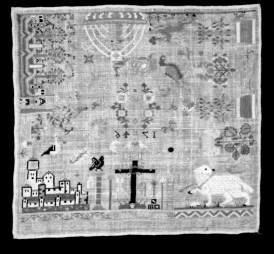

Sampler

Linen, silk, embroidered
22 cm x 25 cm, 8¹¹⁄₁₆ in x 9¹³⁄₁₆ in
1746, Munich, Germany
Gift of the Girard Foundation
A.1981.2.915

Embroidered on sheer linen with silk thread that was once much more brightly colored as seen from the rear view, this sampler is in a different format than the other German sampler shown. The motifs are oriented to each side, an easier way for the embroiderer to work, and depict a fountain, a cityscape, the Lamb of God, the Crucifixion, animals, flowers, and the initials E. H. in cross-stitch. The sun and stars in the lower right are worked in darning stitch. The embroiderer chose another method of depicting sheep's wool by leaving tiny areas unworked, creating texture using negative space. The reverse (left) shows how much the color of the sampler has faded.

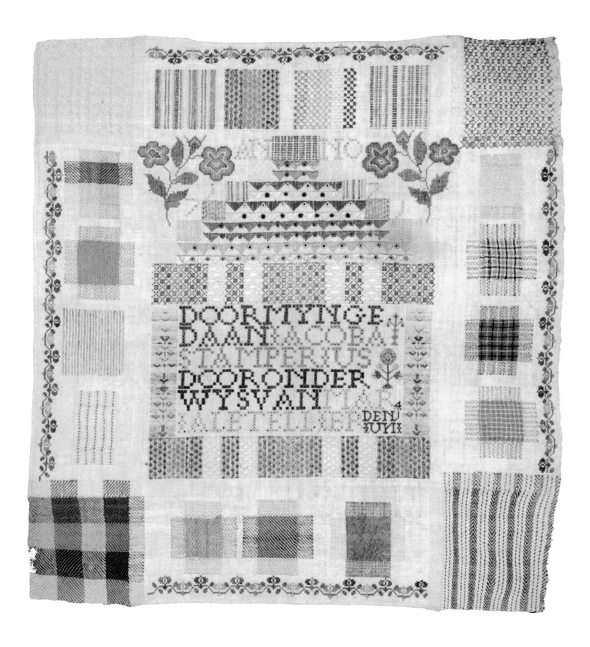

Sampler

Jacoba Stamperius
Linen, silk, embroidered
49.5 cm x 48 cm, 19½ in x 18⅞ in
1771, Zeeland, Netherlands
Gift of the Girard Foundation
A.1980.2.518

This sampler is inscribed with the words "Made by Jacoba Stamperius under instruction of Maria Letellier" and the date. Rectangles were cut from the fabric and filled in with needle weaving in colored silk to reproduce furnishing fabrics of the time. Thus the name darning sampler is applied to this type of work. This piece is particularly graphic with rectangles of pattern, bits of borders, sprays of roses, and other embroidered shapes in satin, cross-stitch and buttonhole stitch. The letters are typically worked in eyelet stitch.

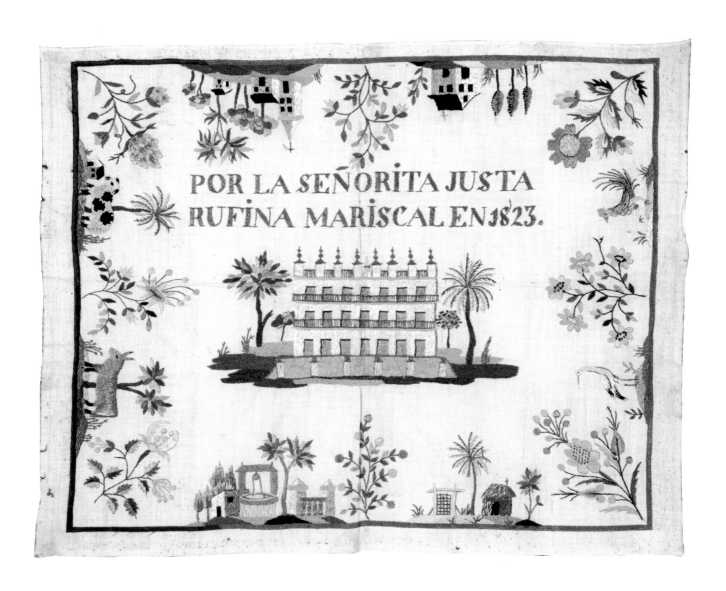

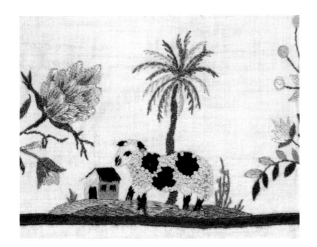

Sampler

Justa Rufina Mariscal
Cotton, silk, embroidered
30 cm x 40 cm, 11¹³⁄₁₆ in x 15¾ in
1823, Spain
Gift of the Girard Foundation
A.1980.2.713

Typical eighteenth and early nineteenth century samplers from Spain consist of rows and rows of border patterns extending halfway across the width of the cloth. This sampler, with its central motif and border of individual motifs, is less typical and more like samplers done in northern Europe at this time. Diverse buildings, trees, and farm animals along with ever-popular floral sprays showcase the senorita's skill with satin, long and short, and stem stitches. French knots in black and white create the texture of wool on the charmingly outsize sheep.

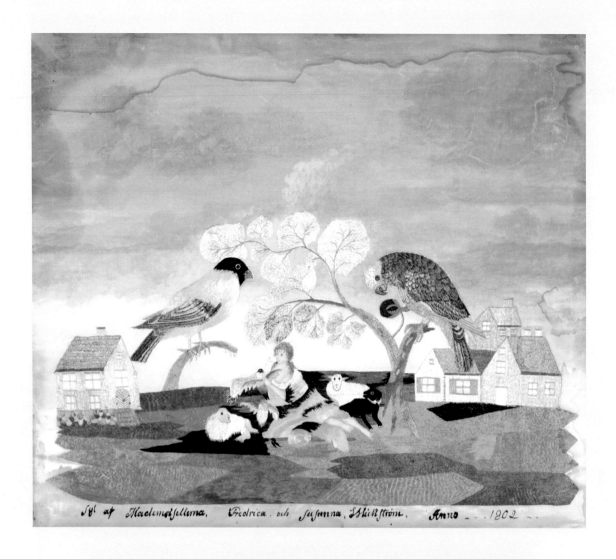

Syd af Mademoiselerna. Fredrica. och Susanna. Skickström. Anno - - 1802 - -

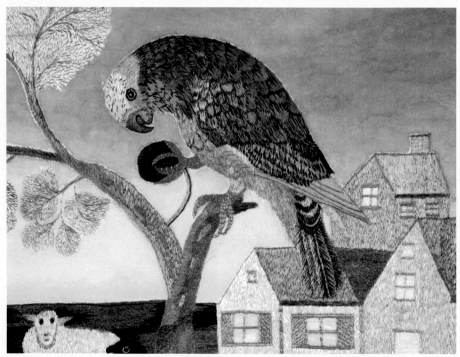

Facing:

Embroidered picture

Frederica and Suzanna Wickstrom
Silk, embroidered, painted
44.5 cm x 51.5 cm, 17½ in x 20¼ in
1802, Sweden
Gift of Florence Dibell Bartlett
A.1955.86.63

Embroidered pictures were a popular art form in Europe and North America from the mid-eighteenth to early nineteenth centuries. The Wickstrom sisters used silk cloth painted blue for the sky as their canvas. The difficult details of the woman's face and limbs were also painted. The most striking feature of this masterpiece of needlework is the contrast between the hyperrealism of the two large birds with feathers so carefully delineated using shades of thread and direction of stitches, and the flat planes of the buildings and ground, where no attempt at perspective or three-dimensionality is evident. The sheep, whose wool is suggested by directionality of the satin stitches, and dog are rendered in less detail but with individual and appealing expressions.

Right:

Sampler

Linen, silk, embroidered
108.5 cm x 24 cm, 42¹¹⁄₁₆ in x 9⁷⁄₁₆ in
1783, Munich, Germany
Gift of the Girard Foundation
A.1980.2.736

Long, narrow samplers were commonly made in the eighteenth century and are one of the earliest forms of samplers known in Europe. Typical of southern Germany, many religious motifs are seen here. Two men carrying a bunch of grapes represent Joshua and Caleb of the Old Testament; the Pascal Lamb is on the right of the standing man; and the Crucifixion is accompanied by related symbols of ladder, dice, scourge, and mourners. The inclusion of alphabets, of which four styles are shown here, began in the mid-seventeenth century. Border motifs at the bottom, medallions, and small individual motifs of plants and animals worked in cross-stitch complete the piece.

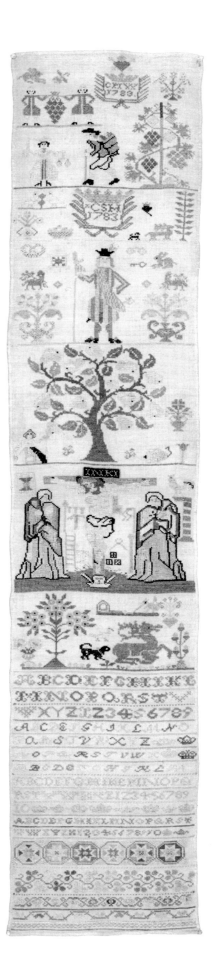

Sampler

Cotton, silk, embroidered
71 cm x 89 cm, 27^{15}/$_{16}$ in x 35^1/$_{16}$ in
1890–1915, Salé, Morocco
Gift of the Girard Foundation
A.1980.2.716

Moroccan embroidery on household textiles and dress has been justly famous for design and execution. Embroidery samplers, on the other hand, are relatively unknown. The museum has three in its collection and all follow the same format of bands of motifs and stitches in the mode of a visual reference rather than a pictorial composition. The stitches used are satin, cross, double running, fern, and darning. The motifs are stylized geometrics and florals as well as small border patterns. The detail shows a pattern that once was a siren or dragon (here so abstracted or degenerate as to be unrecognizable), which was often seen on embroidery produced in Azemmour using a different technique.

Colcha

Wool, pieced, embroidered
200 cm x 130 cm, 79 in x 51 in
c. 1930, Carson, New Mexico
Gift of the Historical Society of New Mexico
A.5.60.7

Along the Rio Grande in northern New Mexico and southern Colorado, the word *colcha* is used to describe an embroidery stitch, also called self-couching stitch, as well as the textile decorated with that stitch. During the Spanish and Mexican colonial periods (1598–1848), bedding, floor coverings, altar cloths, and other ecclesiastical textiles were decorated using the colcha stitch. Two styles emerged, one where a wool ground cloth was completely covered in wool stitching and another where smaller motifs were worked on a cotton ground cloth. In the early twentieth century, an entrepreneur began creating "antique" pieces using bits of old handwoven cloth and raveled yarn but using new iconography. Thus the Carson colcha was born and many were sold to unsuspecting buyers as older pieces. Depicted on this embroidery are four cows, two crucifixes, doves, a procession of *penitentes*, and four intertwined snakes, all motifs that were never associated with earlier colcha work. Many of the museum's traditional colchas are illustrated in *Rio Grande Textiles*, by Nora Fisher.

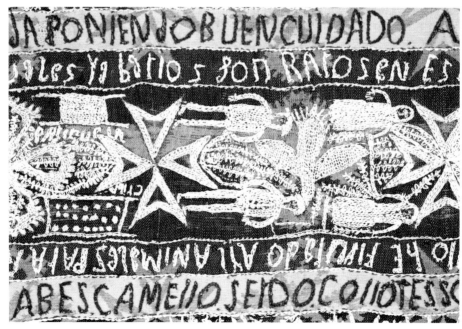

Facing:

Embroidery

Policarpio Valencia
Cotton, embroidered
139 cm x 164 cm, 54¾ in x 64½ in
1925, Santa Cruz, New Mexico
Gift of the Historical Society of New Mexico
b89/13

The six works in the museum made by Policarpio Valencia represent an extraordinary departure from the Rio Grande textile traditions of weaving and colcha embroidery. First of all, textiles were normally created by women, did not include text, and were primarily functional, used in the home or in churches. Valencia, on the other hand, was a man who covered all his known pieces with words, and the end products are not obviously useful. Although little is known about him, it seems he picked up needle and cotton twine—his preferred embroidery thread—toward the end of his life. Although this piece hasn't been transcribed and translated, it seems to deal with animals, rows of which appear, along with their names, across the textile. The detail shows the center stripe where human figures, birds, and cruciform designs predominate.

Right:

Sampler

Francesca Salazar
Linen, silk, cotton, embroidered
80 cm x 49.5 cm, 31½ in x 19½ in
1847, Mexico
Gift of Florence Dibell Bartlett
A.1955.86.234

Sampler making was brought to Mexico by Spanish colonists and European nuns, and quickly became an essential part of the curriculum for urban girls' schools. Francesca Salazar signed her name in the bordered box on the lower left, abbreviating her name and adding the year, 1847. She used cross, double running, darning, long arm cross, fern, and satin stitches to create typical motifs from European pattern books as well as the Mexican national symbol of an eagle with a snake in its mouth perched atop a nopal cactus in the lower right corner. The detail shows a tiny kitchen scene executed in double running, a most individual and whimsical choice of subjects.

Facing:

Hanging, *arpillera*

Cotton, jute, acrylic, wool, bamboo, appliquéd,
embroidered, knitted
60 cm x 30 cm, 23⅝ in x 11¹³⁄₁₆ in
1978, Santiago, Chile
Gift of Louise Durston
A.1979.2.1

The *arpillera* (the word refers to the burlap used as the backing for
these cloth pictures) developed as a form of protest and a means of
income by poor Chilean women affected by the political repression of
General Augusto Pinochet when he seized control of the government
in 1973. The women who made them, *arpilleristas*, were organized
into workshops that also functioned as support groups. These groups
offered aid and comfort to women struggling to feed their families and
find their loved ones who had disappeared into the country's prisons.
Using three-dimensional figures, this hanging pictures the workshop,
or *taller*, itself where women produced yarn for knitting and weaving.
Arpilleras were sold in North America and Europe to raise funds for
the women and publicize the conditions under which Chileans lived.

Above:

Hanging, *arpillera*

Cotton, wool, jute, appliquéd, embroidered
38 cm x 44 cm, 14¹⁵⁄₁₆ in x 17⁵⁄₁₆ in
1980, Santiago, Chile
Gift of Sallie Wagner
FA.1980.68.4

While the previous arpillera represents a benign scene, this piece
graphically tells a story experienced by many Chileans in the
1970s through the use of simple shapes cut out and attached
to a piece of cloth with buttonhole stitch. As with many political
arpilleras made in the '70s, this one includes a small pocket on
the back in which is tucked a note from the maker that reads
"The authorities took Grandma's husband away." Arpilleristas
also embroidered words and slogans on their pieces, a practice
that was banned by the government in 1984.

Blouse panel, *mola*

Cotton, appliquéd, embroidered

38.5 cm x 51 cm, 15³⁄₁₆ in x 20¹⁄₁₆ in

c. 1965, San Blas Islands, Panama, Cuna group

Gift of the Girard Foundation

A.1979.67.774

Originally made as two matching panels that attached to the
yoke and sleeves of a blouse, *molas* have been made
as standalone items for the tourist trade since the 1960s.
The word "mola" actually means blouse or clothing in the
Cuna language. The technique, known as reverse appliqué,
is accomplished by layering colored fabrics, cutting out
shapes in one or several layers to expose the color beneath,
and sewing down the cut edges. Embroidery and appliqué
is then added to enhance certain features such as the heads
and tails of the lizards and fish. The museum has more than
four hundred molas, ranging from blouses and blouse panels
to bags to children's and doll's clothing. Designs range from
pure geometric shapes to birds and animals to popular
culture imagery.

Hanging

Saroj Chaturlal Rathod

Cotton, appliquéd

43 cm x 43 cm, 16¹⁵⁄₁₆ in x 16¹⁵⁄₁₆ in

c. 1975, Ahmadabad, India

Gift of Haku and Vilu Shah

A.1985.259.3

The art of appliqué has been practiced in India to make
bedding, canopies, and other household textiles. In the city
of Ahmadabad, Ms. Rathod began using this technique to
create nonfunctional, decorative textiles depicting typical
Indian motifs such as the dancing women shown here.
The needlework is crude but the composition is quite
effective, filling the canvas with bold shapes and colors.

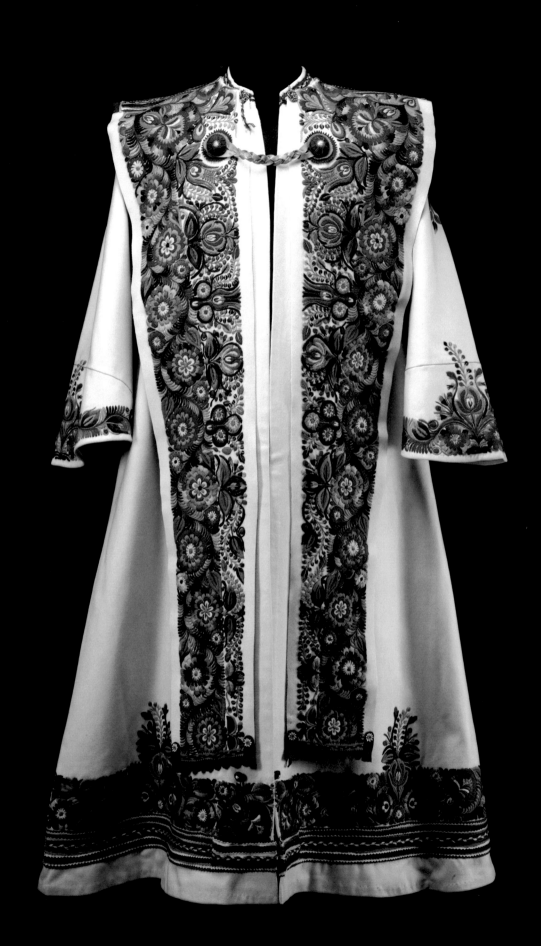

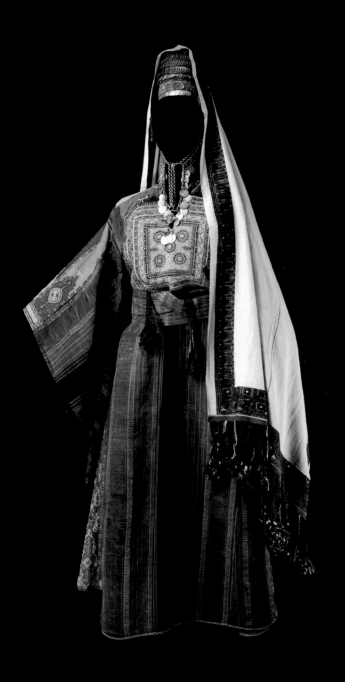

Dress

- Headwear

- Outerwear

- Footwear

- Accessories

- Ceremonial

- Ensembles

Dress is a nonverbal form of communication. From the full-length mink coat of a wealthy New Yorker to the nonleather shoes of an adamant vegan, what we wear tells the world something about who we are or would like to be. In this way, nothing in this section is unfamiliar or exotic. Dress is a universal expression of belonging and boundaries, including and excluding at the same time. What is unique is how cultural groups have developed styles and techniques that reflect their specific situations. Individuals within a culture take those techniques and styles and make something distinctive by following or breaking the rules. The pieces represented here combine recognizable attributes of their place of origin with a high level of artistry and visual qualities.

The oldest textile tool is the needle. Long before anyone invented weaving, people sewed animal skins together to make clothing and shelter. According to recent research, humans first began tailoring clothing about 100,000 years ago.[1] Human history has since been a very long fashion parade, with a large share of the world's time and energy going to dressing its population. By simply looking at pieces of material culture, textiles and dress included, we can admire their visual qualities and the technical skill demonstrated by the maker. But without further study of the culture that produced an item, the deeper significance of any particular piece is obscured from the viewer. Was a dress worn by a bride or a widow? What features on the garment communicate marital status? What differentiates clothing appropriate for a male or a female? Is the color of a garment significant?

The answers to these questions are different for each culture, and they change over time. For example, in Kutch, India, boys and girls both wear a dress-like garment called a *jhuldi* until a certain age. As they grow older, boys put on pants under the *jhuldi* while girls change to a skirt and blouse. A boy might wear a printed *rumal* wrapped as a turban on special occasions, while a girl would wear a patterned cloth over her head. In a different part of the country, pants are worn by both adult men and women. And among other Indians, adult men wear a garment called a *lunghi,* which as a tubular, unbifurcated form could be called a wraparound skirt. Virtually no form of clothing or jewelry is reserved exclusively for male or female across cultures. The cultural construction of gender roles is reflected by the vast differences across cultures in what is considered gender-appropriate dress.

There are fifty-seven closets of hanging garments, hats, shoes, and other accessories along with numerous drawers and plastic tubs holding overflow pieces in textile storage in the museum's basement. Although we continue to call this the costume collection, it should really be named for what it is: items of dress. As I use the term, dress means items that are worn or carried on the person as well as temporary or permanent modifications made to the body. Piercing for earrings or nose rings, makeup, tattoos, and other changes made to the body are not dealt with in this book. Neither is jewelry, a major component of dress and a significant part of the museum collection. Showcased here are garments and accessories primarily made from or including a significant component of fiber that has been processed and worked using recognizable textile techniques.

✿ Headwear ✿

WHEN OUT IN THE WORLD, THE HEAD IS THE MOST IMPORTANT PART OF the body, in part because we are so recognized by our faces. For many cultural groups, the head is the seat of power as well and thus must be properly protected and enhanced. Headwear can be restricted in use, such as the crowns of royalty or the mitre worn by Catholic bishops and abbots, or it can be widespread, such as the head coverings worn by women in many parts of the Muslim world. Headwear is often gender specific, but some functional hats, such as those that keep the sun off a farmer's head, are less likely to be identifiable with one sex or the other.

Some headgear, such as wedding crowns and veils, marks the conditions of a particular moment in time. Once the marriage ceremony is over, the items are put away and not worn again, except perhaps by another family member on her wedding day. Other headwear marks marital status and is thus worn for many years until that status changes. Many hats, by the presence of precious materials and masterful workmanship, show the wealth of the wearer, while others, by their shape or their materials, indicate religious or spiritual affiliation or role. Hats made for children have many functions: they offer protection from the elements for a small, vulnerable head; protection from evil; and show the world, through the care lavished on its manufacture, the parents' love for a baby.

The Museum of International Folk Art has hats from all over the world, once worn by all ages and occupations of people varying from plain, everyday hats to headwear of state. The selection made here focuses on children's hats and on beautifully woven sun hats, as well as unusual pieces that exemplify the importance of headgear as cultural signifier. Hats worn exclusively on ceremonial occasions are included in the ceremonial section.

Hats can be functional or decorative, simple or ornate, designed to hide the hair or be hidden themselves. Whether headwear indicates gender, marital status, religious affiliation, or, by its absence, revolt against authority, it all says something about the wearer, if only to comment on fashion sense.

Hat, *tykkimyssy*
Silk, linen, embroidered, bobbin lace
16 cm, 6¼ in diameter
c. 1900, Terijarvi, Finland
Gift of Hella B. Shattuck
A.1978.45.9

The *tykkimyssy* hat was worn in western Finland by married women. The bonnet is covered with silk with a cotton lining and an inner layer of coarsely woven fabric to stiffen it. Chain stitch embroidery is on each side and a large bow is sewn on the back. The lace, or *tykki*, would be starched for wear.

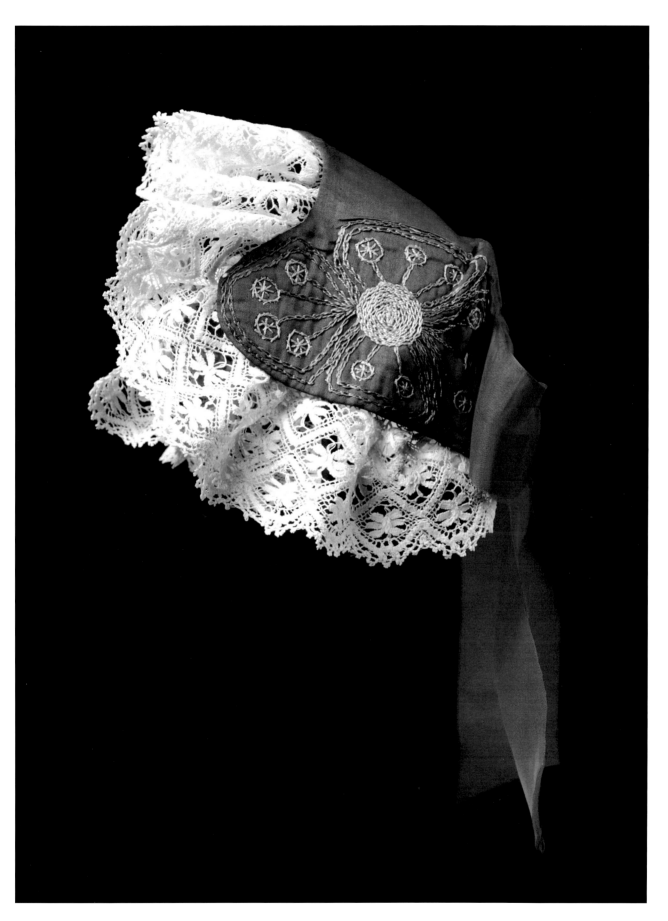

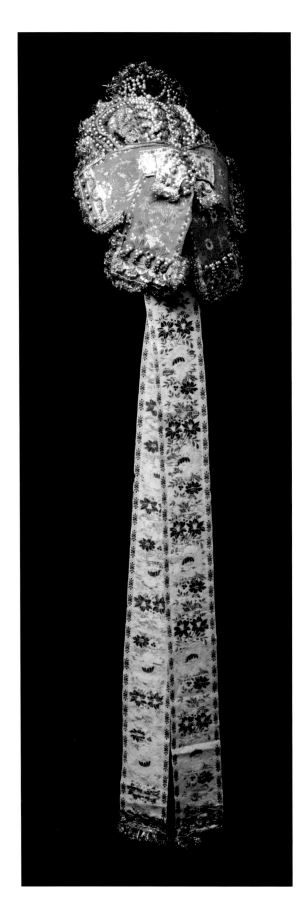

Left:

Wedding headdress
Silk, cotton, glass beads, metallic thread, sequins, applied trim
21 cm, 8¼ in diameter
c. 1920, Somogy County, Hungary
Gift of Florence Dibell Bartlett
A.1955.1.559

Until the twentieth century, and earlier in some parts of the country, unmarried girls in Hungary wore a special crown called a *parta*. On her wedding day, a bride donned a special hat or wedding crown that she wore for a day, a few days, or a few years, depending on the region. As she had children and grew older, she changed her headwear again. Wedding hats were very elaborate, with trailing ribbons and many decorations attached. This one is almost too busy to describe! The body of the hat is made with pieces of blue silk ribbon with rows of sequins and glass beads attached. Around the outside are densely pleated bands with a bead in the center of each pleat. Pleated flowers with beads inserted are also around the entire hat. A bow with a bow on top covers the back of the hat. Two long ribbons trimmed with beads and gilt lace hang down the back. The detail shows the end of the hat flap with beads and trims.

Facing:

Hat
Wool, metallic thread, coral, sequins
15 cm, 6 in diameter
Nineteenth century, Turkey
Gift of Florence Dibell Bartlett
A.1955.1.436

Small hats that perched on top of the head were worn by urban Turkish women during the Ottoman period (1453–1918). This elaborate confection begins with a small cap of burgundy felt. Metal strips wound around silk thread are wrapped around paper forms to make the points and crown of the cap, a separate circle attached to the cap. Long threads are laid and stitched down at points, becoming the fringe with sequins attached. Other elements are braided, wrapped, and looped.

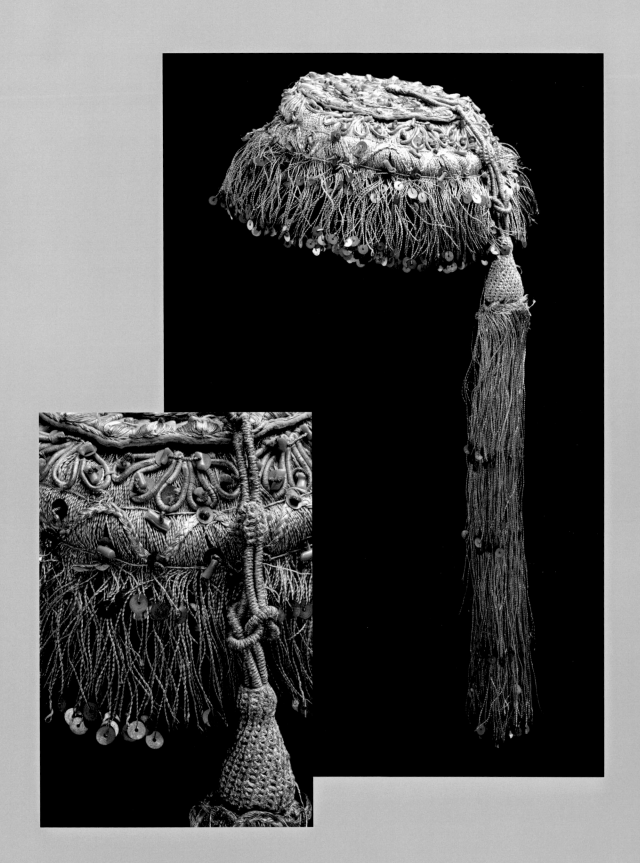

Above:

Hat

Palm leaf, plaited
75 cm, 29 1/2 in diameter
1962, Nigeria
Gift of Mrs. Eloisa Jones
A.1971.19.42

An example of a supremely functional hat, this piece would be worn by a market vendor in Nigeria to provide shade for him- or herself; the extra-wide brim casts a large circle of shade. It is reinforced by four sticks on top to lend rigidity. A small hanging loop is visible on the top left.

Below:

Hat

Palm leaf, plaited
52 cm, 20 1/2 in diameter
Before 1860, Nigeria
Gift of Allison Abbot
A.2006.89.18

Hats using the same materials and techniques as baskets are made all over West Africa. This hat is made from three different aspects of the palm leaf—highly processed threads make the pompom, split leaf is used for the crown and brim, and uncut leaf decorates the crown. A hanging loop is visible. The brim is tightly woven and stiff, unlike the market hat. This is a fine example of the care taken by West Africans when making and wearing an everyday hat. The hat, along with several other pieces illustrated in this book, was collected by a missionary living in Nigeria in the 1850s.

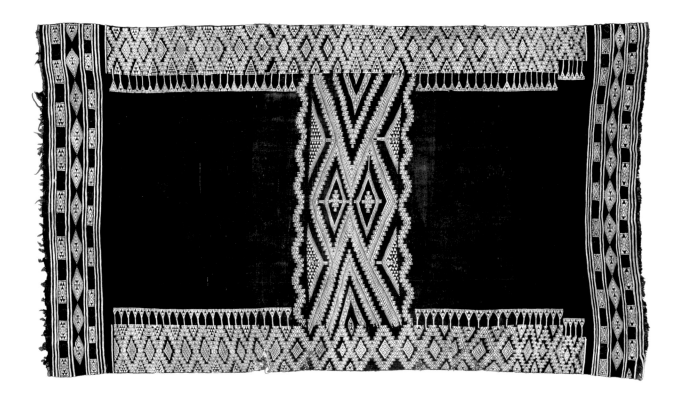

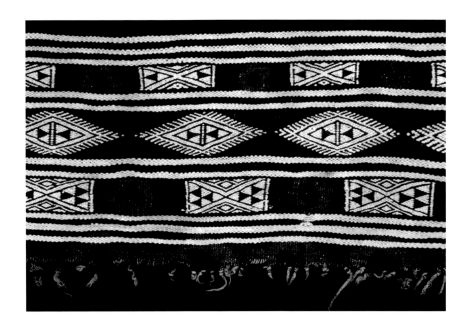

Shawl or veil, *bakhnug*

Wool, cotton, supplementary weft patterning, resist dyed
173 cm x 98 cm, 68⅛ in x 38⁹⁄₁₆ in
Nineteenth century, Gulf of Gabes region, Tunisia
FA.1991.52.2

A shawl worn over the head was an essential part of a Tunisian woman's dress. In cities it might be a large piece of fine cotton or silk. In the countryside, where sheep raising was a primary activity, wool was processed, spun, and woven into *bakhnug*. The shawl started out as white wool with white cotton supplementary weft patterning. The small circles were bound with a material that resists dye. The entire cloth was then dipped into the indigo dye bath until the desired color was reached. When dry, the resist was untied and the two ends of the cloth were dyed orange-red. The cotton yarn did not absorb the dye and thus remained white, creating the intricate patterns. Dark blue shawls were worn by married women, while red was the color for younger women.

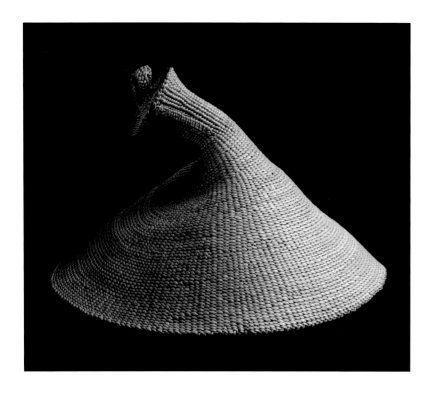

Hat, *khaebana*

Lesuoane grass roots, plaited
33 cm, 13 in diameter
c. 1900, Lesotho
Gift of Lloyd E. Cotsen and the Neutrogena
Corporation
A.1995.93.90

This man's hat from Lesotho, a small country that is surrounded by South Africa, was made to keep off the sun and rain. Boys learn how to make this style of hat while herding cattle. In the 1980s it became a symbol of Lesotho national identity. Individual creativity asserts itself at the top, where different types of loops can be seen on different hats.

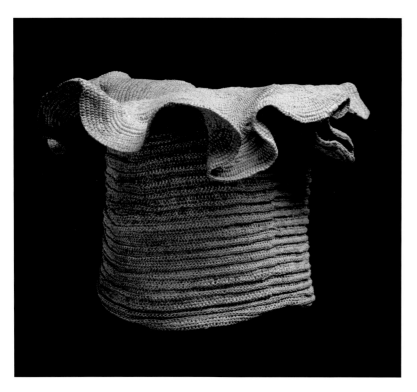

Hat, *ntamp*

Raffia fiber, feather, crocheted
17 cm, 6¾ in diameter
c. 1930, Cameroon
Gift of Lloyd E. Cotsen and the Neutrogena
Corporation
A.1995.93.6

In the Grassfields region of Cameroon, a properly dressed man covers his head when he leaves the house. Hats are an important feature of both everyday and ceremonial dress. This ntamp is a soft, flexible hat worn every day by a man of moderate status and means. Another style of ntamp is crocheted of wool with a flat top. Producing a ruffled brim requires great skill; this one is made almost like a basket with a coiled fiber that was looped or crocheted over to create the stiffness necessary to hold the ruffle out. The feather is not visible in this photograph.

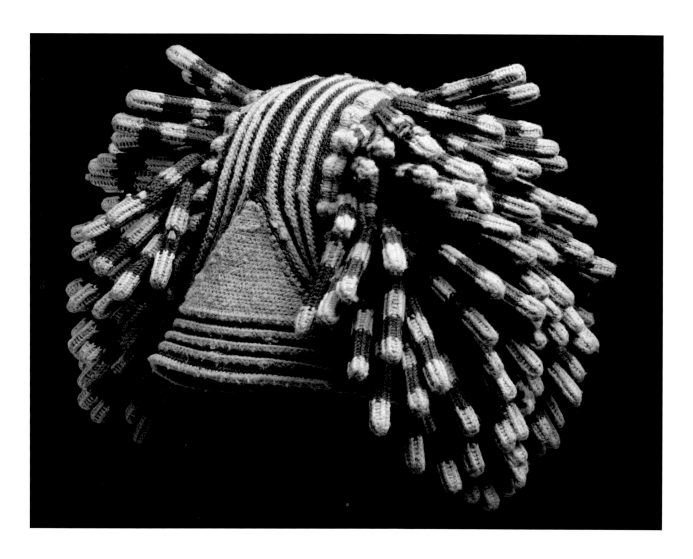

Hat, *ashetu*

Cotton, wood pith, knitted
18.5 cm, 7⅜ in diameter
c. 1930, Cameroon
Gift of Lloyd E. Cotsen and the Neutrogena Corporation
A.1995.93.13

Grassfields men wear many styles of hats displaying their status.
When an *ashetu* is divided down the center with projecting tufts
on either side, it is a hat worn by a high-status man, usually for
ceremonial purposes as part of regalia or prescribed dress. The
projectiles are knitted and then stuffed with a small piece of
wood to stiffen them, imitating an ancient hairstyle.

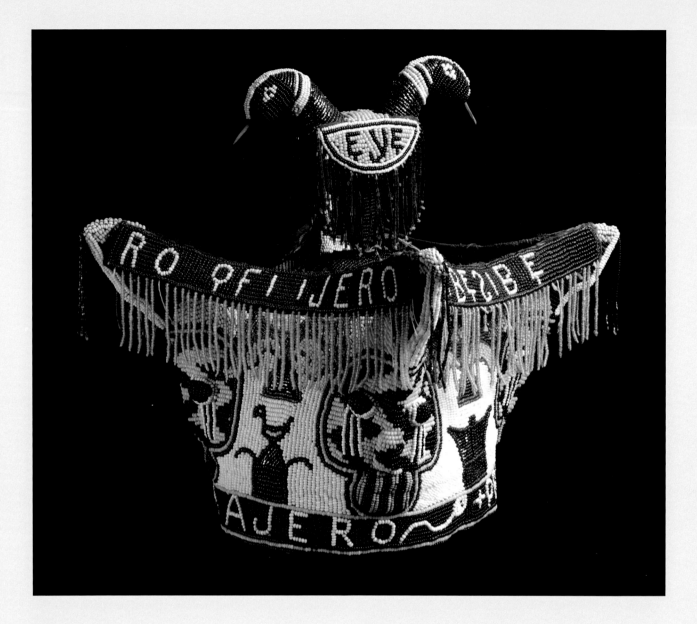

Above:

Hat

Cotton, glass beads
16 cm, 6 in diameter
Twentieth century, Nigeria, Yoruba group
Gift of Diane and Sandy Besser to IFAF
FA.2002.49.35

Fully beaded headgear is made and worn in different styles by the Yoruba rulers of southwest Nigeria. A tall, conical crown, often with a veil of beads that obscures the face, is worn by an *oba* at his installation. Smaller hats like this are worn every day and for minor occasions. A face on each of the four corners of the hat refers to the ancestors. Birds are frequently present on three-dimensional Yoruba art, here on the top and on the sides of the hat. Birds are associated with the mystical power of women and signify that a ruler is dependent on the support of the females who play an essential, if often unofficial, role in leadership. Hats and crowns are made by specialized craftsmen to the specifications of the buyer.

Facing:

Wedding headdress, *soualef*

Silk, cotton, pearls, gold, stones
16 cm x 30.8 cm, 6⁵⁄₁₆ in x 12⅛ in; braids 31 cm, 12¾ in
Nineteenth century, Tetuan, Morocco
Gift of Florence Dibell Bartlett
A.1955.86.757

The *soualef* represents one of the oldest forms of headdress worn by married Jewish women in northern Moroccan cities. Metallic braid is sewn on a base of silk velvet backed with printed cotton. Tiny pearls are attached at the bottom of the piece in a chevron pattern, surrounding the medallions composed of small precious and semi-precious stones set in bezels. Hollow gold beads and pearls are suspended from the bottom edge. In Morocco, married women of all religions covered their heads when outside the house. The false braids attached to the sides of the headdress were visible, while the natural hair was covered by a veil.

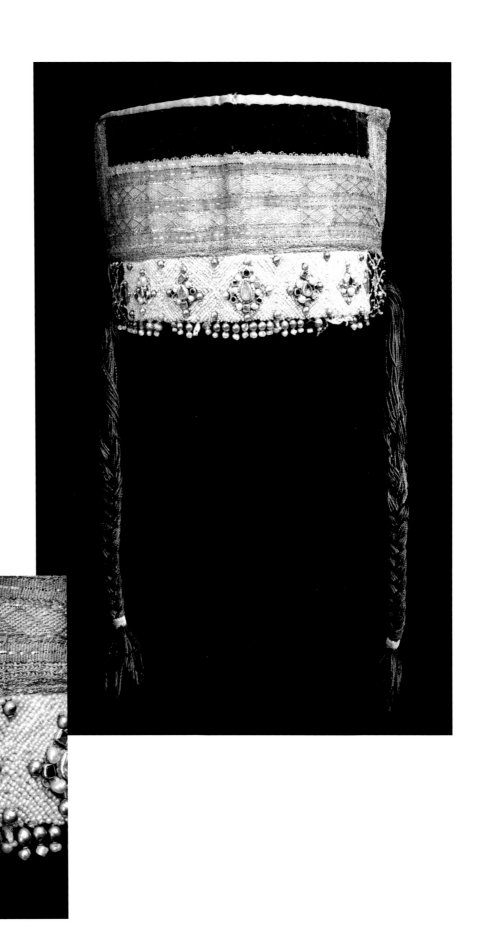

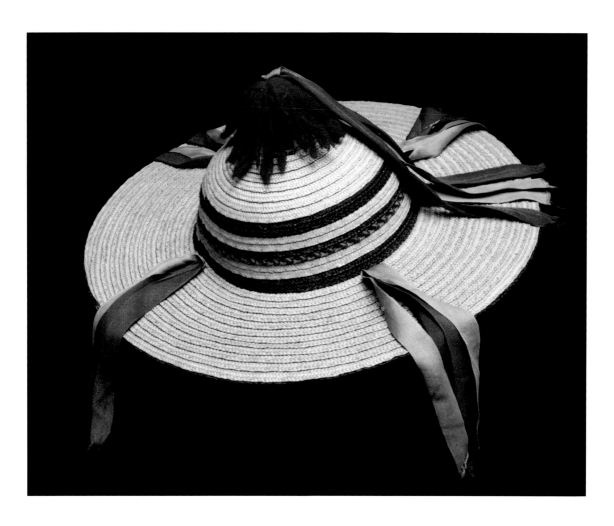

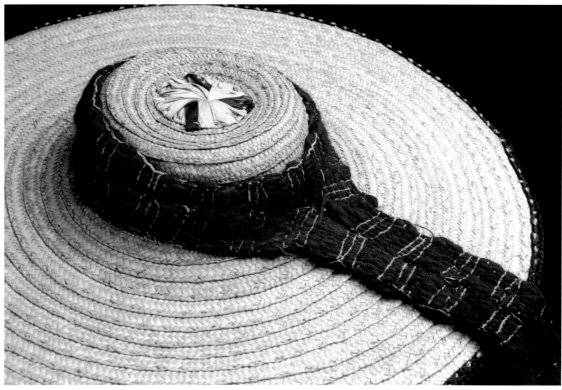

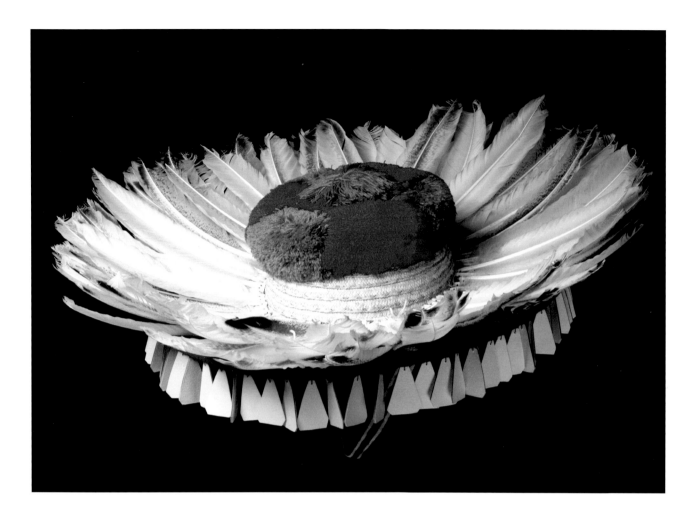

Facing, top:

Hat

Straw, silk, wool, plaited
36 cm, 14 in diameter
c. 1940, Chiapas highlands, Mexico, Tzotzil group
The Elizabeth Norman Collection
FA.1954.32.58

Festive straw hats are made and worn by Tzotzil men in the mountains of Chiapas. Some have a very flat crown and small brim while others such as this one have a higher crown and larger brim. The edge of the brim has a black stripe while the crown shows stripes of red, yellow, and faded black. The making and wearing of hats of this type seems to have been adopted by the indigenous people of Mexico after contact with the Spanish in the early sixteenth century.

Facing, bottom:

Hat

Straw, wool, plaited
39.5 cm, 15⁹/₁₆ in diameter
1970, Huistan, Chiapas, Mexico, Tzotzil group, IFAF
FA.1971.71.53

Here is a flat-brimmed example of a highlands Chiapas Tzotzil man's hat. The construction method is the same as the previous hat, with a double-layer brim. Instead of using purchased ribbons as trim,

in Huistan they attach a woven wool band that hangs down the back. The hat is worn perched at an angle on the head, making it more decorative than functional.

Above:

Hat

Jacingo Robles
Agave leaf, feathers, cotton, wool, cardboard,
plaited, applied trim
39 cm, 15½ in diameter
1991, Santa Caterina, Mexico, Huichol group
IFAF
FA.1990.23.67

Elaborate hats are worn by Huichol men participating in the peyote ceremony. Made by Jacingo Robles in Jalisco, this hat combines old and new materials in a traditional form. The pom-poms that used to be made with wool from their sheep are here made with commercial cotton yarn. Cardboard shapes mimic the madrona leaves or deer hooves originally suspended from the brim. A hand-woven cotton chinstrap keeps it on; an edging of red wool cloth protects the brim. Turkey feathers show the wearer is a veteran *peyotero.*

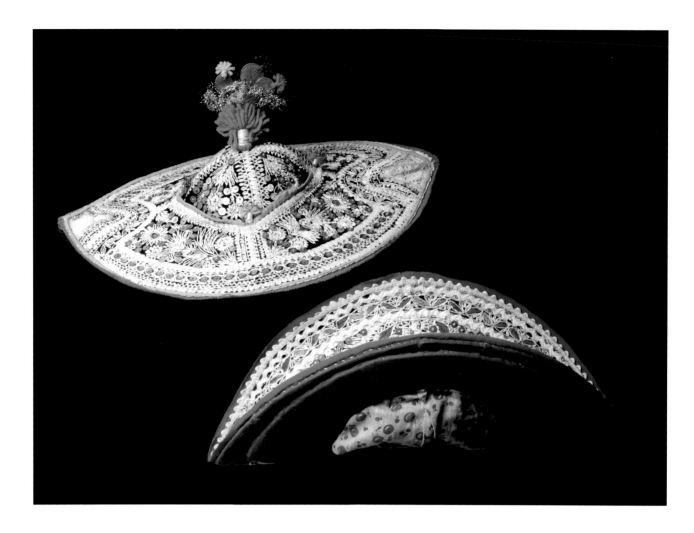

Hat

Wool, cotton, silk, wood, sequins, glass beads,
coins, embroidered, applied trim
42 cm, 16 ½, in point to point
c. 1940, Tarabuco, Bolivia, Quechua group
IFAF
FA.1973.103.22

This women's folding festival hat is ingeniously constructed
to protect the delicate parts sprouting from the crown when
stored. Pieces of shaped wood are covered with cotton and
wool to create a stiff brim. The crown of the hat is soft and
folds neatly between the sides, popping into place when
unfolded. Couched floral embroidery and rickrack are
embellished with sequins, each with a tiny bead sewn in
the center. Two pieces of silk brocade fabric are inserted
at each point. The pink tassel might be wool or acrylic yarn
with coins and tinsel attached. A different hat of the same
type is shown folded.

Headdress

Feathers, reed or bark, cotton
112 cm, 44⅛ in long
c. 1960, Amazon region, Ecuador or Colombia
Gift of Lynne and Richard Spivey
A.1982.4.1

A multitude of feathers from different birds are strung together to create the long tail of this spectacular headpiece. They are attached by a thread to long strings of braided cotton cord. The headband is made in two pieces, each a ring of bark or reed wrapped in grosgrain ribbon, red on the outside and blue on the inner band. Individual feathers and bird pelts are stuck between the headbands to stand upright.

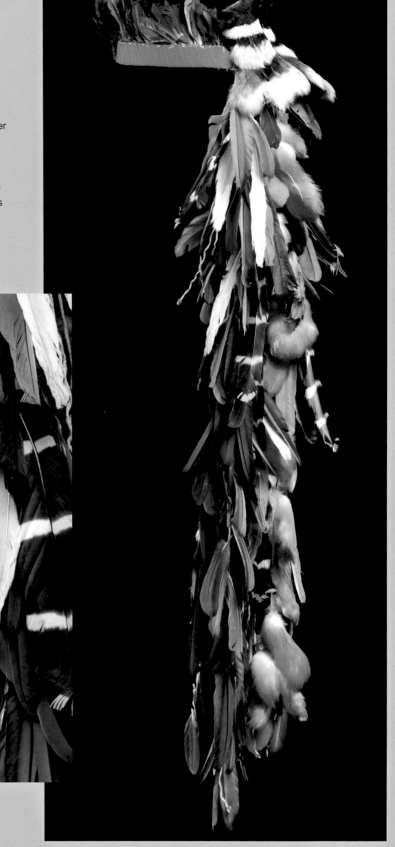

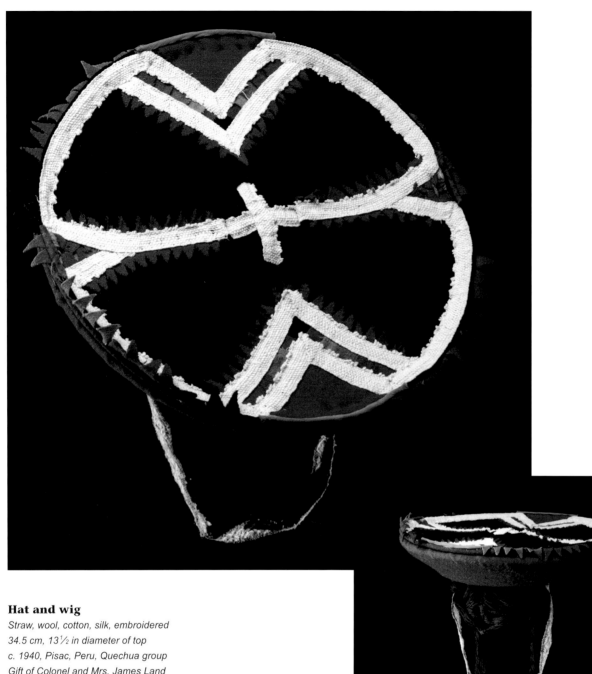

Hat and wig

Straw, wool, cotton, silk, embroidered
34.5 cm, 13 1/2 in diameter of top
c. 1940, Pisac, Peru, Quechua group
Gift of Colonel and Mrs. James Land
A.1966.37.10

Hats of this shape are part of the local dress worn by
Quechua women living in the Sacred Valley near Machu
Pichu. This hat is in two parts: the outer dish-shaped hat has
wool cloth covering a woven straw foundation, and the top is
decorated with strips of white cotton tape sewn down with
strips of wool cut into triangles. A narrow green and white
strap woven on a belt loom goes under the chin. The second
part of the hat is composed of a black silk skull cap with two
long wool braids attached.

Hair ribbon

Silk, metal, tapestry technique
358 cm x 3.4 cm, 140^{15}/$_{16}$ in x 1^{5}/$_{16}$ in
c. 1925, Totonicapan, Guatemala
FA.1972.2.23

Hair ribbons like this are woven in Totonicapan for sale in
other villages but are not worn there. The somber color
scheme is associated with funerals, while the elaborate
fringe and pom-poms shows this is not an everyday piece.
Woven into this piece are the words "Isidro Ranon Pu,"
probably the name of the deceased. The fringe consists
of lengths of braided silk and pom-poms with loops of
wire-wrapped yarn between them.

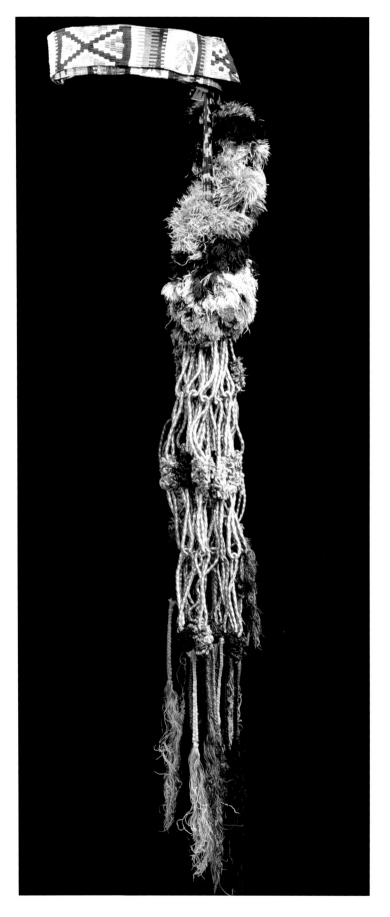

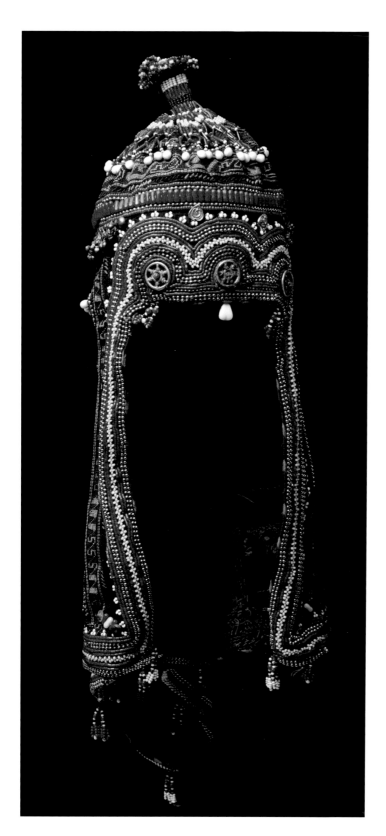

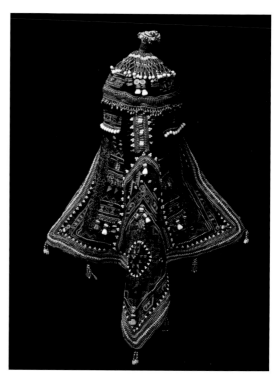

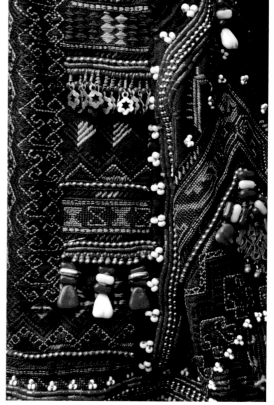

Facing:

Child's hat

Cotton, silk, beads, buttons, metal, embroidered, applied trim
12 cm, 4¾ in diameter, 58 cm; 22¾ in length
c. 1950, Nuristan, Afghanistan
Gift of Ira and Sylvia Seret
A.1990.80.2

This heavily embroidered and embellished hat protects a child in several ways. The long side and back flaps keep the cold and wind prevalent in the high mountains of eastern Afghanistan off the child's body, while the cross and satin stitch embroidered motifs invoke protection from harm. The use of dangling beads and small metal disks to distract the evil eye is common in many parts of the world. The rows of small metal beads are actually bead chain that is stitched down. Hats like this are also attributed to Kohistan, a name used for a district in Badakshan Province to the north as well as a region across the border in Pakistan.

Headdress, *shabka*

Leather, silver, gilt silver, coral, braided, applied trim
15 cm, 5⅞ in diameter
Twentieth century, central region of Oman
IFAF
FA.2002.11.27

With its rolls of leather braids at the bottom, this headdress resembles a wig more than a hat. Each Bedouin woman of this region in Oman made her own *shabka* from goat leather and whatever bits of silver she could afford to put on. Pictured here is a highly embellished version, as evidenced by the gold-washed silver pieces that are more expensive than plain silver. A small piece of coral, very powerful because of its color, is attached to the tab at the forehead. Surprisingly soft and supple because of its construction from braided strips, this headdress smells powerfully of leather and the oil and perfume its owner applied to her hair.

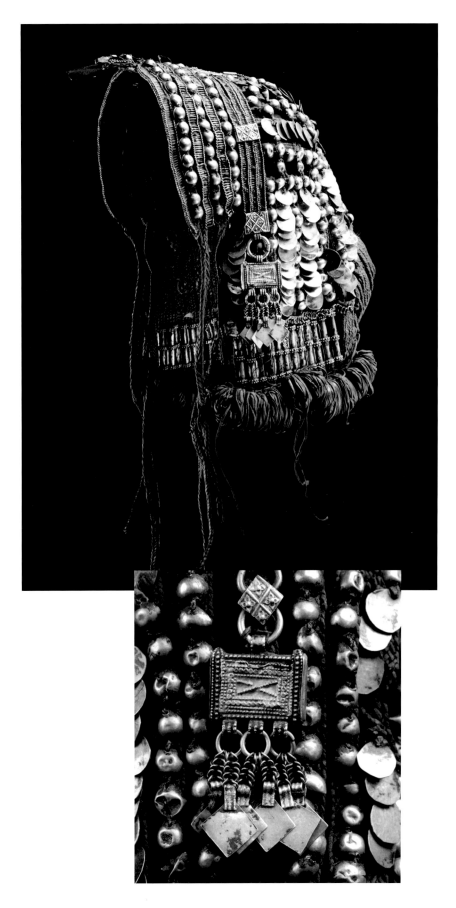

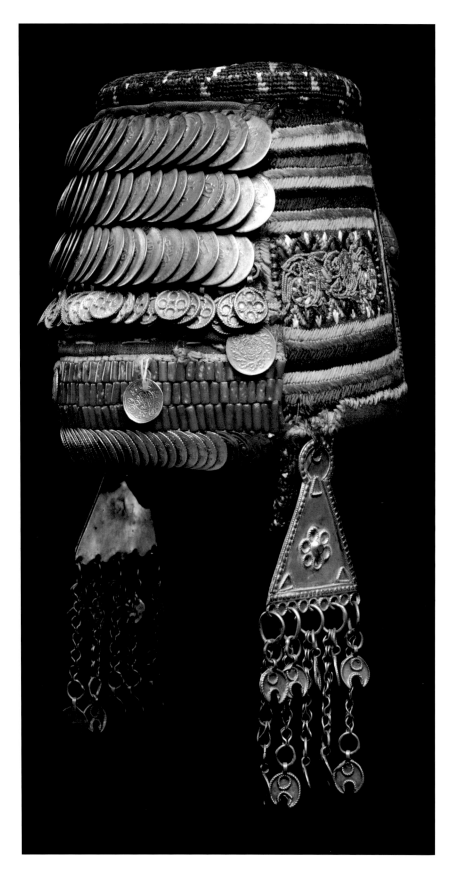

Headdress, *shatweh*

Cotton, silk, gold, silver, white metal, coral,
embroidered, applied trim
13 cm, 5⅛ in diameter
c. 1900, Bethlehem, Palestine
Gift of Florence Dibell Bartlett
A.1955.1.589

Called *shatweh,* another example of this hat is
pictured as part of the full ensemble from
Bethlehem on page 233. As normally worn, it
was perched on top of the head and wouldn't
be visible at all but completely covered by a
veil fastened under the chin. A row of gold
coins and rows of coral beads and silver coins
decorate the front of the hat, while the back
and sides are fully covered with embroidery
done in *sabaleh* (herringbone stitch), couch-
ing, and cross-stitch. Triangular pendants of
low-grade silver are attached over the small
earflaps. The dangling chains probably tinkled
softly as the wearer walked, letting their pres-
ence be known although they were hidden
under a veil. The shatweh was worn every day
by married women and widows in the villages
around Bethlehem as well as in the town.

Hat, *wuqayat al-darahem*

Cotton, silk, wool, silver, white metal, coral,
glass beads, embroidered
16 cm, 6¼ in
c. 1850, South Hebron, Palestine
Gift of Florence Dibell Bartlett
A.1955.86.919

Also called the money hat, this was owned by
the patrilineal kin group and worn by brides
only during the wedding ceremony. Like the
shatweh, the *wuqayat al-darahem* was made
by female specialists in Bethlehem for
purchase. The coins are attached to a hand-
woven, indigo-dyed cotton base stitched to
stiffen the hat. The crown is a piece of silk
embroidery on brown cotton. A replacement
piece on the back has bold red embroidery
on commercial cloth and is a fragment of
shawl. The inside of the crown has been
reinforced with a circle of brown wool fabric.
Coral and blue glass beads adorn the front,
while red and orange glass tube beads and
various other beads hang from the ear flaps.

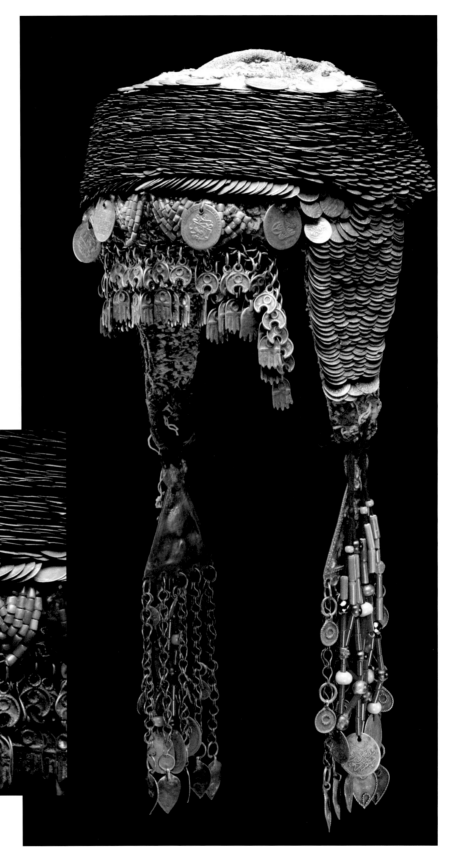

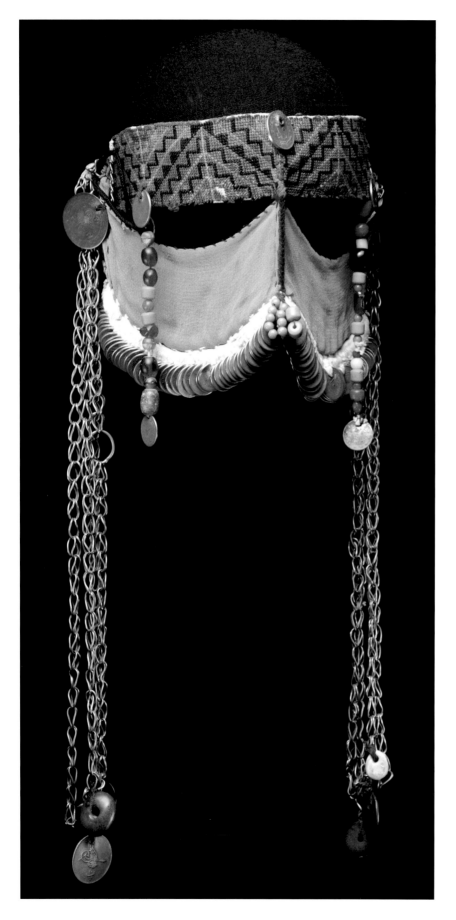

Veil, *burqa'*

Silk, coins, glass beads, wool, embroidered
53 cm x 33 cm, 20⁷⁄₈ in x 13 in
c. 1915, Negev Desert, Palestine
IFAF
FA.1972.25.3d

Nomadic Bedouin women in southern
Palestine wore the *burqa'* in many variations.
What is universal to them is the form of a top
band with rows of coins attached. Side chains
are common as well. Cross-stitch embroidery
decorates the top band of this burqa'. Coins
and strings of beads hang down. Yellow silk
follows the contours of the cheeks and the
coins weight it down. Two polished stone disks
hang from the chains. The burqa' illustrates
the striking difference between village and
Bedouin dress in historic Palestine, as nothing
like this was worn in the villages.

Hat

Cotton, silver, glass beads, metallic thread,
embroidered, applied trim
13 cm, 5¼ in diameter; 27 cm,
10½ in length
Twentieth century, Yemen
IFAF
FA.2002.11.7

This woman's hood-like hat is probably from
San'a, where it was purchased. Made from
indigo-dyed cotton, the hat features coins,
beads, and amulets on the back and framing
the face. Bands of embroidery cover the top
and sides. Stitches used are chain stitch for
the cotton threads and couching for the metal-
lic threads. Coral-colored glass beads are pro-
tective, as are the silver coins, small amulet
holders, and silver medallions attached along
the face and on the back.

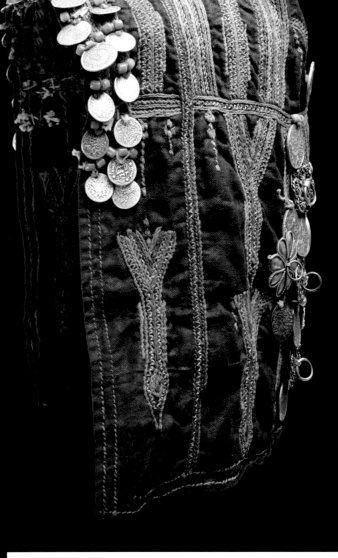

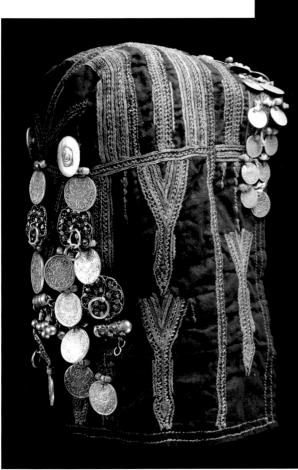

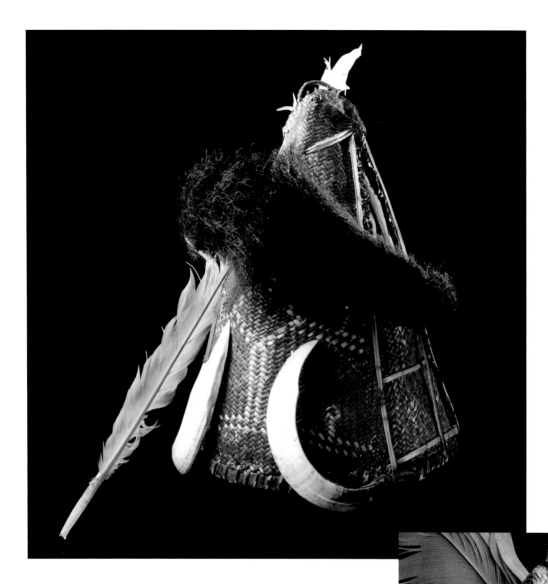

Hat

Bamboo, feather, fur, boar tusk, plaited
17.5 cm, 7 in diameter
Twentieth century, India or Burma, Naga group
Gift of Diane and Sandy Besser to IFAF
FA.2001.54.28

The Naga are an ethnic minority living in Northeast India and
Burma. Male basket weavers make hats with a split bamboo
frame covered with plaited cane dyed red. The yellow fibers
are orchid root. The materials used to decorate the hat—
feather, fur, and tusk—are all associated with male power
and fertility. The boar tusk is the insignia of a warrior.
These hats, similar in shape and construction but with
different embellishments and meaning, are worn by many
Naga groups in India and Burma during community cele-
brations. Celebrations used to revolve around the taking
of enemy heads and the killing of dangerous animals,
activities that gave prestige to the individuals involved
and brought fertility to the community.

Child's hat

Silk, cotton, mirrors, shells, embroidered
20 cm, 7⁷⁄₈ in diameter and 32 cm, 12¹⁄₂ in length
n.d., Kutch, India
Anonymous gift
A.1978.68.3

Three-petaled flowers in double buttonhole stitch
fill the spaces between the mirrors on this magnifi-
cent example of the embroiderer's art. As a bor-
der, mirrors alternate with small patches of
detached interlacing. Narrow inner borders are
composed of bundles of black thread couched
with yellow silk. Tiny shells are attached at strate-
gic points. Mirrors are used all over the world to
confuse evil spirits and deflect evil intentions. The
child this hat was made for was truly well loved.

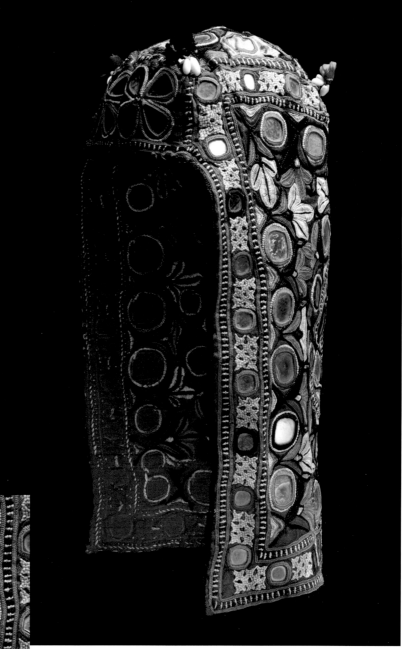

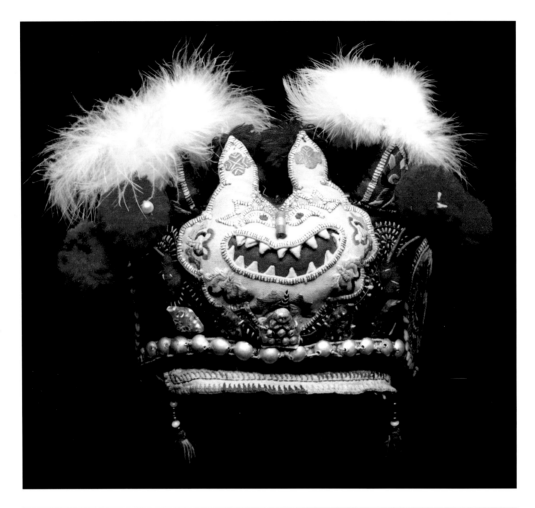

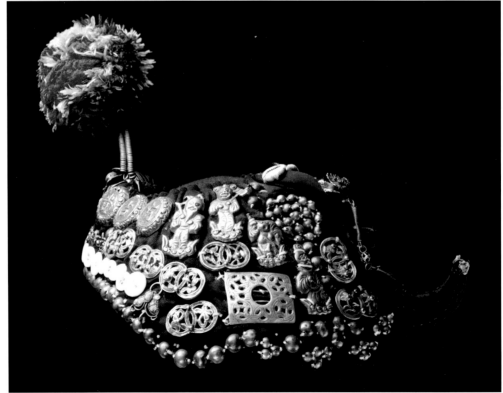

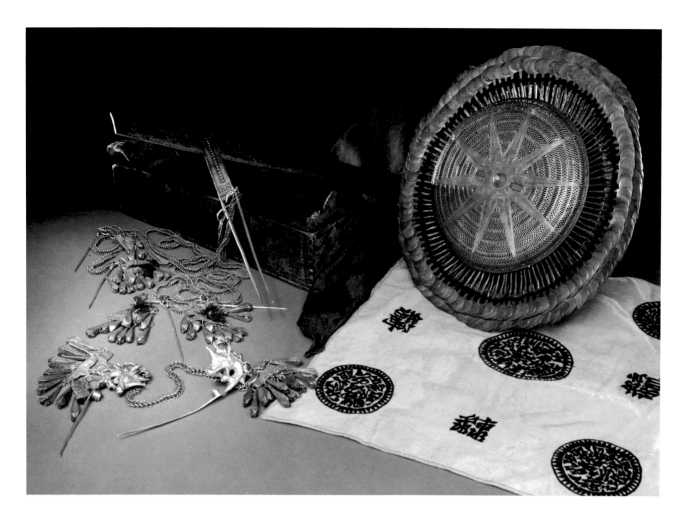

Facing:

Children's hats

Cotton, silk, feathers, metal, beads, buttons, embroidered, appliquéd, applied trim
Tiger hat: 14 cm, 5½ in diameter; elephant hat: 17 cm, 6¾ in diameter
Twentieth century, Dali County, Yunnan, China, IFAF
FA.1995.55.1 and FA.1992.104.10

Chinese children's hats are loaded with charms, amulets, and symbols to ensure health, happiness, and good fortune as well as to protect the wearer from harm. Animals, plants, representations of the Buddha, other deities, and characters are all important symbols. One of the most common animals to appear on a boy's clothing is the tiger, seen here in yellow. Ferocious enough to scare off evil spirits, yet benevolent toward humans, the tiger represents hope for a prosperous future and for robust health. Buddha, often shown as Shouxing, the God of Longevity, helps to ensure survival and long life, and the Eight Immortals protect children from evil and bring good fortune. The black hat has a small trunk and two cowry shell eyes, with a pom-pom on back. Both of these hats contain many of these good-luck and protective symbols.

Celestial crown

Silver, hair, wood, silk, cotton
24 cm, 9½ in diameter of crown
Nineteenth century, Laos, Yao Lantien group
IFAF
FA.2003.9.1V

The Yao of northern Laos migrated from China over the course of hundreds of years. There are many groups of Yao in China, Laos, and Vietnam. The two main groups in Laos are called Mien and Mun and are further divided into several subgroups. The celestial crown is worn by women of the Mun group only. Women of different Mun subgroups wear the crown daily after initiation at puberty, while others wear it on special occasions. The crown is made up of several parts. The central dome is mounted on a disk of human hair. Two rows of silver pins inserted into the disk surround the dome. A two-pronged pin helps to hold the crown in place. Several other pins with dragons and dangles are pinned to the outside of the crown. The white square embroidered with Chinese poetry characters is wrapped around the crown when not in use. The wooden box that holds the pins is painted with characters as well. For the wedding, the crown is worn covered with a red cloth. For daily and other ceremonial wear, a long white scarf with blue embroidery is worn.

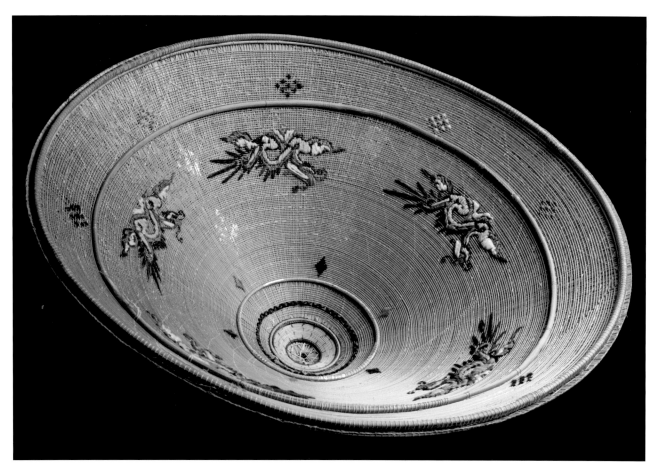

Hat (interior view)

Palm leaf, bamboo, reed, paper, cotton, embroidered
42 cm, 16½ in
1953, Vietnam
Gift of Mrs. F. H. Bunting
A.1994.41.4

The typical palm leaf and bamboo hat made and worn all over Vietnam, the *non la* and its variations, is an unbroken cone with sixteen to eighteen bamboo ribs and a rim covered with palm leaves stitched into place with thread made from a reed. A version of the non la is called the *non bai tho*, and in earlier times it contained a verse of poetry, cut from palm leaf and inserted between the interior layers of the hat. The verse could be seen only by the woman wearing the hat. In more recent times, paper shapes have replaced the poetry. In this hat, pieces of gold foil have been inserted between the leaf base and the reed thread interior. The cotton embroidery is on the outside layer only.

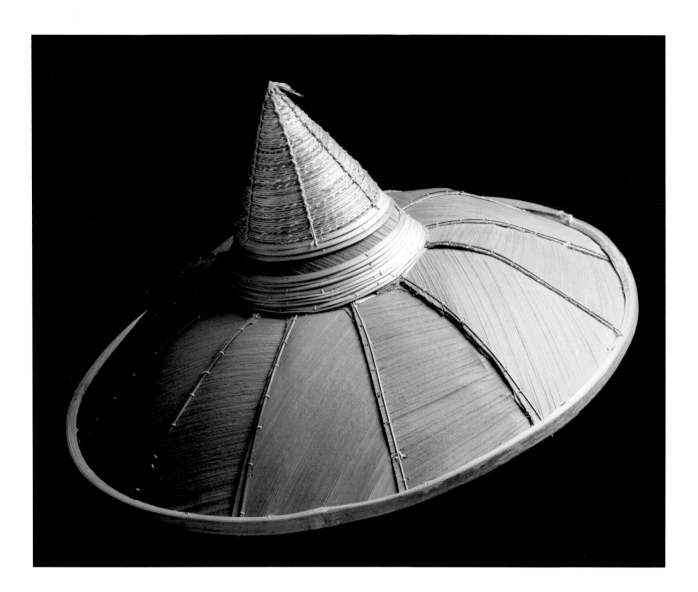

Hat

Palm leaf, bamboo, coiled
48 cm, 19 in diameter
c. 1970, Shan States, Burma
Gift of Mr. and Mrs. Denis Robinson
A.1997.53.40

The area known as the Shan States in Burma is the eastern part of the country, bordered by China, Laos, and Thailand. It is home to a number of ethnic groups, notably the Tai in the lowlands and the Kachin, Karen, Lahu, and Wa in the hills. Although the records do not give a specific group attribution to this hat, it could be from the Tai, valley rice growers, also known as Shan. Leaf and bamboo hats are made all over Southeast Asia. Some shapes are specific to different ethnic groups and some are more generic. All are lightweight and functional, shielding the wearer from sun and rain. Some, such as this hat, are made with much care and attention to workmanship and appearance.

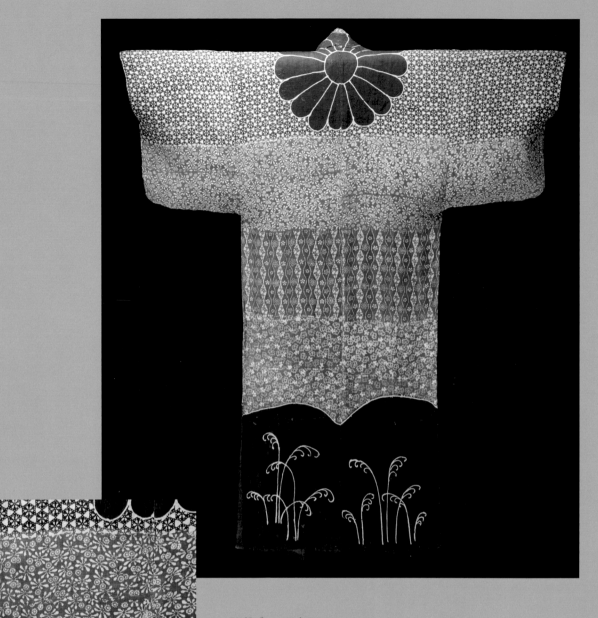

Veil, *katsugi*
Bast fiber, stenciled, painted
135 cm x 118 cm, 53⅛ in x 46⁷⁄₁₆ in
c. 1800, Shonai, Japan
Gift of Ralph Altman
A.1957.11.2

Although shaped like a kimono, *katsugi* were worn over the
head and held closed at the neck by upper-class women
during the Edo period (1603–1867). Katsugi made from silk
are associated with the Kyoto area, while those made from
hemp or ramie come from around Shonai, in the northern
prefecture of Yamagata. The small patterns were made by
pushing rice paste through a stencil made from mulberry
paper, *katagami,* then dyeing the cloth with indigo. The
grasses at the bottom of the veil were hand-painted.
The government outlawed the wearing of katsugi in the
late Edo.

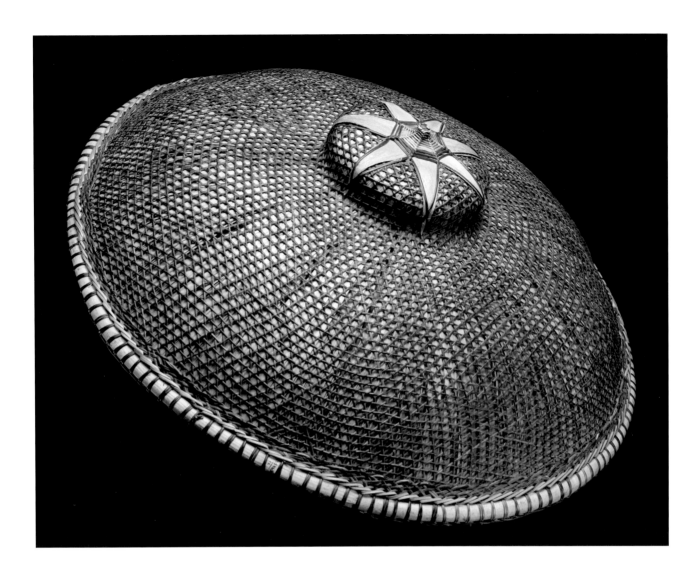

Hat

Bark, bamboo, plaited
58 cm, 22¾ in diameter
c. 1940, Coastal northeastern Papua New Guinea
Gift of Caroline Kelly
A.1970.41.5

The donor purchased this hat and other items while stationed with the Red Cross at Buna on the northeast coast of New Guinea during World War II. Whether it was made in the Buna area by local people, imported from Southeast Asia, or made by an Asian person living there is unknown. It does show some similarities to hats from Burma.

❀ Outerwear ❀

OUTERWEAR IS A WIDE CATEGORY THAT ENCOMPASSES GARMENTS WORN over underwear that are not accessories. Thus, skirts, blouses, trousers, coats, dresses, tunics, and ponchos are all considered outerwear. Outerwear is often heavily embellished with embroidery, woven pattern, dye effects, and applied trim such as beads and lace. Many fibers, from silk to tree bark, are represented and many pieces are made with mixed fibers and techniques. Great care is often taken on the construction and decoration of these garments, as they are the most likely to be seen by others.

Shapes, techniques, and embellishment acquire a cultural dimension, but how the process works is obscure. Why is the *szur* worn in Hungary but not in neighboring Austria? How come Nubian girls wore a skirt made from strips of leather, while other people in Sudan use whole skins for skirts? The answers to these questions will never be known; the origins of customs go too far back in time. When people are asked why they wear a particular garment or use a particular motif, the answer is often, "Because that's what we do." Even where centuries of written or visual documentation are available, it's not enough to trace back to the origins of most cultural traditions. The garments themselves seldom survive the hard wear they receive and imperfect storage conditions. The study of upper-class and royal fashion is aided by the care taken to preserve these pieces, while the study of ethnic dress is hindered by its relative unimportance in most collectors' eyes.

There is a higher percentage of women's garments in the collection than men's wear, a common phenomenon since women's clothing is often more interesting to look at and more noteworthy as material culture than men's. In many parts of the world where ethnic dress still plays a significant part in people's lives, it is usually women who continue wearing it long after men have abandoned it for t-shirts and jeans. Dress for special occasions or that worn by the wealthier classes also tends to survive and then appear in museum collections, whereas everyday garments are worn out, too plain, or too soiled to be displayed. The following pages highlight the more unusual and unexpected pieces in the museum's collection.

Dress, *savarna kebe*
Linen, cotton, appliquéd, embroidered
22 cm x 42.5 cm, 48 1/16 in x 16 3/4 in
c. 1900, Saratov Province, Russia,
Chuvash group
IFAF
FA.1955.57.1

Chuvasia is a republic within Russia, on the Volga River, the homeland of the Turkic Chuvash people. Over the centuries, a distinctive form of dress developed, reaching its peak in the nineteenth century. Difficulty maintaining this tradition ensued after the Russian Revolution and the incorporation of Chuvasia into the USSR. This dress is one of two in the museum that were collected by Caroline Bieber in London in the 1920s. It was worn by a woman, probably a married woman. Its name, *savarna kebe*, means "trimmed" or "completed" dress and refers to the strips of red cotton cloth appliquéd to the linen dress. Embroidery motifs include the eight-petaled flower, called *keske*, on the sleeves and the tiny "Chuvash bird" border running vertically down the front and back of the dress. This figure is interpreted as a tree of life or as the goddess of the ancient religion. The full ensemble would include a sash, a beaded hat with coins worn on top of a cloth covering the hair, and various pieces of jewelry. Chuvash people migrated south to the Saratov region of Russia beginning in the eighteenth century, looking for land.

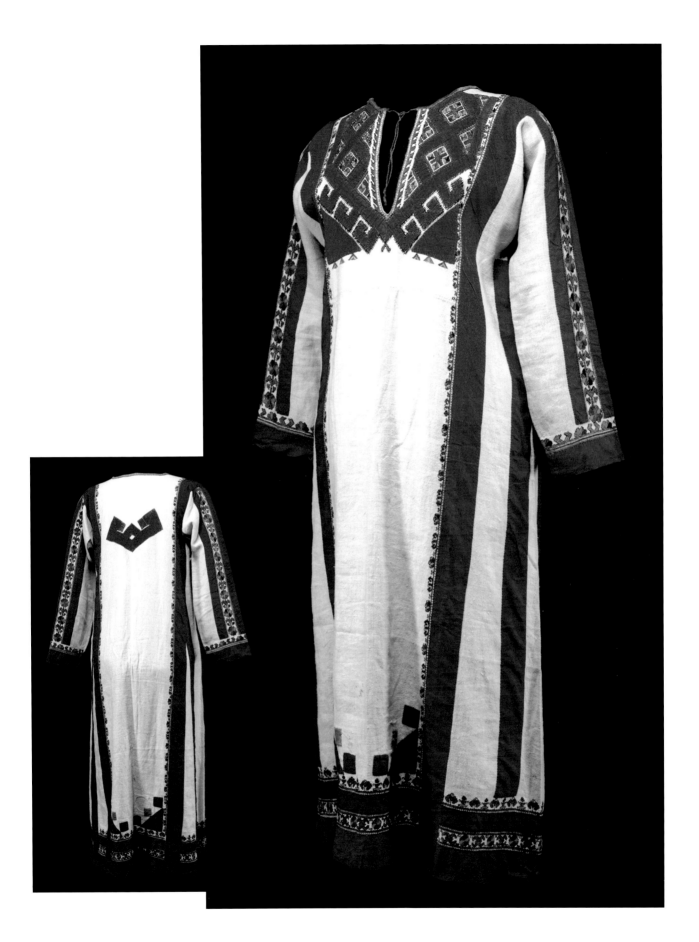

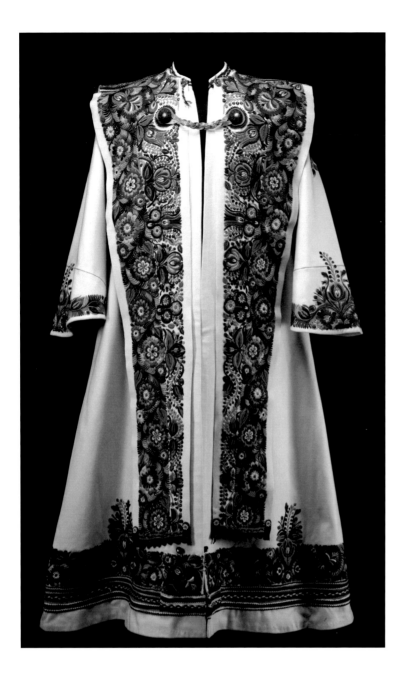

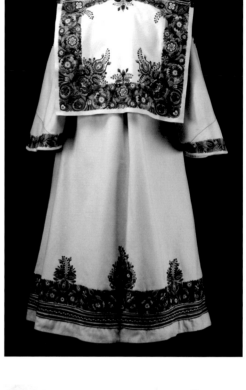

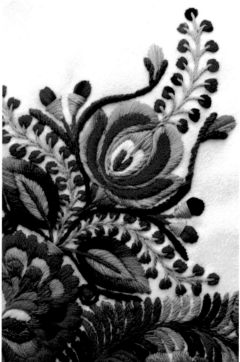

Cloak, *cifraszur*

Wool, embroidered

128 cm x 148 cm, 50⅜ in x 58¼ in

c. 1920, Hungary

Gift of Mary W. Vinton in memory of Warren J. Vinton

A.1992.64.1v

Richly embroidered outer garments like this were worn by Hungarian men on Sundays and special occasions. This *cifraszur*, made from fine wool cloth called *aba* with shaded wool embroidery, grew out of a functional cloak made from thick wool cloth (*szur*) and worn by herdsmen and peasants. The *szur* was also used as a blanket and mattress at night. From this rough, humble garment there developed refinements in decoration, materials, and use until its demise in the mid-twentieth century. The cifraszur was worn as a cloak, thrown over one or both shoulders. They were made by professional tailors, always male.

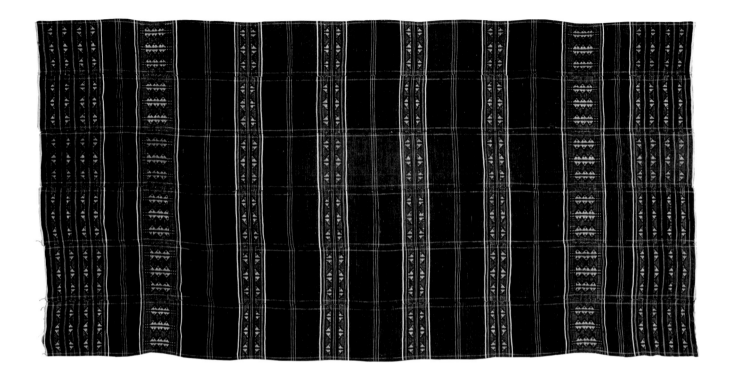

Wrapper, *pano d'obra*

Cotton, supplementary weft patterning
179 cm x 90 cm, 70½ in x 35½ in
c. 1930, Cape Verde Islands
IFAF
FA.2007.5.1

Cape Verde is well known for its intricately patterned cloths that were an integral part of the slave trade from the mid-fifteenth to the mid-nineteenth century. Less well known are the cloths produced for use by the islanders themselves. This *pano d'obra* was made from cotton grown on the islands, spun by women and woven by men on small treadle looms. The cloth is made from six strips carefully aligned and sewn together. It was worn as a sash around the waist or used to carry a baby on a woman's back.

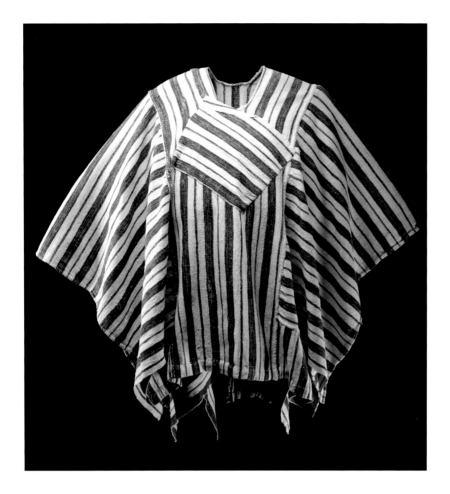

Man's garment, *duriki ba*

Cotton
92 cm x 142 cm, 36¼ in x 55⅞ in
c. 1860, Liberia or Sierra Leone
Gift of Allison Abbott
A.2006.89.3

This man's gown is the type known as *duriki ba*, or "large shirt," in Mande. The category of large shirt also includes longer, more elaborate gowns and those with embroidery. The common features are sleeves where the sewn strips run perpendicular to the body of the gown and a pocket attached to the front chest. In this gown, the strips are 5 inches/12.5 centimeters wide; each contains two wide blue, two narrow blue, and four white warp stripes. Each sleeve is made with twelve strips. Simple striped cloth made by male weavers in rural areas and formerly traded to the coast is known as country cloth in Sierra Leone and Liberia. This gown is remarkable for its age and condition, especially in an American museum.

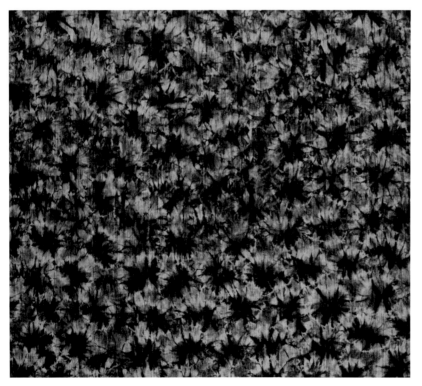

Wrapper detail

Cotton, tie-dyed
259 cm x 130 cm, 102 in x 51¼ in
c. 1860, Liberia or Côte d'Ivoire
Gift of Allison Abbott
A.2006.89.1

Because of its size, this magnificent cloth was probably made to be worn by a man. White cotton yarn was woven into a 4½-inch-wide strip, cut into eleven pieces, and sewn together. It was then gathered in handfuls, tied, and put into the dye pot, producing the cloud-like effect. The cloth was given to the Reverend Bott and his wife, Fanny, who were missionaries in Nigeria.

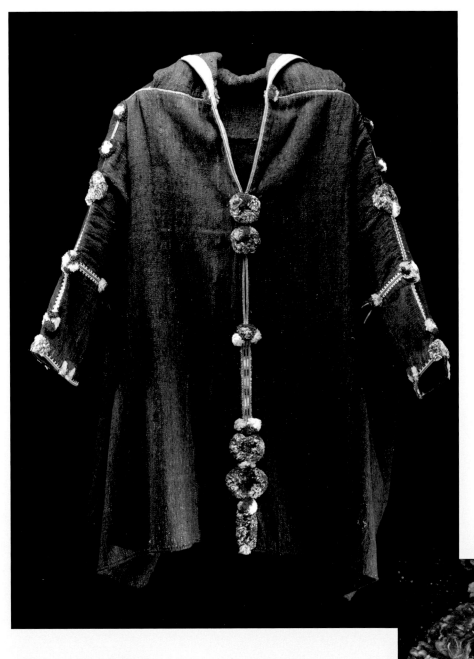

Outer garment, *djellaba*

Wool, cotton, silk, embroidered
88.9 cm x 264 cm, 35 in x 104 in
c. 1920, Rif Mountains, Morocco, Kabyle Berber group
Gift of Amelia Elizabeth White
A.1953.8.12

The *djellaba* was worn in many parts of Morocco by men as the outermost garment.
Styles varied by region, some more fitted, of different colors or fabrics and with different
decoration. This wide, loose djellaba with sleeves was worn by Kabyle Berbers in the
Rif Mountains of northern Morocco. The cloth made from hand-spun wool weft on cotton
warp was probably woven at home. The silk embroidery and pom-poms signal a special
garment, not worn every day. Today, full-length djellaba with hoods are worn by both men
and women all over the country as an outer garment. Other types of outer garment from
Morocco in the museum are *akhnif* from the Siroua Mountains and women's wrapped
garments from the Rif, and the High, Middle, and Anti-Atlas Mountains.

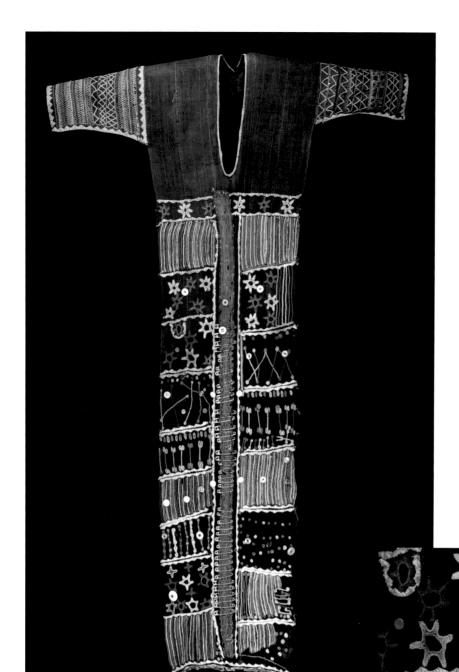

Tunic

Cotton, buttons, safety pins,
embroidered, applied trim
101.5 cm x 62.4 cm, 40 in x 24½ in
Twentieth century, Niger,
Wodaabe/Fulani group
IFAF
FA.1991.55.3

This tunic was worn by a man during the Geerewol festival in Niger, a competition where the young men try to impress the young women with their beauty and finery. It is made from a variety of materials. The body of the tunic is composed of gauze-like handwoven cotton strips just over 2 inches wide. Each strip has three threads carried along the front at ½-inch intervals. The sleeves are made from strips that are ⅝ inch wide and slightly heavier than the body. The strips are woven and dyed near Kano, Nigeria, and are also used to make the veils prized by Tuareg men of the Sahara. Trims include plastic buttons, round metal clamps stamped "Japan," a "pearl" snap like on a Western shirt, and safety pins. Chain stitch embroidery in silk thread forms lines, stars, and geometric motifs. The front band with safety pins is made from different yarn and might have been added later.

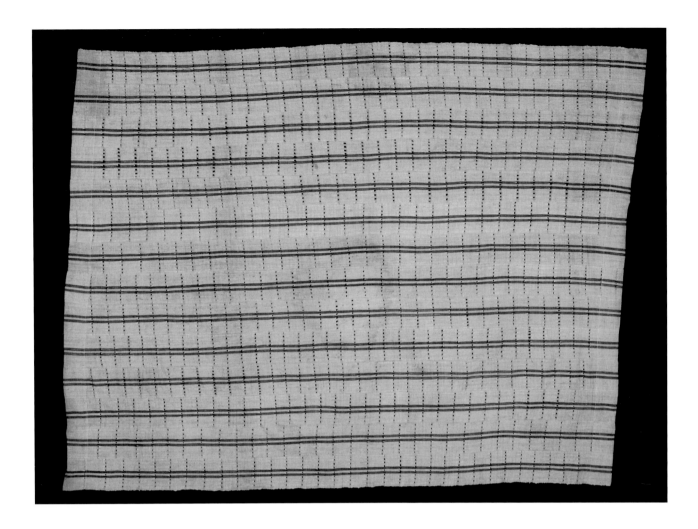

Wrapper

Silk, cotton
188 cm x 143 cm, 74 in x 56$\frac{5}{16}$ in
c. 1950, Nigeria
IFAF
FA.2001.16.1

Wild silk from a variety of *Anaphe* moths was gathered and processed to make cloth in all parts of Nigeria. In the southwestern part of the country, where this cloth comes from, wild silk is called *sanyan* by the Yoruba people and was highly prized for its rarity. The natural color of the silk is tan; the purple and black narrow stripes are dyed cotton. Narrow strip cloth is called *aso oke* by the Yoruba and is used to make both men's and women's clothing. This cloth is decorated with a version of Yoruba lace weaving, which leaves holes in the cloth. Spinning and weaving of wild silk has disappeared in Nigeria.

Skirt, *rahat*

Leather, shells, beads
42 cm x 69 cm, 16⁹⁄₁₆ in x 27³⁄₁₆ in
c. 1900, Egypt or Sudan
Gift of Florence Dibell Bartlett
A.1955.86.907

The *rahat,* or fringed leather skirt, is an ancient garment worn in southern Egypt and Sudan from before the seventh century CE. Examples have been recovered from archaeological excavations in both Sudan and Egypt. The rahat was worn by girls of different ethnic groups in the area, including the Nubians and the Shilluk. Once married, a girl would exchange the rahat for a white cotton dress and veil. This skirt is one of three in the collection and is made from leather strings knotted over a waistband. Strands of glass, metal, and ceramic beads are suspended from the bead band at the waist, each ending in a large shell. Many of these beads were obtained through trade, as were the shells.

Shirt

Leather, quill, fur
82 cm x 61 cm, 32⁵⁄₁₆ in x 24 in
c. 1880, Northwest Territory, Canada,
Slavey Athapaskan group
Gift of Florence Dibell Bartlett
A.1955.86.486

This shirt is a fine example of a hybrid of tradition and
innovation in far North America. Athapaskan Indians living
around the Great Slave Lake made shirts for themselves from
moose or caribou hide decorated with loom-woven quill work.
They usually had closed fronts and quill-wrapped fringe and
ended in points front and back. Small stepped patterns were
normally used in quillwork until the mid-nineteenth century
when the floral patterns associated with Woodlands bead-
work became popular. This shirt was most likely made for a
trader, with its button front, chest pockets, and collar, but the
older style of geometric motifs of the dyed quills was retained
as well as the wrapped fringes on the shoulders. The hem of
the shirt was cut into small tabs.

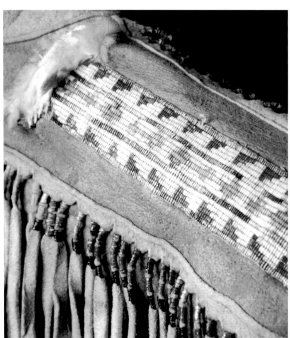

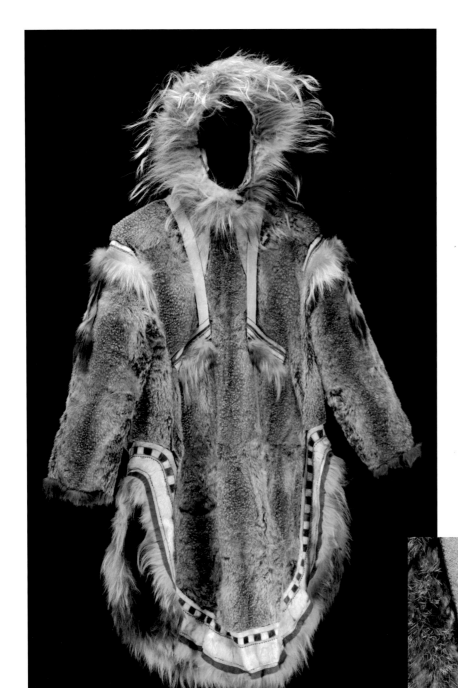

Parka

Ground squirrel pelts, wolf or
wolverine fur, caribou hide
142 cm x 143 cm, 55 7/8 in x 56 5/16 in
c. 1880, Southwestern Alaska, Yup'ik group
Gift of Louis Criss
FA.1974.42.1

Yup'ik parkas have several features that
distinguish them from other North American
Arctic Inuit groups. They are usually made
from ground squirrel pelts rather than caribou
skins, the ruff around the hood is made with
long-haired fur, and fur mosaic trim is used.
The long white projections made from caribou
pelt that extend onto the chest and the back of
the parka are also characteristic of Yup'ik
garments. The curved bottoms identify this
parka as a woman's garment. Around 1880
women's parkas started to be cut straight
across the bottom like men's garments.
The Inuvialuit of the Mackenzie River Delta
adopted many of these same design charac-
teristics from the Yup'ik. The museum
collection has several other Arctic garments
and footwear as well.

Coat

Wool, tapestry technique
105 cm x 58 cm, 41⁵⁄₁₆ in x 22¹³⁄₁₆ in
c. 1920, Chimayo, New Mexico
Gift of K. Gabrielle
A.1991.21.1

Along with blankets (see page 27) the weavers of Chimayo also make garments for sale. These coats, vests, and jackets, as well as purses and pillows, all represented in the museum collection, sport the same motifs and color combinations as those used on the flat textiles. They are instantly recognizable as the products of northern New Mexican looms. This unlined coat shows the central Saltillo-like motif of a blanket on the back and what would be border stripes running down one side. The fringe on the front and the pocket are not added on but are warp and weft elements, respectively.

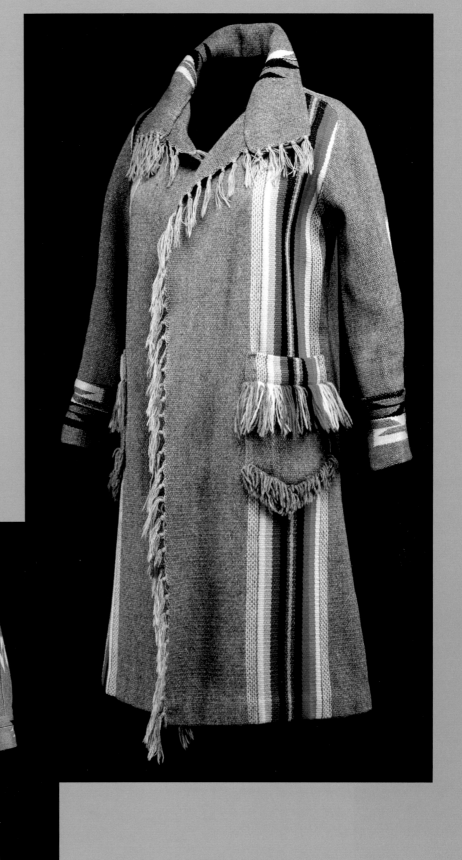

Upper garment, *huipil*

Cotton, silk, supplementary weft patterning, embroidered
59 cm x 120 cm, 23¼ in x 47¼ in
c. 1950, San Pedro Sacatepequez, Guatemala
Gift of Penelope M. Cooper
A.1985.525.15

A woman's upper garment made from uncut loom lengths is called a *huipil* in Guatemala and Mexico. Huipils are woven on a back strap loom by women. Male weavers use a floor loom for making wider fabrics used for skirts and tailored clothing. This is a two-panel huipil joined in the center with an embroidered seam called a *randa*. The neck hole is cut out. The body is cotton and the woven decoration is white silk and purple and red cotton. There's a small amount of embroidery around the neck. The detail photo shows the pile effect on the motifs. Many of the patterns in Guatemalan huipils have symbolic meaning. Zigzags are said to symbolize the god of lightning or the path taken by Mayan priests up the steep temple steps. This is a ceremonial huipil worn by a member of the *cofradia*, a Catholic religious organization.

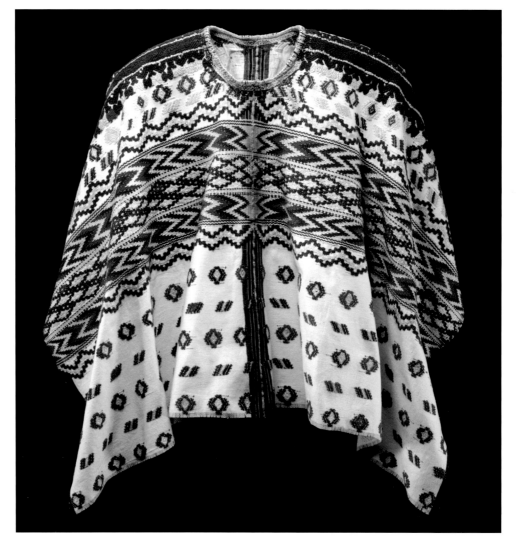

Pants, *scaf*

Cotton, embroidered
85 cm x 65 cm, 33⁷⁄₁₆ in x 25⁹⁄₁₆ in
c. 1960, detail 1956, Santiago Atitlan,
Guatemala
Gift of the Girard Foundation
A.1981.42.475

Two different pairs of men's pants are shown here
to illustrate the change over time of the decoration
used in Santiago Atitlan. The pair of pants with
only purple stripes is newer and is more fully
embroidered than the older pants leg shown in
the detail. The embroidery itself is more skillfully
accomplished—the motifs are more densely filled
and far better drawn than those on the older pair.
Historically, short trousers were worn with a shirt
that opened part way down the chest, along with a
sash and a head cloth called *tzute*. Unlike many
places in Guatemala, men in Santiago Atitlan still
wear local styles of clothing made in the village.
A village-made garment might be worn with
something purchased in the secondhand
market or in a shop.

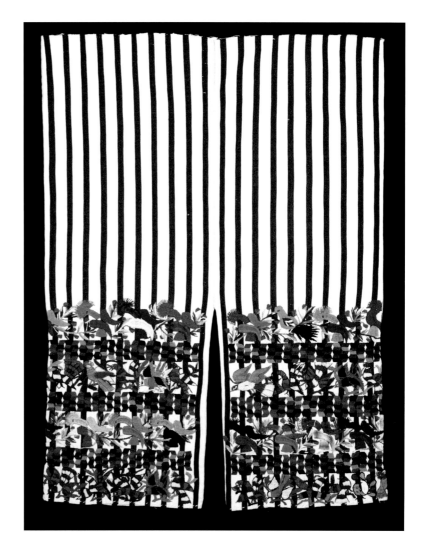

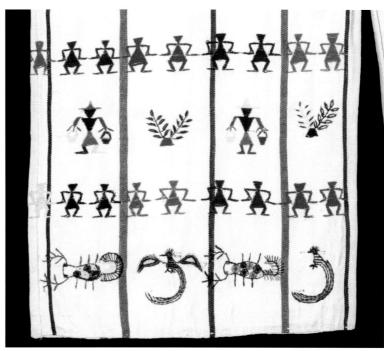

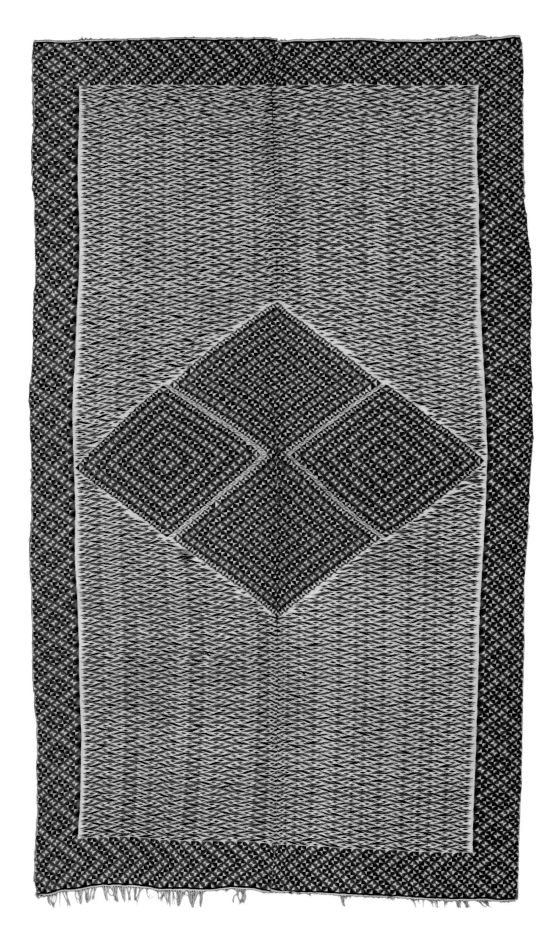

Facing:

Wearing blanket, *sarape*

Wool, cotton, tapestry technique
219 cm x 131 cm, 86¼ in x 51⁹⁄₁₆ in
c. 1860, Mexico
IFAF
FA.1970.37.15

The Mexican *sarape* reached its artistic zenith in the second half of the nineteenth century. Woven with fine wool yarn on hand-spun cotton warp in two sections, this example exhibits two shades of cochineal red, green, yellow, and purple worked in the typical Saltillo style of outside border, central lozenge, and background filled with a small pattern. Sarapes can have a center slit for wearing as a poncho or not; this one does not. They are often seen in prints and paintings of Mexican horsemen, rolled up and carried at the front or back of the saddle. There were many qualities of sarapes woven for any budget. Those with intricate patterning, like this one, were very expensive and used by the upper classes.

Right:

Wearing blanket, *sarape*

Wool, cotton, silk, metallic yarn,
tapestry technique
232 cm x 123 cm, 91⁵⁄₁₆ in x 48⁷⁄₁₆ in
1870–1900, Mexico
Fred Harvey Collection, IFAF
FA.1979.64.90

Unusually, this sarape was woven in one piece with a neck slit that is now sewn together. The words "Epifanio Jimenez" are woven into the two blue rectangles on the bottom border; this is most likely the name of the man who commissioned the weaving. With the introduction of chemical dyes in the 1860s,[1] new colors became available to sarape weavers, as can be seen here. Weavers in San Miguel de Allende introduced the use of silk and metallic yarns and floral motifs in the 1860s, all elements seen in this weaving. This is perhaps the most spectacular of the many sarapes in the collection, which also includes a printed version made in Europe.

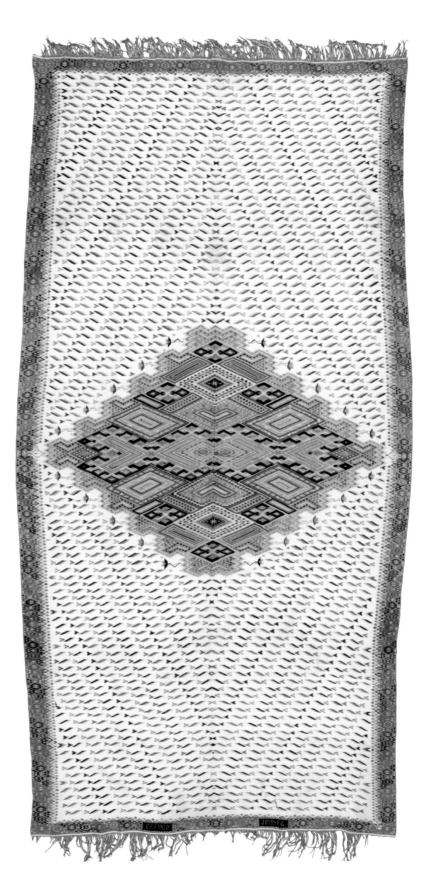

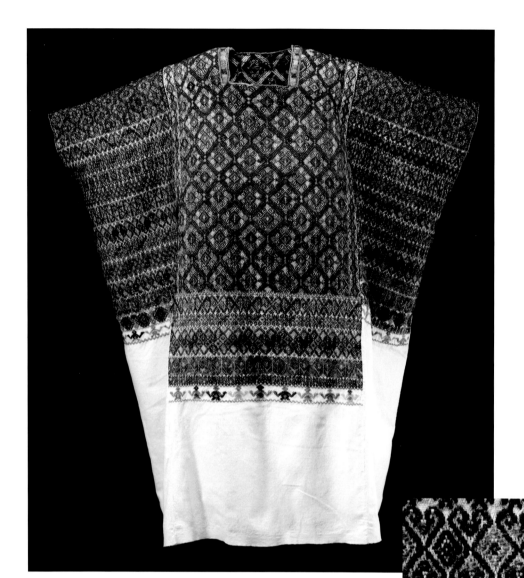

Upper garment, *huipil*

Cotton, wool, supplementary weft patterning
100 cm x 96 cm, 39⅜ in x 37¹³⁄₁₆ in
c. 1984, Magdalenas, Mexico, Tzotzil group
IFAF
FA.1988.79.3

Tzotzil Indians live both in the lowlands and highlands of Chiapas. In the highlands with their colder temperatures, wool is used in making clothing. This is a ceremonial huipil with wool supplementary weft patterning on cotton cloth. Traditionally, these were worn by female religious officials during major festivals. The statues of female saints in Magdalenas and Santa Marta are dressed in layers of similar huipils. The patterns are all symbolic of aspects of the weaver's world view. The diamond shapes of the main part of the center panel represent the square Mayan world with the sun in the center. In the detail showing the bottom of the center panel, the bottom row of diamond spirals is the symbol for Magdalenas itself. The top row of "X" shapes are called the Kurus cross and probably symbolize the four corners of the earth.

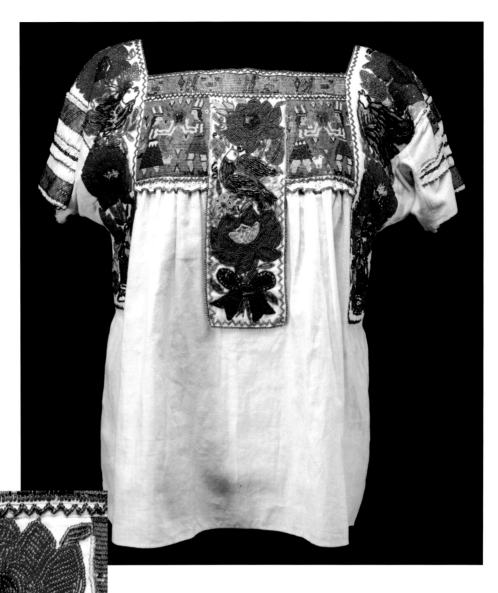

Blouse

Cotton, glass beads
62.25 cm x 53.5 cm, 24½ in x 21¹⁄₁₆ in
c. 1935, Puebla, Mexico
Gift of Florence Dibell Bartlett
A.1955.1.135

This blouse is part of a China Poblana outfit consisting of a gathered skirt with sequin decoration and a shawl. The origins of this style in Mexico are shrouded in legend. La China Poblana is said to have been a Chinese girl who was captured and sold in Mexico in the seventeenth century. She lived in Puebla, thus "Poblana," and wore clothing somehow similar to this outfit. Others say the word "china" means a servant of mixed origin in Mexico and "poblana" means "of a town." In any case, the entire ensemble became very popular both in urban Mexico and the United States for fancy dress occasions in the 1930s. The decoration on the blouses became more and more elaborate until pieces like this were made. The beading is superb on front and back with large three-dimensional flowers and birds and flat panels of Indians and traditional small textile designs on the narrow borders. Of the several China Poblana ensembles in the museum, this blouse is the most elaborate.

Upper garment, *huipil*

Bark, beaten, painted
174 cm x 78.7 cm, 68 ½ in x 31 in
1978, NAHà, Mexico, Lacandon group
IFAF
FA.1978.80.7

The Lacandon people live in the lowlands of southern Chiapas, near the Guatemalan border. Like people all over the tropical world, they use the bark of a fig tree to make cloth and clothing. The bark is stripped from the tree, soaked, and beaten with a wooden mallet until the fibers spread out into a sheet. The finished fabric is then painted with dye made from the *achiote*, or annatto, seed, resulting usually in a blood-red color, which has changed here to a rusty brown. Tunics like this were worn by men. Bark cloth was often produced in areas where other fibers such as cotton or flax did not grow. With the introduction of other fibers and fabric, the use of bark cloth often ceases, remaining only in ritual use. Skills such as the beating of bark are often revived, in hopes of providing an income to impoverished people as well as sparking a cultural renewal for people who have lost contact with their past due to foreign domination.

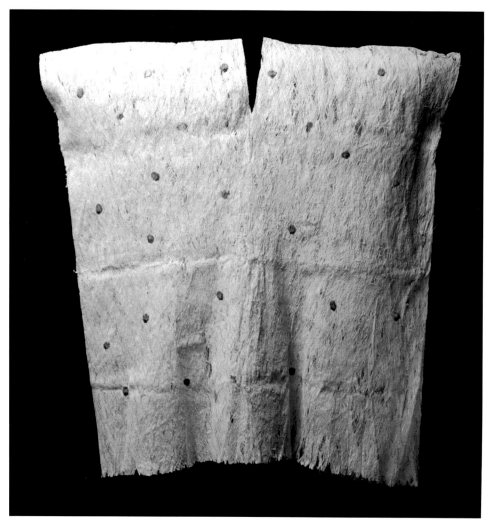

Skirt, *aksu*

Alpaca, complementary warp patterning, embroidered
130 cm x 94 cm, 51³⁄₁₆ in x 37 in
c. 1960, Macha region, Bolivia, Quechua group
Gift of Robert Holzapfel
A.2002.43.1

Aksu is a Quechua word for dress or skirt. Historically, it was worn belted and pinned at the chest or shoulder. It now refers to a cloth that is worn wrapped over another dress or skirt and fastened with a belt. They are made from two pieces of cloth, not identical, patterned with stripes and geometric motifs created with complementary warp. Aksu are typically assymetrical, as can be seen in the size and number of the stripes and the difference in width of the pattern bands. Three edges are finished with a red and black woven tubular edge binding. The yarn is very evenly spun and the weaving is very fine for this time period. It must have been made for the weaver's own use as other pieces in the museum from this era are quite coarse—evidently woven quickly for sale.

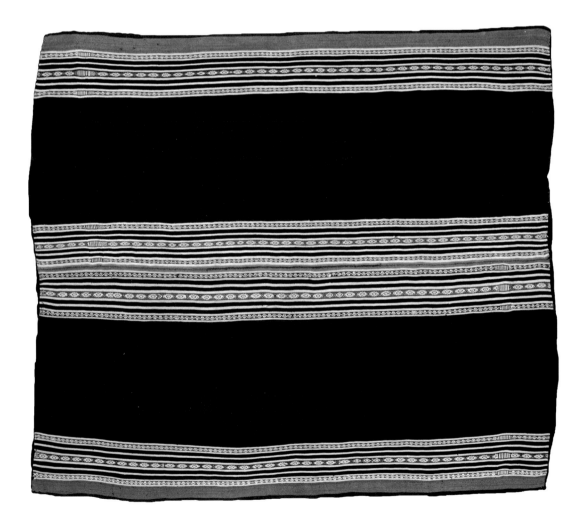

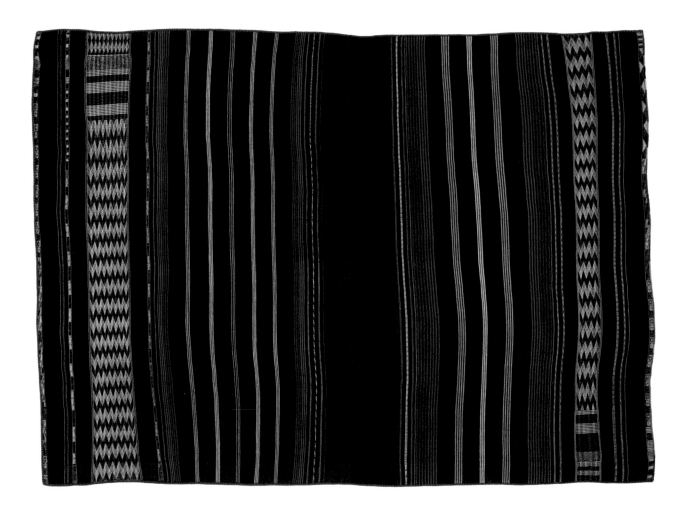

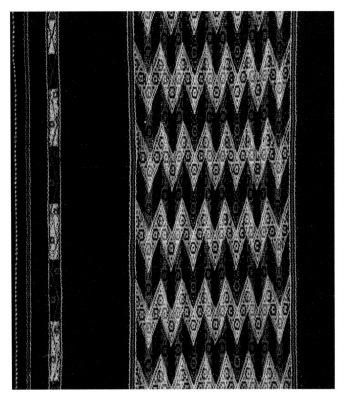

Mantle, *awayu*

Alpaca, complementary warp patterning
112 cm x 96.5 cm, 44⅛ in x 38 in
c. 1860, Pacajes, Bolivia, Aymara group
Gift of William Siegal
A.1996.50.17

The *awayu* is worn over the shoulders like a small shawl or used as a carrying cloth by the indigenous people of the Bolivian Andes. The restrained nature of the color scheme and the small designs on this textile are immediately recognizable as a nineteenth century Aymara weaving. Interestingly, the Aymara were part of the great Tiwanaku culture (600–1000 CE), whose textiles, recovered in archaeological excavations, have proven to be skillfully dyed in a rainbow of colors and decorated with a multitude of techniques. The fineness of the yarn and evenness of the weaving give this mantle a supple hand.

Poncho

Wool, resist dyed
176 cm x 140 cm, 69⁵⁄₁₆ in x 55¹⁄₈ in
Nineteenth century, Chile, Mapuche group
IFAF
FA.1973.85.1

The Mapuche, sometimes called Araucana, live in the foothills of the Andes in Central Chile and across the mountains in Argentina. Indigo ikat-dyed ponchos like this one are dated from the mid-nineteenth century to the early twentieth century; before 1850 ponchos were buried with their owners. They were worn by chiefs to signify their new social status that developed out of centuries of fighting first the Inca and later the Spanish. Prior to their sustained resistance to the Spanish, the Mapuche lived in non-hierarchical groups. The development of the ponchos is directly related to the development of a new social hierarchy. This example is covered with three bands of stepped cross design. The white warp is so precisely tied to resist the blue dye that the pattern appears crisp, as if woven in. This is the finest of several Mapuche pieces in the collection.

Loincloth

Cotton, wool, tapestry technique
71 cm x 40.5 cm, 27¹⁵⁄₁₆ in x 15¹⁵⁄₁₆ in
1100–1400 CE, Central Coast, Peru,
Chancay culture
Gift of Lloyd E. Cotsen and the
Neutrogena Corporation
A.1995.93.1261

Although Pre-Columbian textiles are not a focus of the museum's collection, there are a number of pieces in storage. Most of the significant pieces were donated by Lloyd Cotsen and the Neutrogena Corporation, as was this example. Woven in slit tapestry technique on the central coast of Peru, it is very similar in color scheme and technique to a tunic panel pictured in the book *The Extraordinary in the Ordinary*. Staggered rows of regular bird-like figures are animated by a random use of color in their "wings," making an otherwise static design lively. Other Pre-Columbian pieces in the Neutrogena collection include Nasca needle looped bands, Wari tie-dyed tunics, and Chimu painted cloths.

Facing:

Tunic, *cushma*

Cotton, painted
122 cm x 104 cm, 48¹⁄₁₆ in x 40¹⁵⁄₁₆ in
c. 1975, Amazon River, Peru
Gift of Lloyd E. Cotsen and the
Neutrogena Corporation
A.1995.93.1255

The *cushma* is worn by both men and women of several different groups in the Amazon River area. This is a man's garment with its vertical neck slit. Women's cushma has a wider horizontal opening for the head. Cotton is gathered, spun, and woven by women. The dyes come from forest plants. Two striped panels were woven, sewn together, and the plain areas painted with spirals.

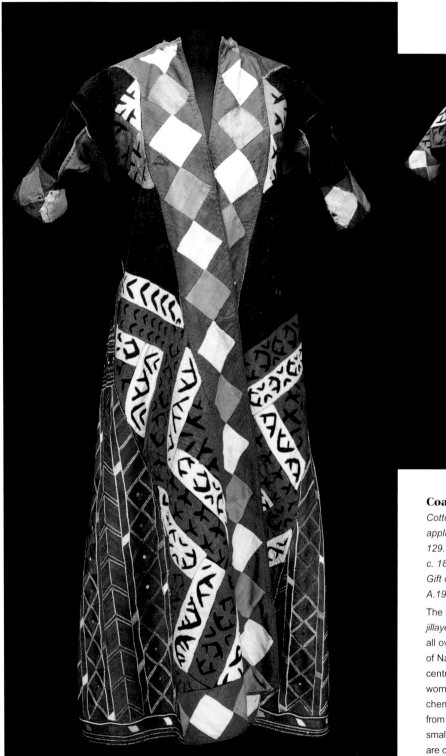

Coat, *jillayeh*

Cotton, silk, glass beads, embroidered, appliquéd
129.5 cm x 94 cm, 51 in x 37 in
c. 1860, Nazareth, Palestine
Gift of Florence Dibell Bartlett
A.1955.86.920

The short sleeve coat from Galilee is called *jillayeh* when it is heavily decorated. It was worn all over the region in both villages and the town of Nazareth until the turn of the twentieth century. The jillayeh constituted the top layer of a woman's ensemble that included trousers, a chemise, belt, and shoes. Embroidered in silk from hip to hem in the back with stem stitch and a small amount of cross stitch, the front and sleeves are covered with silk appliqué of solid diamonds and cut-out bands. There is a row of tiny blue glass beads running across the back of the coat, added to protect the wearer from the evil eye. Women began to replace this style of jillayeh with a long-sleeved coat in the Turkish fashion in the last quarter of the nineteenth century.

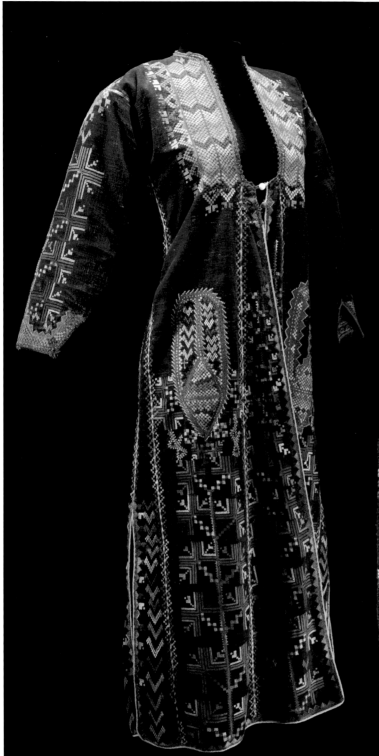

Coat

Cotton, silk, glass buttons, embroidered
127 cm x 44.5 cm, 50 in x 17½ in
c. 1850, Aleppo, Syria
Gift of Florence Dibell Bartlett
A.1955.86.938

This coat was originally collected at the turn of the twentieth century by Grace and John Whiting of the American Colony in Jerusalem. It has similarities to the coat from Nazareth (*facing*) because it is fitted and open in the front. The embroidery is entirely different, less dense and executed in cross-stitch only, and the shape of the front opening is not the same. It was worn over embroidered trousers and a chemise as well. The use of primarily geometric motifs changed in the early twentieth century when European pattern books were introduced to village women in the Middle East. Orange, yellow, and red silks against deep blue make the dynamic patterns in this coat jump.

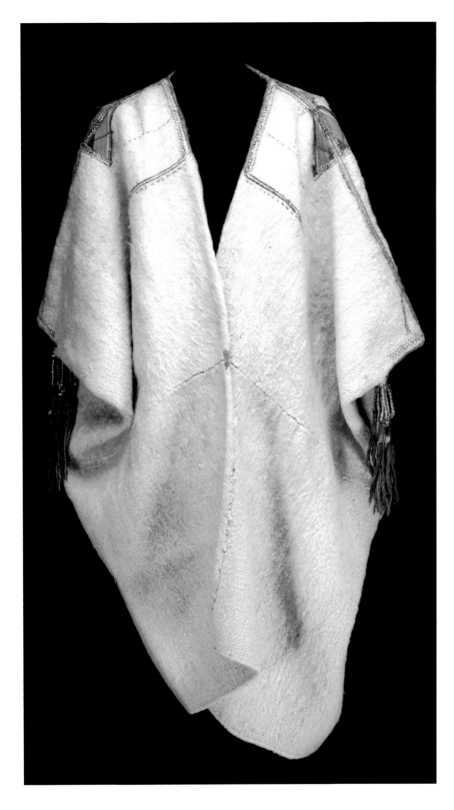

Cloak, *aba*

Wool, embroidered
112 cm x 142 cm, 44⅛ in x 55⅞ in
c. 1940, Saudi Arabia
Gift of Marian and Leland Meyer
A.2000.48.1

The *aba* or *abaya* is a man's garment that serves many purposes in the Middle East. In rough wool with little embellishment, like this one, it is a herder's cloak that provides warmth and protection in the harsh desert environment of Saudi Arabia. Woven from precious silk with gold thread inlay or fine wool with metallic thread embroidery, it becomes an urban prestige garment. The aba is worn from Turkey to Morocco in different forms. The most common form is sleeveless, open in front, and made from two rectangular pieces of cloth. Small armholes are cut and the edges are bound. Four tassels swing from each armhole. An aba is often worn thrown over the shoulders and can double as a blanket at night. This piece was acquired by the donor's father in Saudi Arabia during World War II. The museum has several silk abas as well as wool styles from other countries.

Tunic, *lukus rumoan*

Ramie, shell beads
100 cm x 45 cm, 39⅜ in x 17¹¹⁄₁₆ in
c. 1900, Taiwan, Atayal group
Gift of Julia Meech and Andrew Pekarik in honor of Nucy Meech
FA.1986.539.86

The Atayal are one group of several indigenous groups living in the mountains of Taiwan. The tunic called *lukus rumoan* was traditionally made from cloth woven on a back strap loom with ramie yarns. The beads, made from the shell of the giant clam *Tridacna*, were obtained through trade with coastal people. It could be worn only by men who were warriors and accomplished headhunters during the welcoming of the heads ceremony. Being a skilled weaver was vital to being an adult woman; being strong and fearless, as shown by taking a head, was crucial to a man's identity. These two essential and related activities came together in this man's garment. Both weaving and headhunting were banned during the Japanese occupation of Taiwan from 1895–1945. See *The Extraordinary in the Ordinary* for another lukus rumoan in the collection.

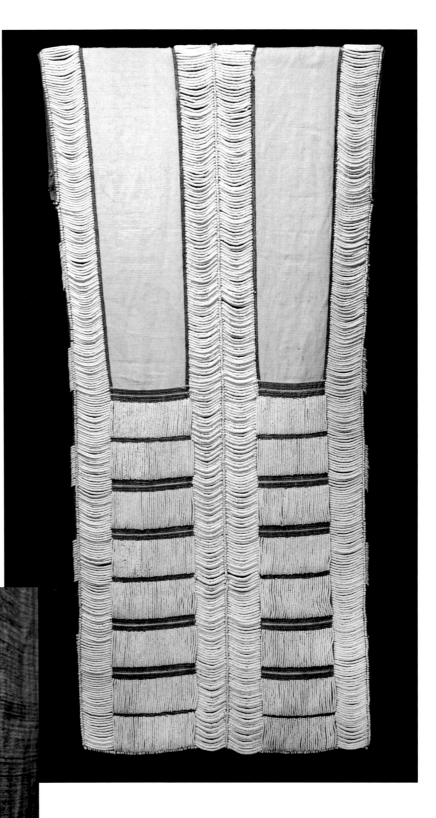

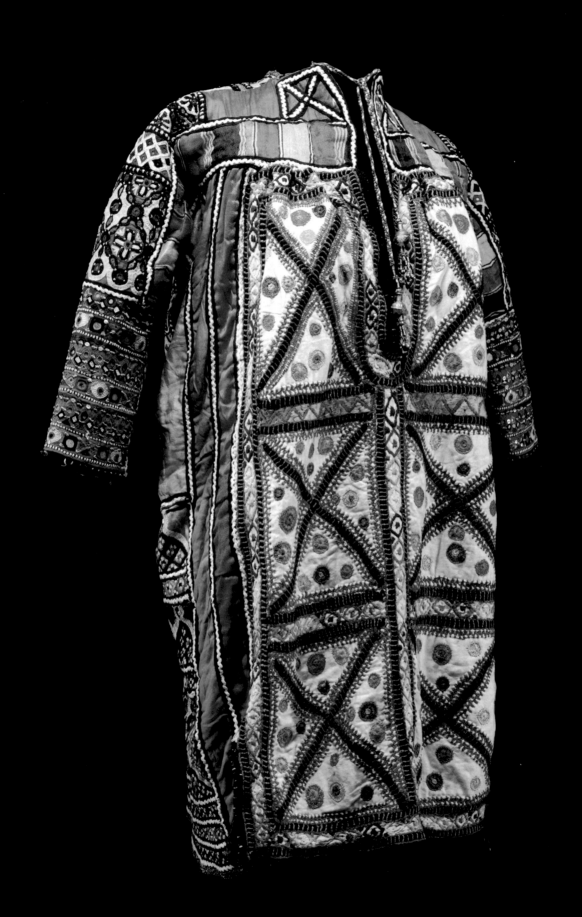

Upper garment, *chola* or *cholo*

*Cotton, silk, synthetic fibers, mirrors, sequins, metallic
thread, pieced, embroidered, applied trim*
87.5 cm x 170 cm, 34⁷⁄₁₆ in x 66¹⁵⁄₁₆ in
Twentieth century, Sindh region, Pakistan or India
IFAF
FA.1976.3.5

A long blouse or dress called *chola* is worn by women in
many different groups in southeast Pakistan and northwest
India—the region known as Sindh that existed long before
the country borders were drawn in 1947. The chola doesn't
actually have a back or front but is worn both ways. The side
with the extended neck opening is said to be worn in front
after marriage, while the closed neck side is worn in front
before. The garment is made from many different pieces of
fabric sewn together and covered with embroidery. Stitches
used are satin, double buttonhole, and couching. Sequins,
mirrors, and rickrack are attached.

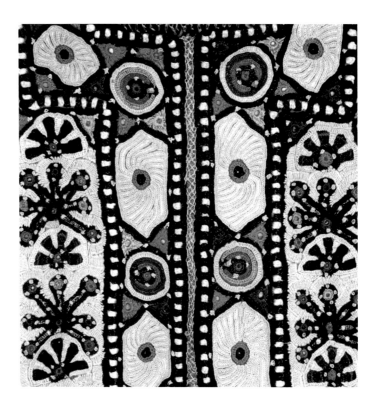

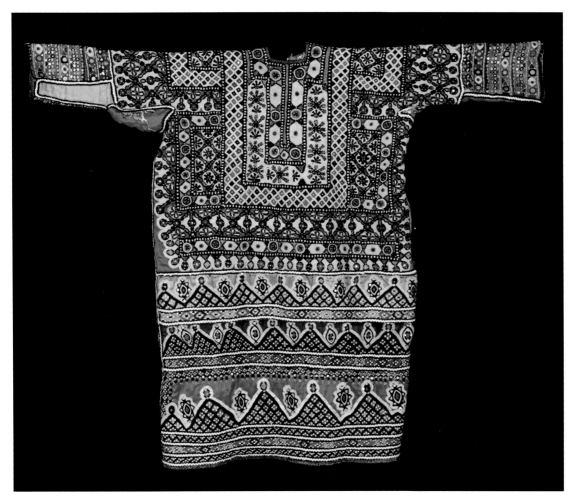

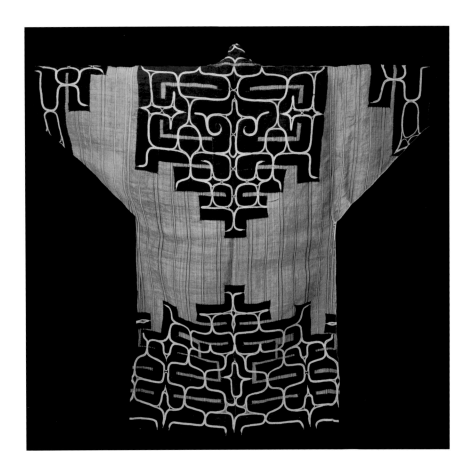

Coat

Elm bark, cotton, embroidered, appliquéd
117 cm x 119 cm, 46 in x 47 in
c. 1880, Hokkaido, Japan
Gift of Sallie Wagner
FA.1978.54.1

Coats made from the elm bark cloth called
attush are perhaps the most famous of all
Ainu textiles. The cloth was woven on the
back strap loom. This piece has blue warp
stripes. The blue cotton used for the
appliqué design was obtained through
trade, embroidered, and then stitched onto
the coat. Designs, handed down from
mother to daughter, have no significance
other than to beautify the garment and
please the gods. Cotton textiles were highly
valued and saved until enough was avail-
able to trim an attush garment or make
another cotton garment. The Ainu also
made coats from fur, fish skin, and bird
skins.

Coat

Cotton, quilted, resist dyed
117 cm x 117 cm, 46$\frac{1}{16}$ in x 46$\frac{1}{16}$ in
c. 1900, Noto region, Japan
Gift of Lloyd E. Cotsen and the Neutro-
gena Corporation
A.1995.93.668

The dramatic visual effect seen on this
country garment was produced by quilting
layers of cotton cloth together with white
thread, a technique known in Japan as
sashiko. The practice of quilting garments
grew out of a necessity to make cotton or
bast fiber garment warmer and more
durable. Sashiko also reflects economic
necessity of using what was at hand and not
wasting worn-out clothing that had even a
shred of life left in it. When rural women
combined their creativity and skill with a
needle to these conditions, graphic patterns
and deep texture appeared to enliven the
surface of the cloth. Look closely and you
will see pieces of ikat cloth on the sleeves,
stitched over for a layering of design motifs.
The inside of the coat is light blue, perhaps
an older fabric than that on the outside.

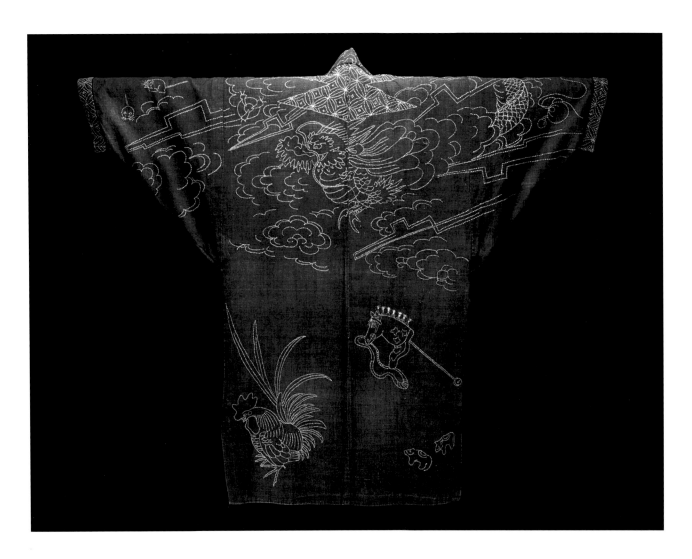

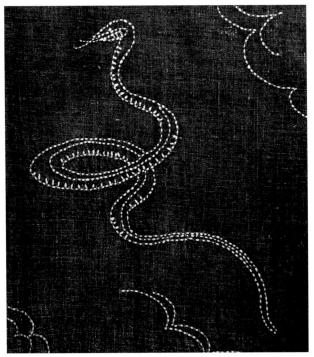

Coat

Cotton, embroidered
105 cm x 127 cm, 41½ in x 50 in
c. 1900, Japan
IFAF
FA.1955.6.1

Unlike the sashiko coat, this one is simply embroidered with scattered figures of birds, clouds, a rabbit pounding something in a mortar, a tiger, other animals small and large, and even a stick pony. Tapered sleeves were more common on work clothing; they were less cumbersome than the wide, hanging sleeve of kimono.

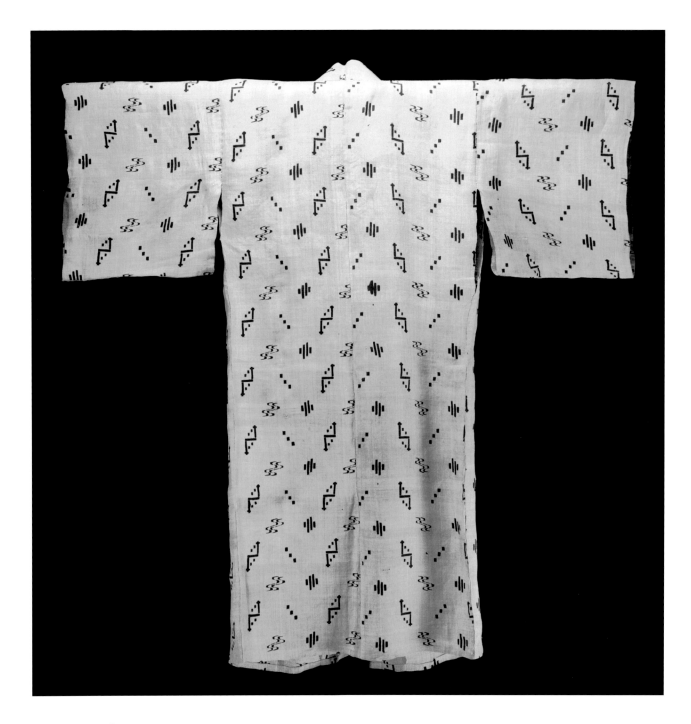

Kimono

Banana fiber, stenciled
119.5 cm x 116 cm, 47¹/₁₆ in x 45¹¹/₁₆ in
c. 1920, Okinawa
Gift of Lloyd E. Cotsen and the Neutrogena Corporation
A.1995.93.671

This kimono shows the interchange of ideas between Okinawa and Japan through its materials and form. It is made from the fiber extracted from the stem of the male banana plant, *Musa ryukyuensis*, which was brought to Okinawa in the thirteenth or fourteenth century and has since grown to be the emblematic textile of the island.

Basho-fu is light, breathable, and cool to wear in Okinawa's tropical climate. The form of this kimono, however, shows Japanese influence through the shape of the sleeves. Okinawan-style kimono have narrow sleeves and a wide body compared to this garment. The stencil technique used to create the small patterns originated in China and was widely used in Japan as well (see page 116). Fine basho-fu garments were used by the elite classes, while cloth made from the coarser fibers was used for everyday clothing by commoners.

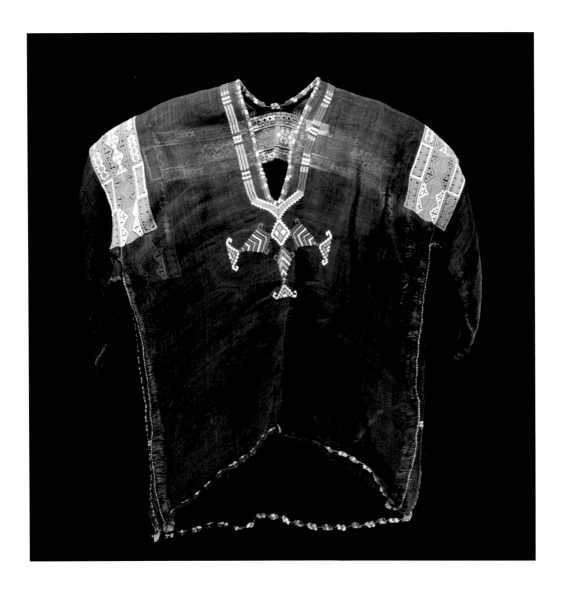

Blouse, *bado*

Abaca, cotton, embroidered
52 cm x 129 cm, 20$\frac{1}{2}$ in x 50$\frac{13}{16}$ in
c. 1900, Mindanao, Philippines, Mandaya group
Gift of Mrs. Gregg Ward
A.1972.24.39

The sheer fabric of this blouse is woven from the fiber of a
relative of the banana, *Musa textiles*, known in the Philippines
as *abaca*. The fiber is processed from the stem of the leaves.
It is not spun but used as a strand, knotted together to make
a long yarn. To produce the sheer fabric for this blouse, the
weaver chose the finest fibers to work with. The cotton
embroidery thread was purchased. The island of Mindanao is
home to a number of ethnic groups known for their weaving
of local fibers as well as introduced cotton and silk.

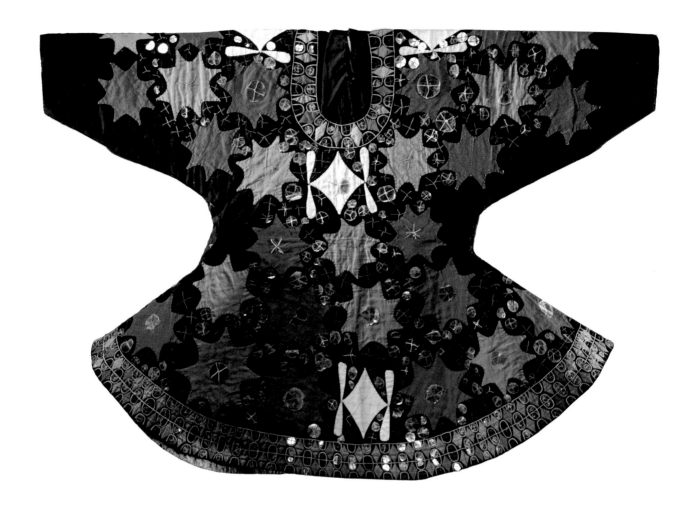

Blouse, *halili petondu*

Cotton, bark, mica, embroidered, appliquéd
64 cm x 88 cm, 25³/₁₆ in x 34⁵/₈ in
Twentieth century, Sulawesi, Indonesia, To Kaili group
IFAF
FA.1982.37.1

Stars and diamonds dominate the surface of this woman's blouse made from commercially woven cotton fabric lined with bark cloth. The mica was procured locally, its sole use to decorate clothing. The distinctive shape of the blouse is also seen in older pieces made entirely from bark cloth, the original textile in this part of Sulawesi. Cotton fabric arrived with the Dutch in the first decade of the twentieth century and was quickly adopted. Bark cloth remained in use for ritual purposes. These blouses were worn by women for ceremonial occasions.

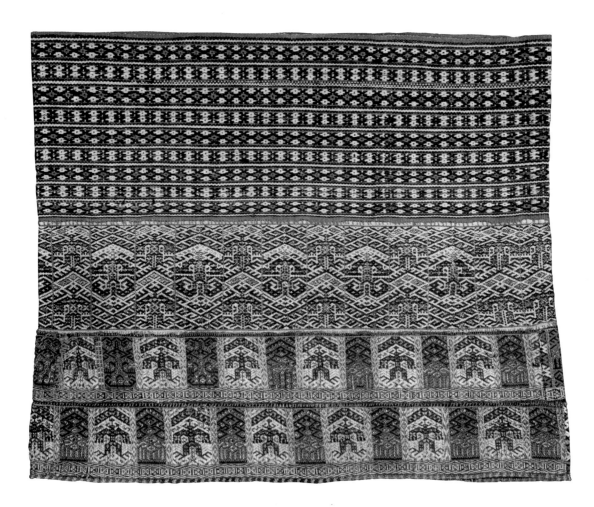

Skirt

Cotton, supplementary weft patterning
30 cm x 37 cm, 11¹³⁄₁₆ in x 14⁹⁄₁₆ in
c. 1930, Hainan Island, China, Li group
IFAF
FA.2006.22.7

These short skirts were woven in three separate sections on a small body tensioned loom in the interior mountains of Hainan Island. Little if nothing is published as to the meaning of the figurative humanoid motifs with wing-like arms and fanciful heads. Seen most clearly in the bottom two bands, they also appear in the middle red and blue section. Skirts were still being worn with long sleeved, pullover, embroidered blouses made from handwoven cotton or commercial cloth late in the twentieth century in remote areas of the island. The museum has begun acquiring pieces from Hainan Island—jackets, skirts, hair ornaments, and men's clothing—in the last five years.

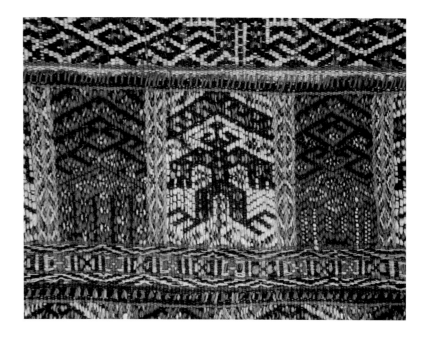

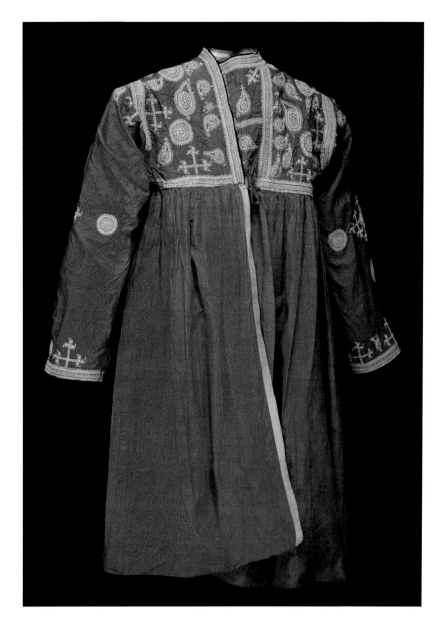

Child's dress

Silk, cotton, embroidered
74 cm x 118 cm, 29⅛ in x 46⁷⁄₁₆ in
c. 1900, Sindh Province, Pakistan
IFAF
FA.1976.3.9

Tiny straight stitches in white and blue silk floss creating flowers, medallions, and precise yet unidentifiable motifs embellish the yoke front and back and the sleeves of this child's *kurta*. The triangle at the back of the neck is a powerful amulet, while the other designs have a somehow mystical feel. The red silk of the bodice was lined with fine red cotton and then embroidered; the sleeves are attached at the shoulder with an underarm gusset. The unlined silk skirt was gathered and sewn to the top; the resulting seam was covered with rows of minute stitches. A very similar garment in the Victoria and Albert Museum is attributed to Shikarpur in northern Sindh.

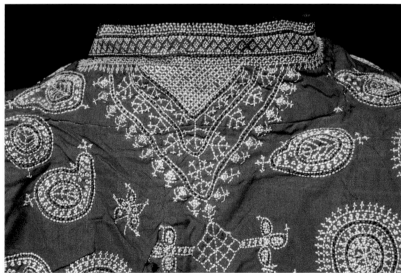

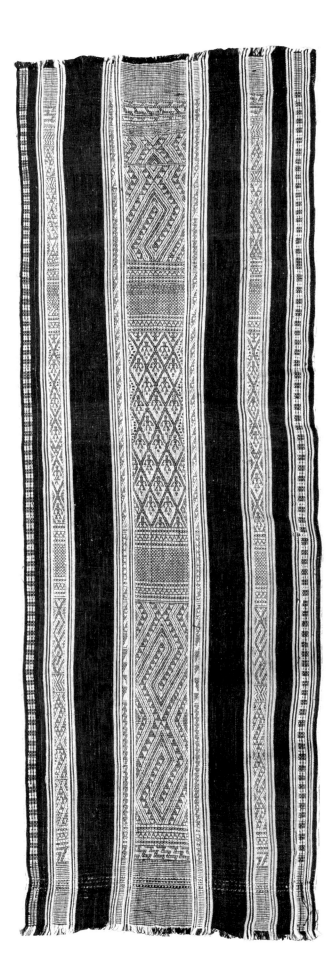

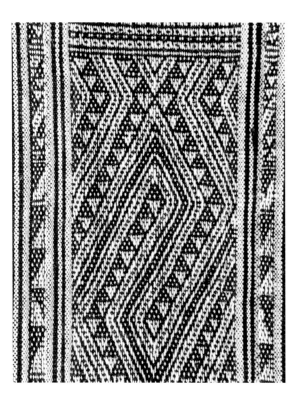

Skirt

Cotton, supplementary weft patterning
154 cm x 52.3 cm, 60⅝ in x 20⁹⁄₁₆ in
c. 1950, central highlands, Cambodia
Gift of Elizabeth Berry
A.1999.26.40

Tiny patterns proliferate on this wrapped skirt woven in a single width on a body tensioned loom. Immediately evident is the angular spiral shown in the detail; on closer inspection, triangles and diamonds appear as the building blocks of other patterns. Humanoid figures inhabit the diamonds in the center band, while the narrow side bands contain smaller versions of the center patterns. The use of only two colors enables a contrast of light and dark values and highlights the skill of the weaver who conceived of and executed this complex textile.

❁ Footwear ❁

ALTHOUGH PRIMARILY FUNCTIONAL, FOOTWEAR CAN ALSO BE FANTASTIC. At its most basic, footwear protects the feet from the hostile environment of thorns, stickers, insects, and sharp rocks. But it also conveys social position and status. Consider the situation of people who have no shoes at all. Although some footwear, such as the Saami boots and the Sioux moccasins, were made at home, professional cobblers made most shoes in the museum collections. Special tools are needed and skills are applied that not everyone has. They are still culturally identifiable and significant, some styles going back thousands of years in the same locality. Socks, on the other hand, are still hand-knitted for personal use even in many parts of the industrialized world, where they are readily available in stores.

Whether footwear was made by nonprofessionals or cobblers depends mostly on the materials used. More easily manipulated fibers such as birch bark or felt could be shaped to fit an individual foot. People developed techniques and styles to suit the conditions and materials available to them. Over time these styles became associated with a region or culture. Whether entirely functional or more elaborated over time, footwear became an essential part of a culturally prescribed ensemble.

Footwear made by professional shoemakers or cobblers tends to be made from harder-to-work materials such as stiff leather and wood. Local style preferences and functional needs are still important. Where weather conditions are harsh and much time is spent indoors in the winter, softer footwear is often used inside an outer boot and worn in the dwelling. Knitted socks and felted inner boots serve this purpose and are easily made at home with local materials. In parts of Balkan Europe, shoes are fairly generic, while the hand-knitted socks worn with them are identifiable by village, region, or ethnic group. This extremely local differentiation shows up in the colors and patterns used and how they're combined, the way the heel is turned, and the texture provided by stitch choice.

Socks and stockings are important where the weather dictates their need. Leg wrappings have been used to protect the legs and keep them warm as

Women's boots
Leather, silk, brass, wood, wool, embroidered
24 cm x 8 cm x 27 cm, 9⁷⁄₁₆ in x 3¹⁄₈ in x 10⁵⁄₈ in
Early twentieth century, Ersekosenad, Pest County, Hungary
Gift of Miss Juana de Laban
FA.1955.16.46

These elegant boots incorporate many decorative techniques, including embroidery on the outer velvet covering of the upper and cut-outs that reveal a red underlayer. Brass brads and bells decorate the quarter; the wooden heel is painted red. These boots would have been worn at the wedding and afterward by a married woman.

well as providing another surface for embroidery and embellishment. In tropical places, children often go barefoot until school age, especially in a village situation where money for purchasing quickly outgrown shoes is scarce. In this industrial age, cheap plastic footwear is ubiquitous.

Styles change in ethnic dress in the same way they change in cosmopolitan dress. Tall leather boots were worn by the gentry in Hungary, associated with horsemanship, and probably introduced during the Ottoman period (1541–c. 1699). The style was adopted by villagers in the nineteenth century—a time of increasing prosperity and great elaboration in rural dress. Illustrations of Hungarian village dress show women in plain leather boots reaching the calf or the knee. The boots shown on page 157 might indicate a style brought from the nearby city of Pest, a local innovation on a cobbler's part, or an evolution based on previously existing footwear. Footwear follows fashion as much as any other type of dress.

To today's eye and sensibilities much of what is included in this section looks pretty uncomfortable to wear. Comfort is a learned notion, one that is as rooted in culture as language and food ways. More importantly, a conventional notion of comfort is not always high on the list of reasons for using something. While a patten, an overshoe or attachment to the sole of a shoe that elevated the wearer, was used to negotiate muddy streets, modern stilettos have no function other than to enhance the wearer's appearance and are rarely called comfortable. Keep that in mind as you turn these pages.

Child's shoes
Wood, leather, carved, tooled
11 cm x 7 cm x 20 cm, 4⁵⁄₁₆ in
x 2¾ in x 7⅞ in
1912, France
Given in memory of my mother, Edwina Dean Skubi, by Tonia Skubi Clark
A.2004.26.1v

These shoes were brought back from France by an uncle of the donor. The original leather laces have long ago disappeared. The shoes were made for local wear, not for sale to a tourist.

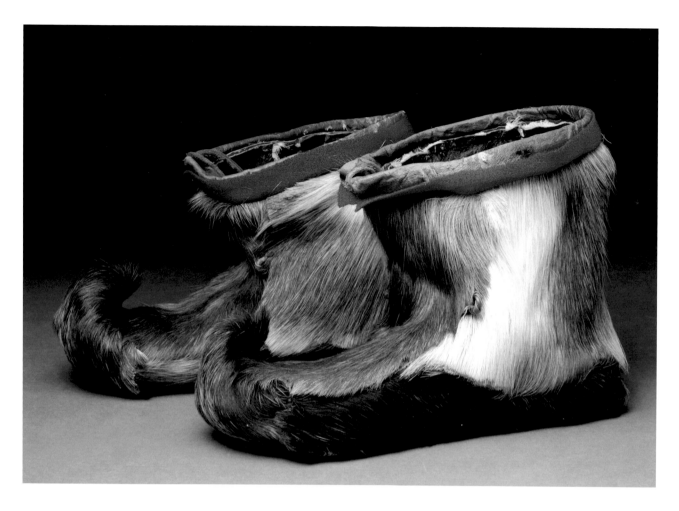

Boots

Reindeer hide, leather, wool
19 cm x 10 cm x 28 cm, 7 1/2 in x 3 15/16 in x 11 in
1968, Kautokeino, Norway, Saami group
Gift of Berit Aaker Pietsch
A.1978.32.1

Saami reindeer herders of northern Norway, Sweden, and
Finland all make boots with upturned toes, a style that helps
hold the boots on skis. Boots were worn stuffed with grass to
keep the feet warm. Socks were unnecessary. Narrow woven
ties would be wrapped around the ankle to keep the boots snug.

Gaiters, *botines*

Leather, metal, rawhide, stitched, appliquéd
37.5 cm, 14 3/4 in height
n.d., Spain, IFAF
FA.1963.13.183

Gaiters, or leggings, were worn all over Spain well into the
twentieth century in some parts of the country. They were asso-
ciated with herders and horsemen and protected the lower leg
when pants often stopped at the knee. The use of cloth or
leather leggings grew from the earlier practice of wrapping the
leg in strips of cloth. The diminutive size of these *botines* proba-
bly means they were made for a child or young man for a fiesta.
Decorative stitching, studs, and fringe add to the festive effect.

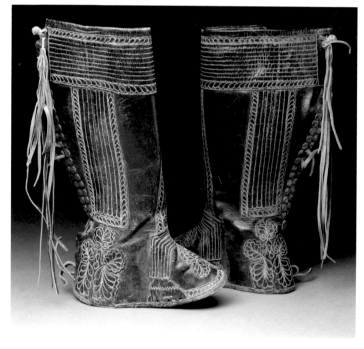

Below:

Bath shoes, *nalin*

Wood, metal, velvet, carved, repoussé, wire inlay
14 cm x 6 cm x 23 cm, 5$\frac{1}{2}$ in x 2$\frac{3}{8}$ in x 9$\frac{1}{16}$ in
Nineteenth century, Turkey
Gift of Florence Dibell Bartlett
A.1955.1.434

Known as *nalin* in Turkey and *kabkab* in Syria, shoes like this were worn when women went to the *hamam*, or public bath. They raised the wearer off the wet floor. The level of decoration established her place in society. These are carved from one piece of wood with silver plaques on the foot bed, heel, and strap. The strap is lined with velvet and a brass band circles the foot. There is wire inlay on the heel and foot bed. Platform shoes called *chopines* were popular in Venice during the fifteenth century, a direct knock-off of the nalin.

Facing, above:

Socks

Wool, knitted
13 cm x 11 cm x 22.5 cm, 5$\frac{1}{8}$ in x 4$\frac{5}{16}$ in x 8$\frac{7}{8}$ in
c. 1960, Turkey
Gift of Mr. and Mrs. B. Blackman
A.1967.10.21

Thick, patterned, knit socks were a common article of dress among rural people from Iraq and Iran up into the Balkans and Eastern Europe. Knitting is an ancient art in Turkey, and female knitters have developed a special technique for creating multicolored patterning, a skill that is fast disappearing. Using simple color changes, the knitter of these socks has produced a dynamic and eye-catching pair.

Facing, below:

Wedding socks

Cotton, knitted
10 cm x 20 cm x 10 cm, 4 in x 8 in x 4 in
c. 1960, Turkey, Iraq, Iran, Syria, Kurdish group
Gift of Mr. and Mrs. Leland Wyman
FA.1970.18.2

These women's socks show floral motifs probably found in embroidery patterns. Unlike European or American hand-knit socks, they are finished at the top with a braided edge instead of ribbing.

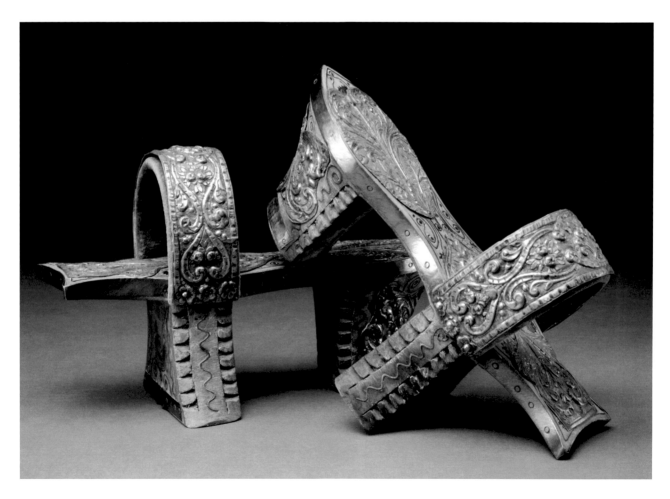

160 Dress

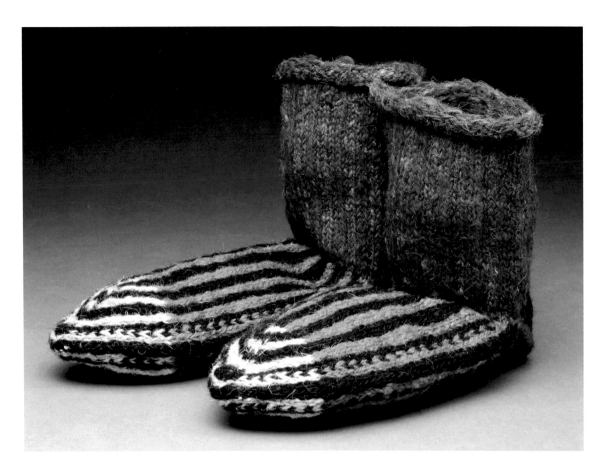

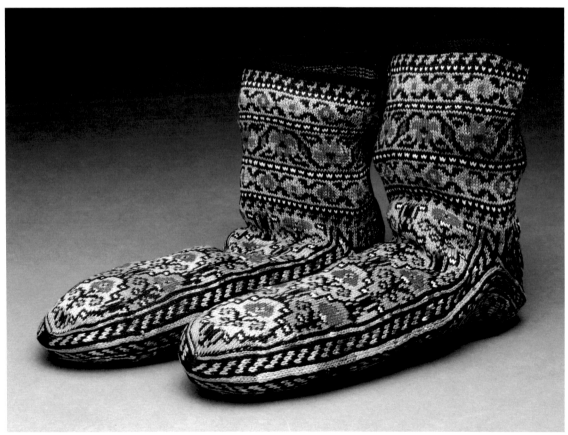

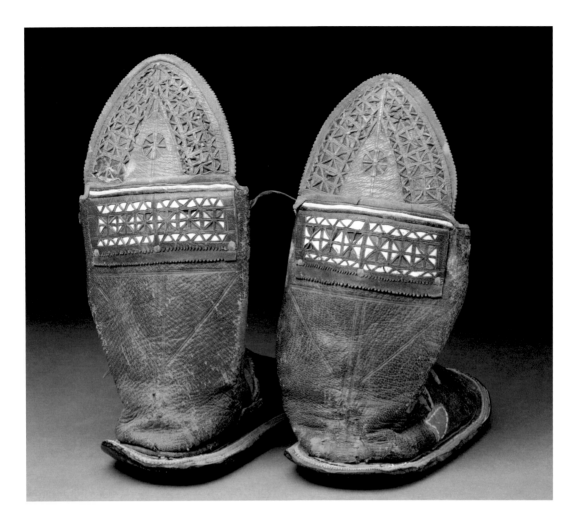

Shoes

Leather, cotton, rubber, cut work
25 cm x 11.5 cm x 25.5 cm,
9¹³⁄₁₆ in x 4½ in x 10 in
c. 1920, Anti-Atlas Mountains, Morocco,
Ida ou Nadif group
Gift of Guy Bellinx and Ivo Grammet
A.2001.32.1

Although from the back they look like boots, these are really more like a babouche or mule with a tall back attached at the heel. The front is open and the foot covered by the vamp. The shoes tie at the ankle. Although not as ornate as some women's shoes that have silk and metallic embroidery, these were probably worn on special occasions.

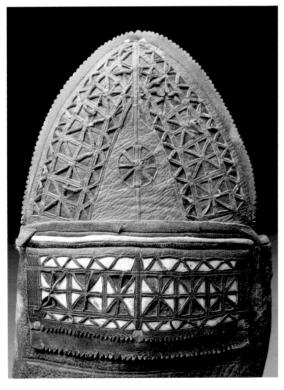

Right:

Shoes

Goat leather
25 cm x 7.5 cm, 9¹³⁄₁₆ in x 2¹⁵⁄₁₆ in
1950–1954, Northern Nigeria
Gift of Ruth Perry
A.1956.45.26

Appealing in their classic simplicity, these shoes could be worn today anywhere in the world. They were purchased by the donor from a cobbler in a northern Nigeria market town and were made for local use.

Below:

Moccasins

Leather, quills, glass beads
25 cm x 8.5 cm, 9¹³⁄₁₆ in x 3³⁄₈ in
c. 1890, Wyoming, Teton Sioux
Gift of Florence Dibell Bartlett
A.1955.1.916

Before European traders arrived on the continent, native people used quills of all sorts to decorate clothing and other items. Glass beads quickly replaced quills in many places, but some people, such as the Teton Sioux, continued to use quills in conjunction with beads into the twentieth century. The strip of leather on the top is called an ankle flap, a feature more common in women's moccasins.

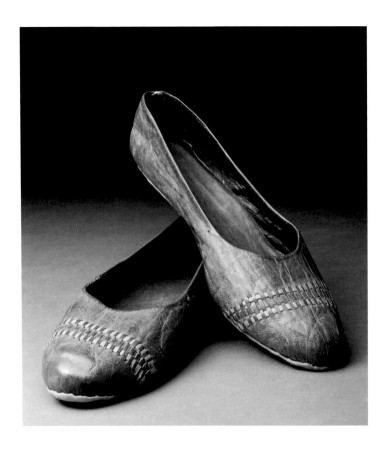

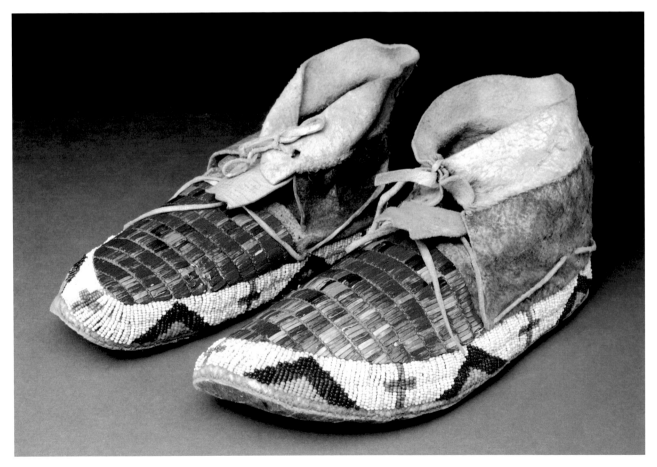

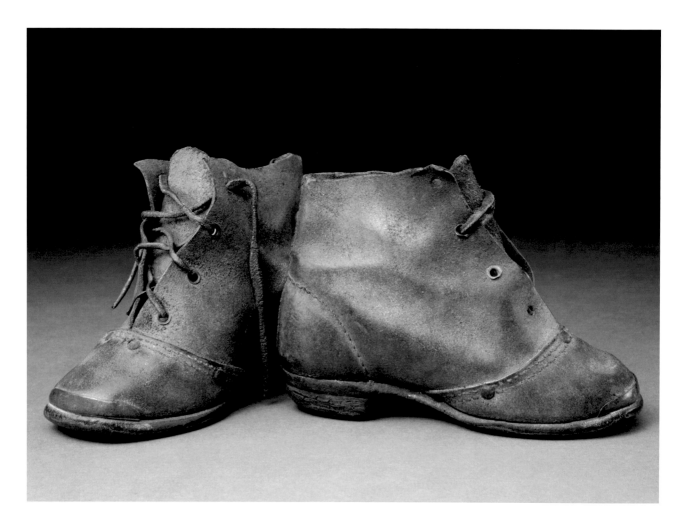

Child's shoes
Leather, wood, metal
9.5 cm x 5.5 cm x 5.5 cm, 3³⁄₄ in x 2³⁄₁₆ in x 2³⁄₁₆ in
Nineteenth century, Southern United States
IFAF
FA.1967.29.128

The soles of these shoes are held together with
wooden pegs and must have been seldom worn to
be in such good condition now. The toe is protected
by a copper strip. The uppers are sewn and grom-
meted.

Right:

Men's shoes, *caites*

Leather, nails
21.5 cm x 26 cm, 8½ in x 10 in
c. 1960, Zinacantan, Mexico, Tzotzil group
MNM purchase
A.1964.57.1

There are fourteen layers of leather on the sole of these *caites*, worn by men in the highlands of Chiapas. With a back of medium height, this pair is for everyday use. Caites with a higher back are worn on festival days. There are also caites with a back of just a few inches in the collection.

Below:

Ankle bindings, *wini*

Beads, string
Twentieth century, San Blas Islands,
Panama, Cuna group
Gift of J. M. Thorington
FA.1976.131.50

Wini are the strands of beads that San Blas women wrap around their arms and lower legs. When not worn, they are wrapped this way for storage. The beads are threaded on a string in such a way that they make the desired pattern when wrapped.

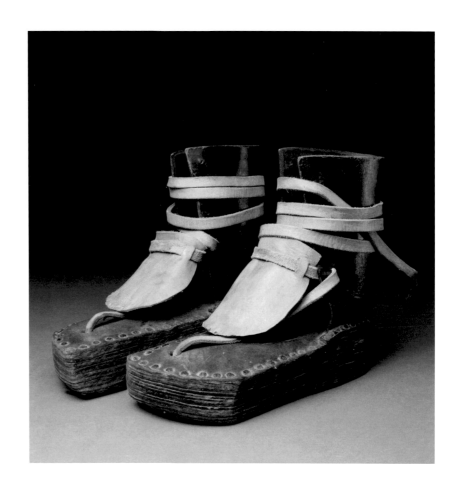

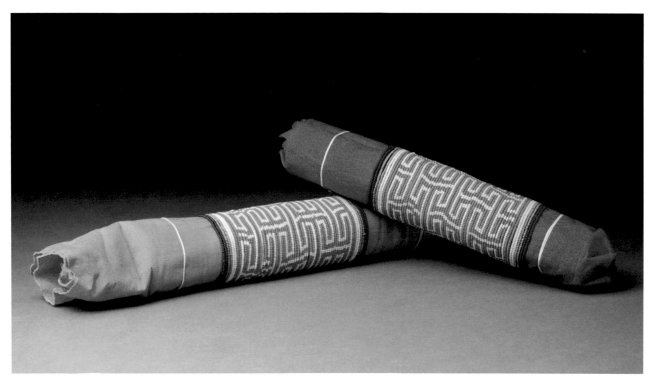

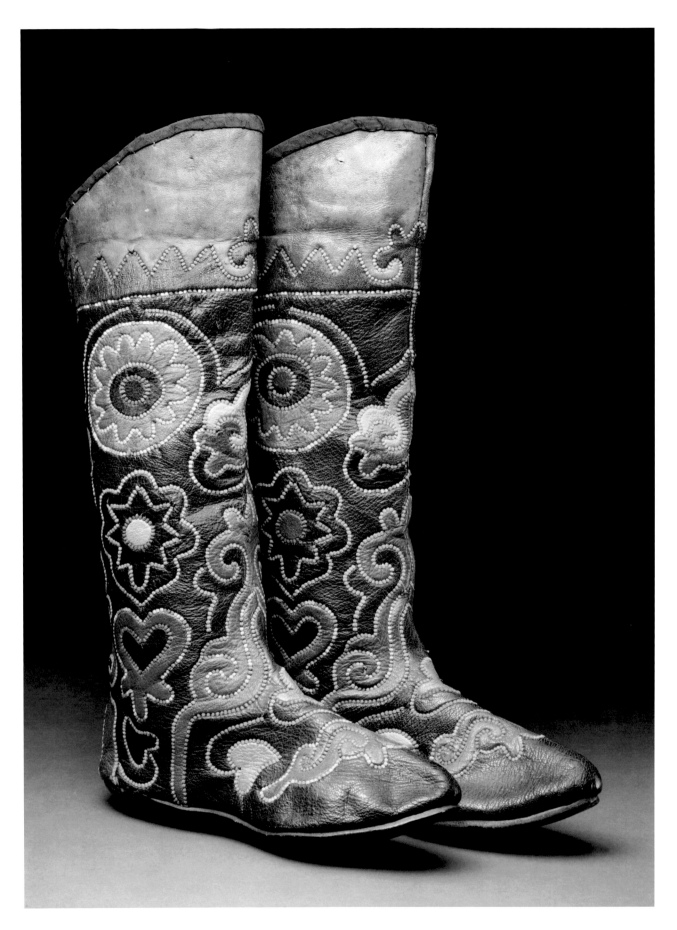

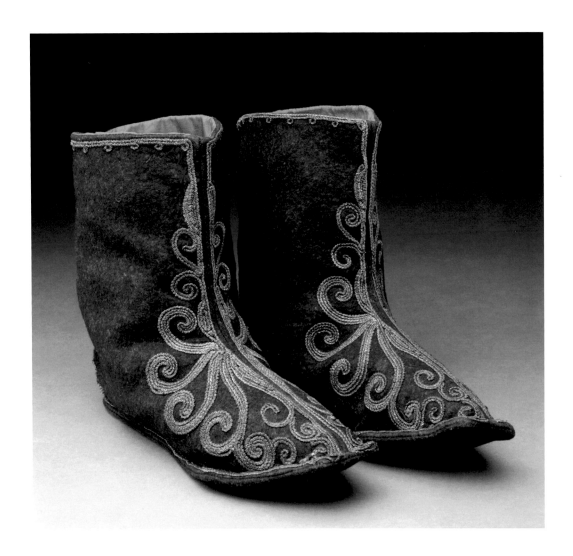

Facing:

Boots

Leather, cotton, embroidered, appliquéd
41 cm x 22.5 cm, 16⅛ in x 8⅞ in
Late nineteenth century, Central Asia
Gift of Mr. and Mrs. Blackman
A.1967.10.17

Soft leather boots such as these were worn by both urban and rural people in Central Asia. The appliquéd shapes are outlined with rows of stitches. When worn outside, an outer shoe with a platform sole and heel was worn over the boot to protect the soft leather sole.

Above and right:

Boots

Wool, silk, metallic thread, felted, embroidered
21.5 cm x 25 cm, 8⁷⁄₁₆ in x 9¹³⁄₁₆ in
n.d., Mongolia
Gift of Arturo and Paul Peralta Ramos
A.1956.22.51

Soft and warm, wool felt boots are worn inside the yurt and as inner boots when outside. These are lined with red silk and decorated with couching.

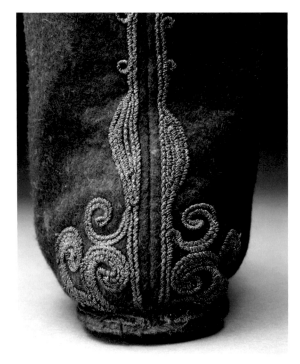

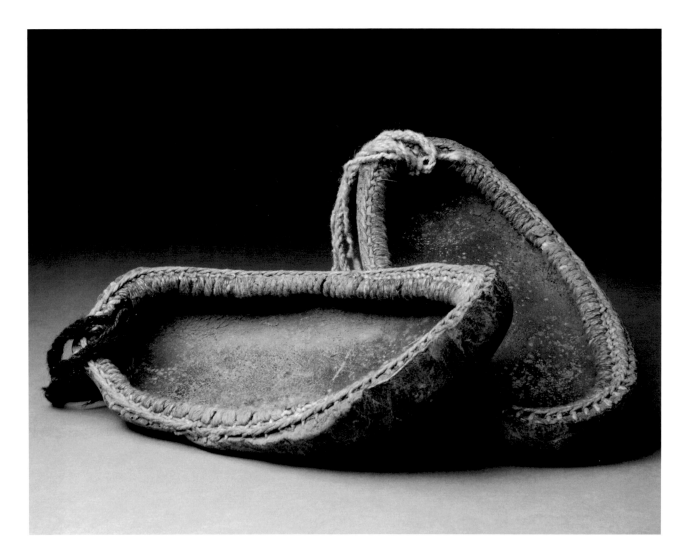

Shoes

Leather, wool
25.5 cm x 13 cm, 10$\frac{1}{16}$ in x 5$\frac{1}{8}$ in
c. 1930, Iran
Gift of Mrs. Eric Schroeder
A.1972.24.65

Shoes made of one piece of leather that was shaped while wet and stiffened as it dried are perhaps one of the oldest styles of footwear as well as the simplest. The edges are finished with a yarn binding, providing a somewhat softer surface against the skin. The ties at the back go around the ankle.

Boots

Leather, linen, metallic thread, tooled
16 cm x 11 cm x 26.5 cm, 6⁵⁄₁₆ in x 4⁵⁄₁₆ in x 10⁷⁄₁₆ in
n.d., Syria
Gift of Irene Fisher and Dr. Estella Warner
A.1956.11.1

Another ancient type of shoe, this example has its roots in the Hittite kingdom of the eighteenth through eleventh century BCE. The outer layer of the tassel yarns has faded to a soft purple, but the original color, a deep blue, can be seen underneath. The top of the tassel is wrapped with bundles of thread lightly wound with metal strips. A delicate punched design decorates the heel.

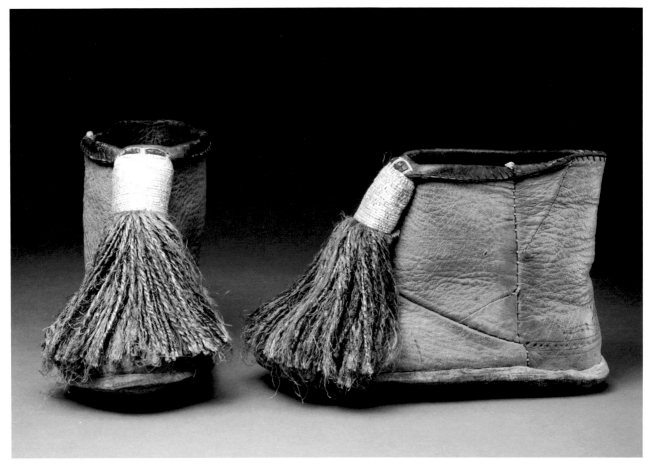

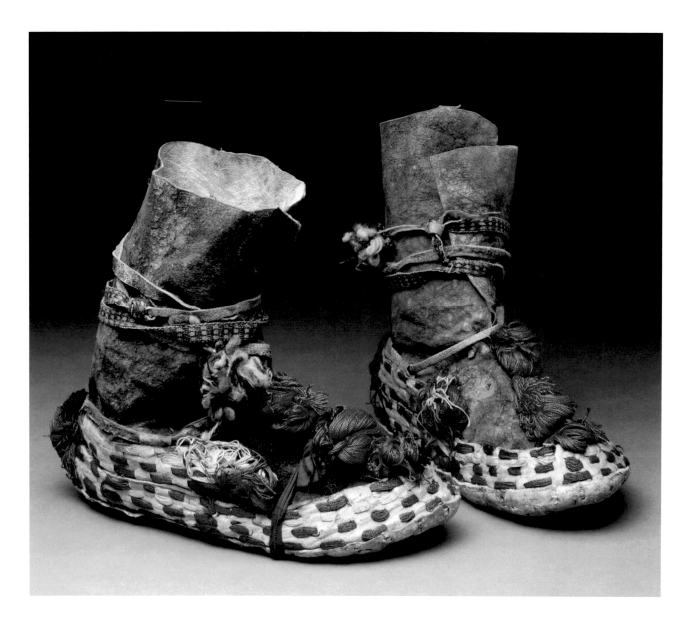

Men's boots

Leather, cotton
4 cm x 27 cm, 9$\frac{7}{16}$ in x 10$\frac{5}{8}$ in
c. 1960, Bumburet Valley, Pakistan, Kalash group
IFAF
FA.1980.47.20

When we took these boots out of their bag to photograph
them, we were nearly overcome by the odor of rancid leather.
Bundles of red and yellow thread are laced through the white
leather, and pom-poms are attached to the upper at the heel,
front, and each side. Narrow, woven tapes hold the boot
closed. The Kalash are a non-Muslim group living in the
remote valleys of Northwest Pakistan.

Sandals

Straw, braided, looped
24 cm, 9 $\frac{7}{16}$ in length
1945, Calicoan Island, Philippines
Gift of Kenneth Spiller
A.1958.26.1

Braided straw is sewn together to make the soles of these sandals. The vamp is looped construction, done with a needle or a hook. The pink color is faded. The center medallions must have been made and attached after the rest of the shoe was made. The donor notes in his letter, "The fact that some of the natives wore them at that time [1945] does not vouch for their authenticity. The great majority of them went barefoot!"

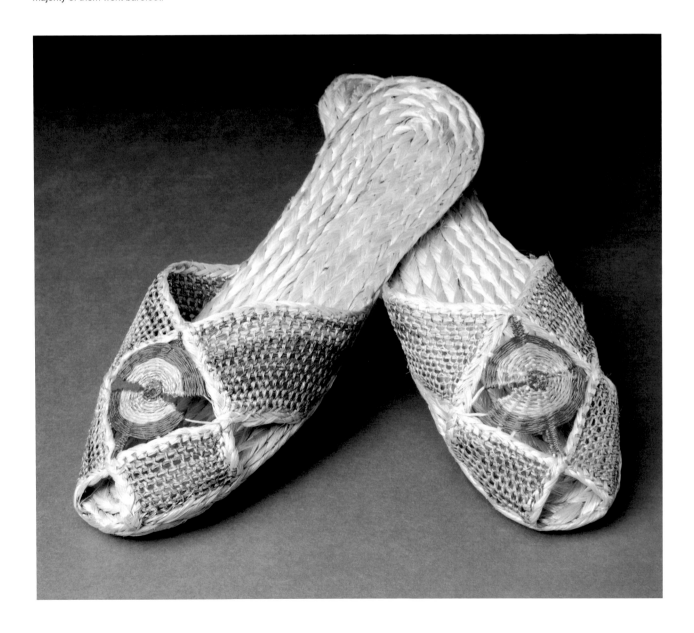

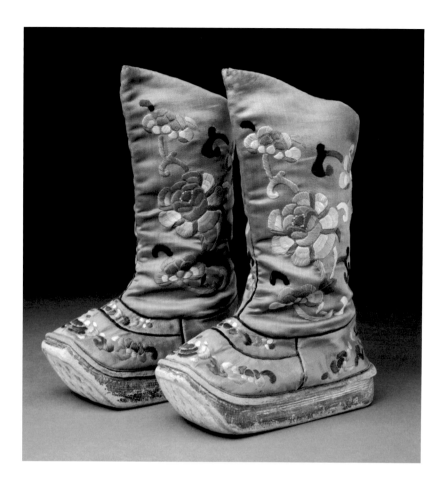

Child's boots

Silk, cotton, leather, embroidered
22.9 cm x 5.5 cm x 16.8 cm, 9 in x 2³⁄₁₆ in
x 6⁵⁄₈ in
c. 1915, China
Gift of Mrs. Dwight B. Heard
A.1949.1.106

The height and shape of the stiff soles of these boots are modeled on horseman's boots from Mongolia. It's not hard to imagine a small Chinese boy proudly stomping around in his first pair of cowboy boots. The fine silk embroidery is executed in satin stitch.

Child's shoes

Silk, embroidered
13 cm, 5¼ in length
c. 1900, China
Gift of Muriel Boone
A.1985.195.21

As on Chinese children's hats, animals are often depicted on shoes. We know the tiger is depicted here by the embroidered character for *king* on its forehead. Along with symbolizing hope for a prosperous future and for robust health, the big bulging eyes are meant to see trouble coming.

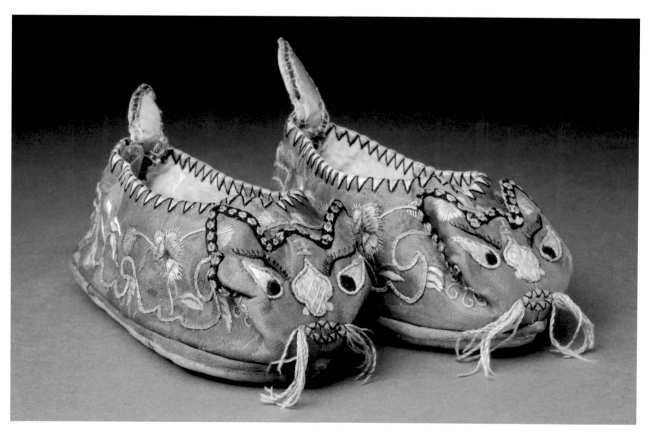

Right:

Child's shoes

Synthetic, cotton, sequins, embroidered
13 cm, 5¼ in length
c. 1990, China
IFAF
FA.1996.36.11

Although made with more contemporary materials, these shoes serve the same purpose as the older tiger shoes. Pigs symbolize abundance, richness, and sumptuousness to the Chinese.

Below:

Child's boots

Rice straw, cotton, plaited
14 cm, 5½ in length
c. 1950, Japan
Gift of Mrs. Charles Meech
A.1983.1.311

Rice straw has been used to make many kinds of shoes in Japan for centuries. These would be winter shoes for a child. They have a cuff of ikat-patterned cotton cloth at the ankle.

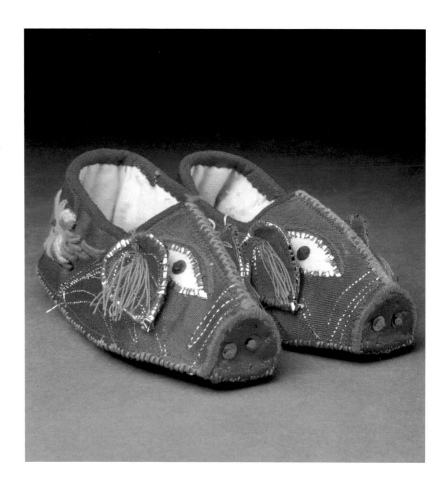

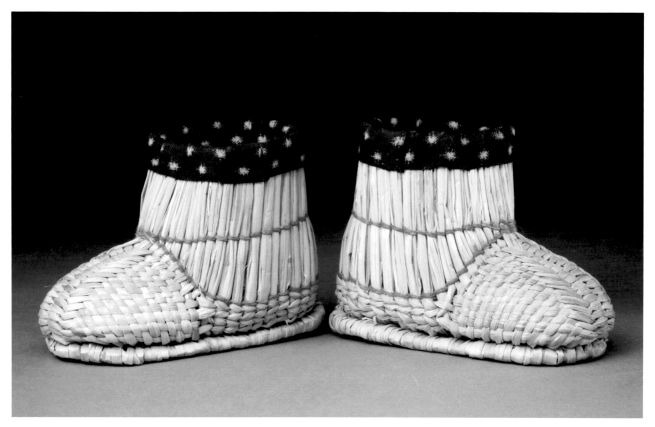

❁ Accessories ❁

ACCESSORIES ARE NOT MAIN GARMENTS BUT ARE THE DETAILS OF DRESS. Head- and footwear could have been included in this category since they are not major garments either, but their visual qualities seem well served with individual sections. Belts, bags, aprons, gloves, and mittens are included here along with a few other items. Some of these items are still worn and others have long ago disappeared from everyday life.

Small accessories such as belts have a very functional aspect. In many places, zippers and other fasteners are not used, so clothing is held up and together by a belt or sash. Belts are often made with different techniques than wider textiles. The finger woven sash from Quebec on page 196 shows a very old and simple technique that doesn't require a loom yet produces a complex-looking fabric. Card and inkle looms are limited in the width of cloth they can produce, as are single heddle ribbon looms. In other places, the same weaving techniques are used but on a narrower loom. This is especially true of the belts and sashes from the Andes. The same patterns associated with the wider fabrics woven on the back strap loom are seen as well. Sometimes the types of belts and sashes are different for men and women, and sometimes they are the same. The Kuba belt pictured on page 191 is an example of a gender-differentiated belt used for special occasions, while the belts from Guatemala are everyday items of dress.

Bags are needed to carry all manner of items, from small change to large loads. Similar to belts, the bags that are woven can use the same materials and techniques as the cloth woven by a cultural group. Alternatively, in cotton-growing Nigeria, we show a bag made from raphia, a fiber extracted from the leaf of the raphia palm (see page 193). The removable pocket shown on the Delsbo ensemble on page 229 is another form of bag. Although called a pocket, it is not a part of a garment but is separate and worn hooked over the belt. In fact, all pockets were separate from garments until the late eighteenth century.

Not all people use bags to carry things. In some places, personal items are tucked into a wide waistband or sash or tied into a corner of a wrapped

Cape
Wool, silk, metallic thread, appliquéd, embroidered
48.5 cm,19 in length
c. 1900, Spain
Gift of Florence Dibell Bartlett
A.1955.1.75

Collected in 1925 in Gibraltar, this women's cape, said to be from Andalucia, is embellished with couching, stem, and straight stitches, embroidered rickrack, tape trim, and appliqué.

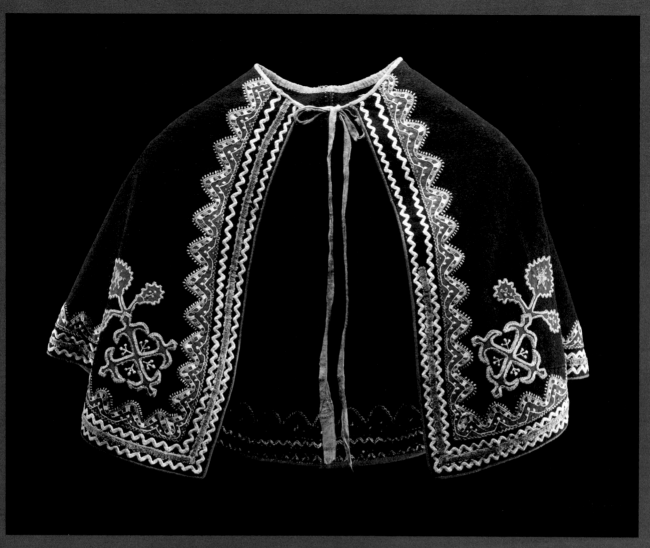

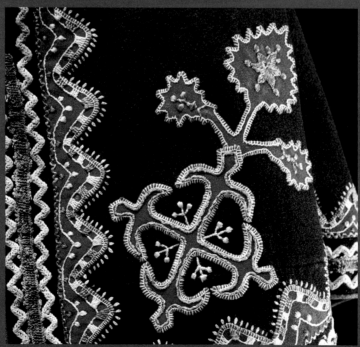

garment, while large items are carried in a basket on the head or on the back. Wrapping cloths for carrying things are discussed in the dwelling section.

Mittens and gloves are meant to protect the hands from cold or exposure, so they are seldom used in warm climates except in a ceremonial setting. Aprons, on the other hand, are very widespread; the word covers many different types of garment. Some are worn over a skirt or trousers and others are the only lower garment worn. Aprons are very symbolic and evocative, whether displaying designs and motifs typical of a village or culture, covering a private part of the body, signifying a profession, or protecting the wearer's clothing from stains.

Apron
Wool, metallic tape, woven, embroidered, split ply braiding, crocheted
56 cm x 58 cm, 22$\frac{1}{16}$ in x 22$\frac{13}{16}$ in
c. 1960, Thrace, Greece,
Sarakatsani group
Gift of Betsy Carpenter
A.2001.45.3

Three narrow panels of cloth were sewn together to make the central section of this apron. The motifs were embroidered in cross-stitch, gold tape was attached, and a split ply border (a technique done with a needle), was added around the entire apron. Tiny picots surround the edge on three sides. The Sarakatsani were the last nomadic group in this area to settle in towns during World War II.

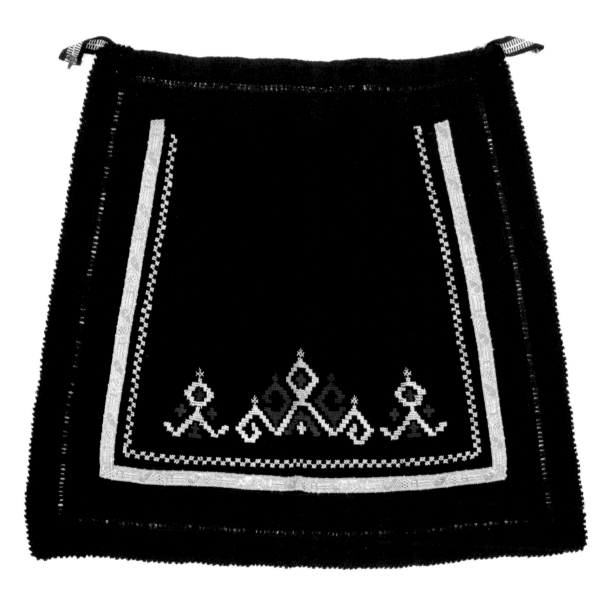

Apron

Cotton, wool, linen, printed,
embroidered, machine lace
73.5 cm x 58.5 cm, 28$^{15}/_{16}$ in
x 23$^1/_{16}$ in
c. 1900, Piešťany, Slovakia
Gift of Miss Florence Weaver
FA.1956.34.13

Indigo block printing was a cottage industry in Slovakia from the
mid-eighteenth century into the twentieth. The indigo was imported
from India. The owner of the apron purchased the printed fabric,
embroidered the top, and attached the purchased lace to the bottom.
Indigo block print fabric was also used for skirts, tablecloths, and bedding,
and continues as a cottage industry in a few Slovakian villages today.

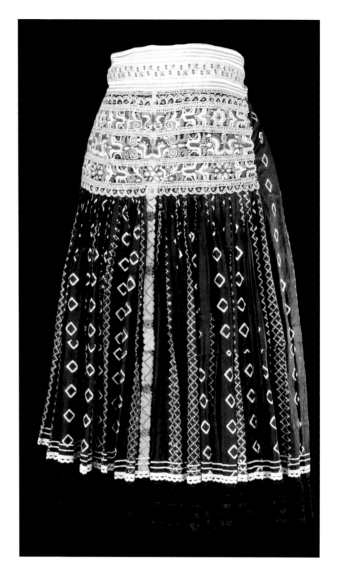

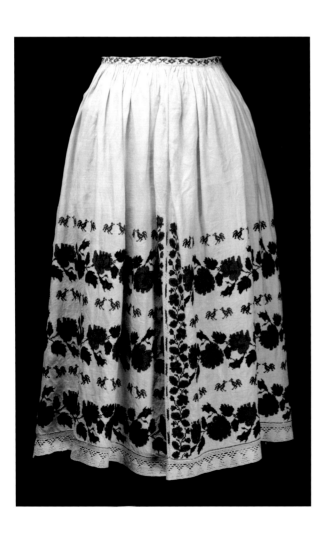

Apron

Linen, embroidered, crocheted
71 cm x 98 cm, 27$^{15}/_{16}$ in x 38$^9/_{16}$ in
1900–1950, Kiev, Ukraine
Gift of Mrs. Dwight B. Heard
A.1949.1.80

There are many different types of embroidery done in the Ukraine, but
the cross-stitched flowers in red and black from Kiev are perhaps the
most recognizable. Aprons were an essential component of dress for
females of all ages in Ukraine. The apron is made from two pieces of
linen crocheted together, with a band of crocheted lace along the bottom.

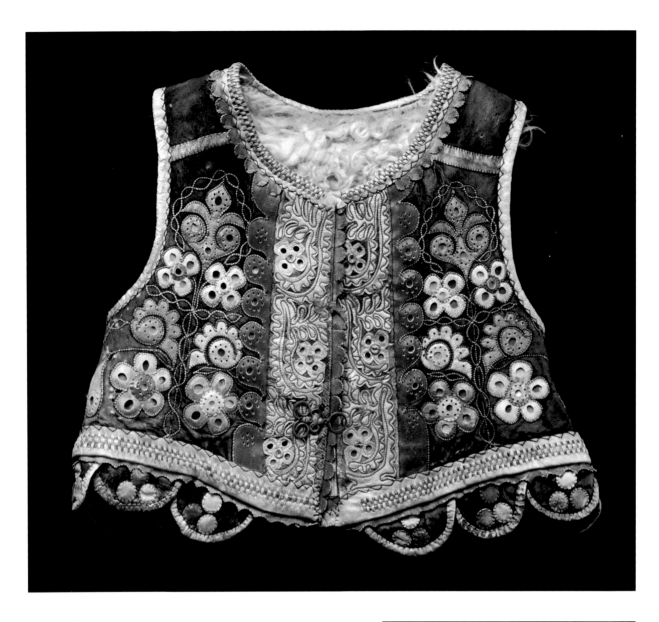

Woman's vest

Sheepskin, leather, wool, mirrors, appliquéd
34 cm x 28 cm, 13⅜ in x 11 in
c. 1880, Southern Transdanubia region, Hungary
Gift of Helen Walker Hansen
A.1955.78.3

Leather vests and jackets were worn all over Hungary by both men and women and are some of the most ancient types of clothing. Vests and jackets were worn by women, while men also had the sheepskin cape called *suba*. Garments from Southern Transdanubia are the only ones that are decorated solely with leather appliqué. Leather- and fur-trimmed vests were also used in Russia, Romania, the Balkans, and Greece.

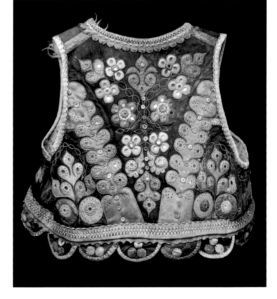

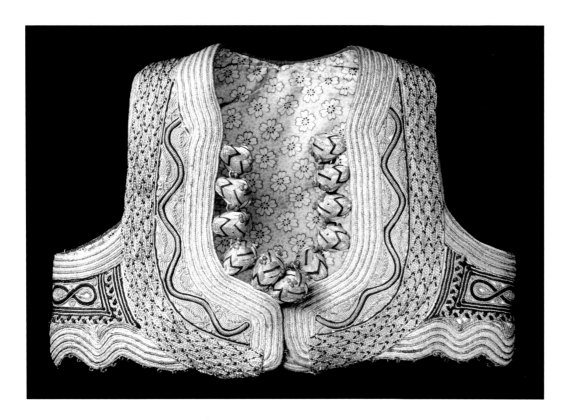

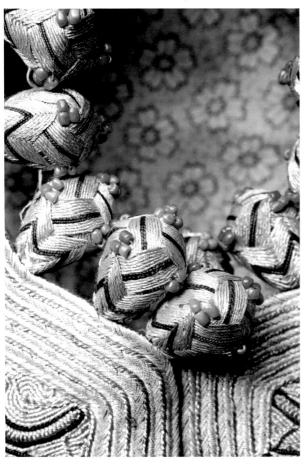

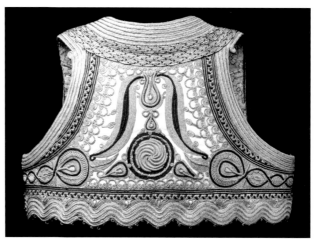

Woman's vest

Wool, cotton, silk, metallic thread, coral, embroidered
28 cm x 38 cm, 11 in x 14$^{15}/_{16}$ in
1875–1925, Montenegro
Gift of Mrs. Frank Hibben
A.1978.2.6

This vest is an example of urban dress that was heavily influenced by Ottoman style. This type of garment, couched with metallic thread, lined with cotton print, and sporting decorative buttons, was worn all over the Balkans, Greece, and Turkey during the Ottoman period. It was probably produced by professional embroiderers. Like other parts of the former Yugoslavia, urban dress was more cosmopolitan, while rural or village dress retained ancient local elements.

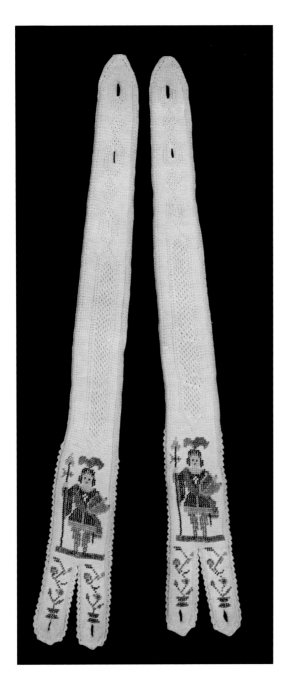

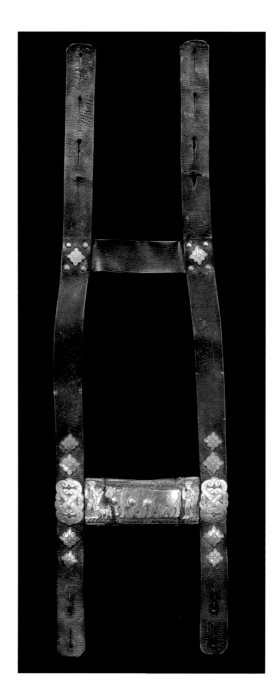

Suspenders

Cotton, linen, glass beads, knitted
61 cm, 24 in length
c. 1800, Florence, Italy
Gift of the Girard Foundation
A.1984.153.714

This charming example of knitting includes bead knitting, where tiny glass beads were strung on the yarn and knitted, creating a guardsman and flowers on each suspender. They are backed with linen fabric and sized for a boy.

Braces

Leather, brass
72.5 cm x 21.5 cm, 28⁹/₁₆ in x 8⁷/₁₆ in
c. 1850, Appenzell, Switzerland
Gift of Dr. J. Monroe Thorington
FA.1970.33.95

Leather braces were worn every day and for special occasions by dairymen and herders in the Appenzell and Saint Gall mountain regions of northern Switzerland. The imagery on these braces of herders wearing similar braces reinforces the importance of this regional item of dress. Other similarly deco-rated pieces in the collection are shoe buckles, a tobacco pouch, and an earring in the shape of a milk ladle, all worn by men.

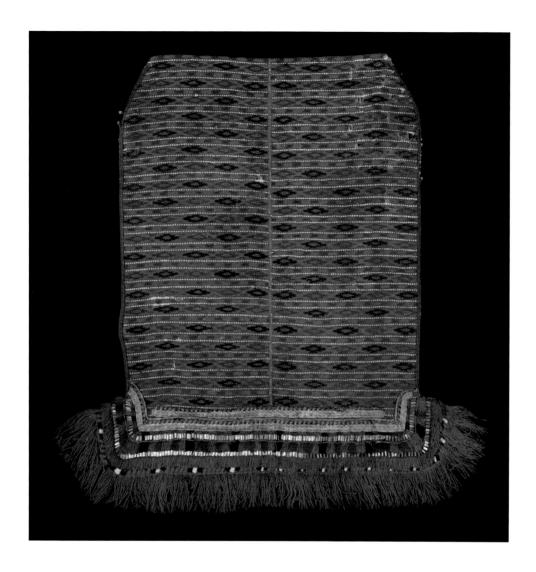

Apron

Wool, brass, metallic tape, tapestry technique, applied trim
84 cm x 82 cm, 33¹/₁₆ in x 32⁵/₁₆ in
1875–1925, Prilepsko Pole, Macedonia
Gift of Mrs. Frank Hibben
A.1978.2.5

This wedding apron was woven in two pieces and seamed in the center. The detail shows the elaborate treatment of the fringe. A plainer apron was worn every day. "Prilepsko Pole" means the villages outside the city of Prilep, in central Macedonia. Although not in the best condition, this is a very fine example, impossible to find today.

Belts

Leather, goose quills, wool, metallic thread, embroidered

98 cm x 9.2 cm, 38$\frac{9}{16}$ in x 3$\frac{5}{8}$ in and

91.2 cm x 11.3 cm, 35$\frac{7}{8}$ in x 4$\frac{7}{16}$ in

c. 1850 and 1833, Austria

Gift of the Girard Foundation

A.1981.2.624 & 742

Quill embroidery on men's belts was common throughout Central
Europe. The narrow belt includes wool and metallic thread embroidery
and the words "Guten Morgen." The wider belt is dated 1833.

Mittens

Ida Valotinen

Wool, nålbinding

29 cm x 11 cm, 11⁷⁄₁₆ in x 4⁵⁄₁₆ in

c. 1962, Mekrijervi, Finland, Saami group

IFAF

FA.1966.21.73 AB

Nålbinding is an ancient technique of looping using an eyed needle. It creates a very dense fabric that resists penetration by wind and water, perfect for use in the Arctic. Knitted mittens were considered inferior; having a nålbinding pair proved someone loved you.

Facing:

Mittens

Wool, knitted, embroidered
25.5 cm x 8.5 cm, 10¹⁄₁₆ in x 3³⁄₈ in
n.d., Sweden or Norway
Gift of Mrs. Dwight B. Heard
A.1949.1.71

Embroidered mittens were common in Norway and Sweden
in the eighteenth and nineteenth centuries. Often, the mitten
was fulled after knitting, resulting in a firmer canvas for easier
embroidery. These were not fulled and show the great skill of
the needlewoman who produced regular stitches on a
stretchy background.

Above:

Mitts

Leather, silk, sequins, embroidered
13.5 cm x 10 cm, 5⁵⁄₁₆ in x 3¹⁵⁄₁₆ in
Twentieth century, Eda, Sweden
Gift of Florence Dibell Bartlett
A.1955.86.61

Herringbone and long straight stitch decorate these
half mitts worn by women on festive occasions.

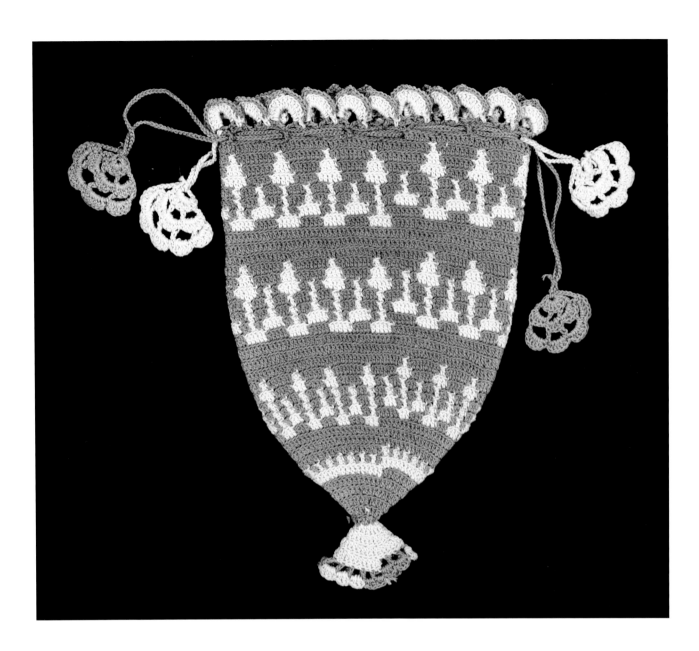

Facing:

Sash, *uçkur*

Cotton, silk, metal strips, metallic thread, embroidered
202 cm x 35 cm, 79½ in x 13¾ in
Nineteenth century, Turkey
Gift of Mr. and Mrs. Gordon Campbell
A.1980.92.10

Sashes were worn by women and men to hold coats closed
and to ornament the waist. Along with satin stitch in silk, this
piece is embroidered with flattened metal strips. Graceful
floral sprays were prevalent in Ottoman period embroidery.

Above:

Bag

Cotton, crocheted
16 cm x 10.5 cm, 6⁵⁄₁₆ in x 4⅛ in
c. 1900, Turkey
IFAF
FA.1987.190.43

Small bags of different shapes and sizes were made by girls
and women for their personal use. Cotton is the most
common fiber used to make the bags in our collection, but
we also have bags made with silk and metallic thread.

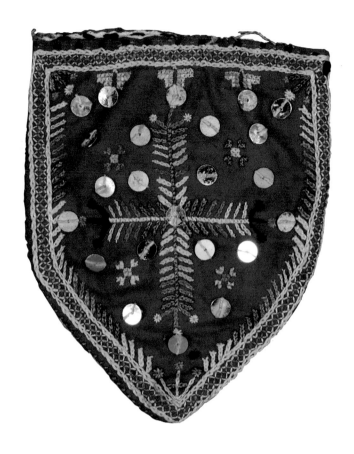

Left:

Bag

Cotton, sequins, embroidered

13 cm x 10.5 cm, 5⅛ in x 4⅛ in

c. 1900, Turkey

IFAF

FA.1987.190.51

Fabric pouches presented a canvas to embroider. This one uses chain, cross, and straight stitches.

Below left:

Bag

Metallic thread, crocheted

14.5 cm x 10.5 cm, 5¹¹⁄₁₆ in x 4⅛ in

c. 1900, Turkey

IFAF

FA.1987.190.46

Below right:

Bag

Cotton, glass beads, crocheted

18 cm x 8 cm, 7¹⁄₁₆ in x 3⅛ in

c. 1900, Turkey

IFAF

FA.1987.190.50

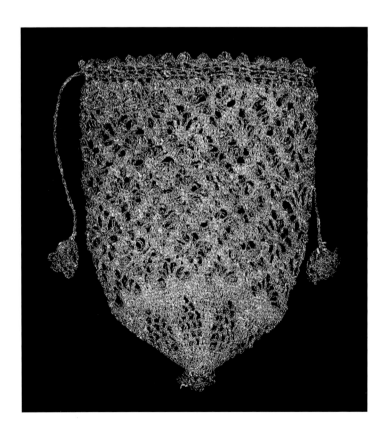

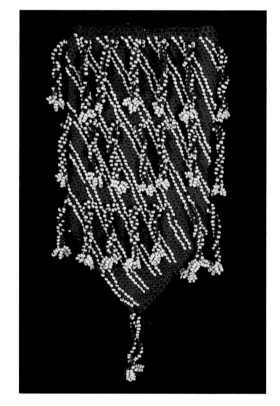

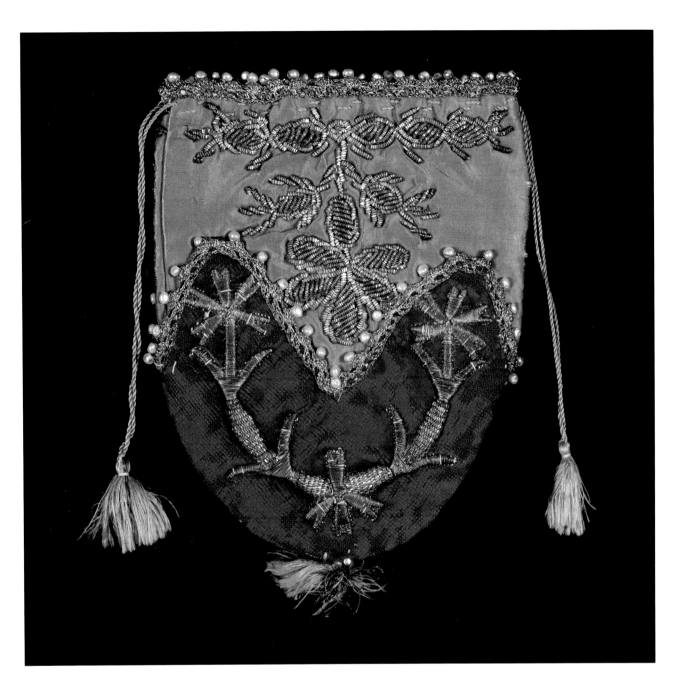

Bag

Silk, cotton, metallic thread, metal strips,
pearls, embroidered
15 cm x 10.5 cm, 5⅞ in x 4⅛ in
c. 1900, Turkey
IFAF
FA.1987.190.48

There are three different metal embroidery
techniques on this small bag.

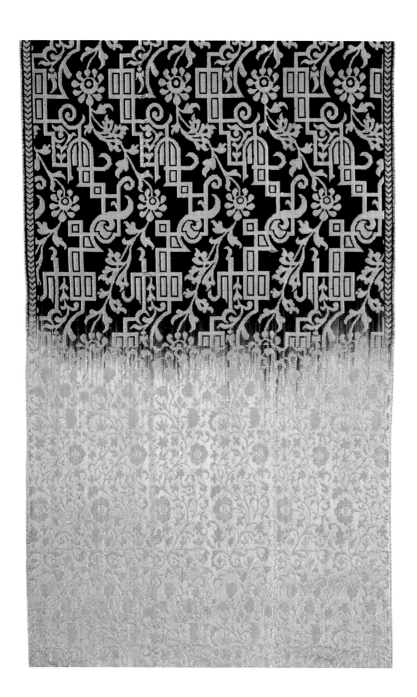

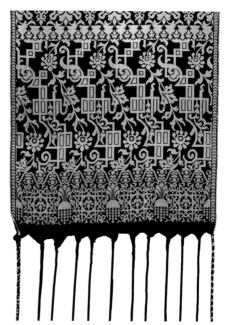

Wedding belt

Silk

380 cm x 36 cm, 149⅝ in x 14³⁄₁₆ in

c. 1830, Fez, Morocco

Gift of Florence Dibell Bartlett

A.1955.1.346

Wedding belts were wrapped around the waist of the Moroccan bride to create a very straight silhouette. Woven on a draw loom by professional weavers, they were treasured family pieces. This belt is a different color on each end, allowing the bride to coordinate the belt with her caftan. It is ornamented on each end with a row of motifs called *khamsa*, meaning five, or the Hand of Fatima, a symbol that predates any of the monotheistic religions and is used to protect against the evil eye.

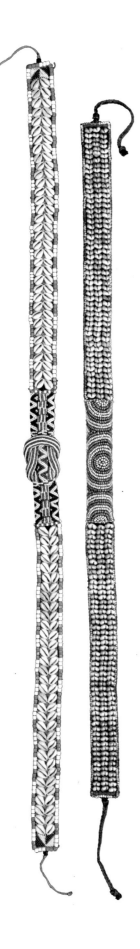

Belts

Raphia, cowry shells, glass beads
137 cm x 6.5 cm, 54 in x 2¹⁄₂ in; 127 cm x 7.6 cm, 50 in x 3 in
Twentieth century, Zaire (Democratic Republic of Congo), Kuba group
Gift of Lloyd E. Cotsen and the Neutrogena Corporation
A.1995.93.190; A.1995.93.194

Narrow beaded belts are worn by Kuba women. Men wear a wider belt decorated in a different style. Glass beads, a trade item from Europe, were associated with wealth and privilege. Their use on these belts make them status pieces.

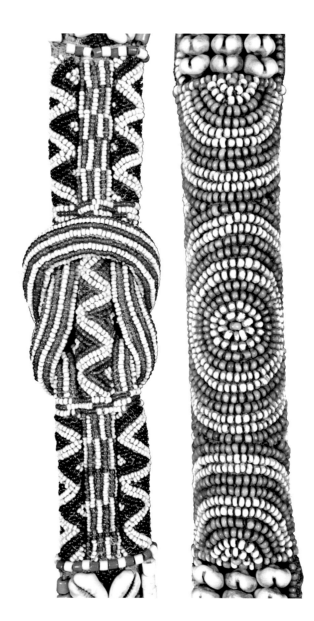

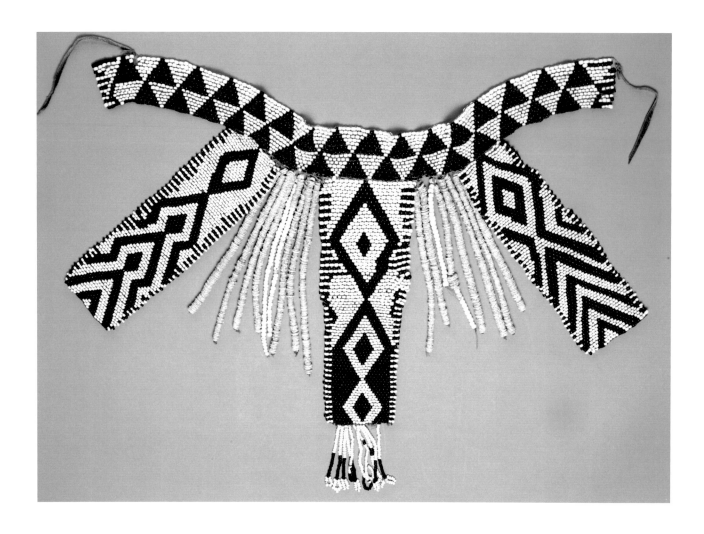

Girdle

Glass beads, sinew, ostrich shell, leather
42 cm x 4 cm, 16½ in x 25⅕ in
Twentieth century, Botswana, Bayei or
Hambukushu group
Gift of the Girard Foundation
A.1982.30.584

This girdle was worn over a leather half skirt by Bayei or Hambukushu Kavango women in Northeast Botswana, along with a rectangular front apron. The dark beads are actually blue with quite a bit of grime on them. Girdles were presented to a girl at puberty by her grandmother and worn on important occasions. A headpiece made from plant fibers and beads completed the outfit. Ostrich shell beads were locally made, while the glass beads originated in Europe and have been a trade item since the seventeenth century. A few strands of the shell beads have been replaced. The beads are strung on sinew and woven together by hand. This is one of several pieces from Botswana in addition to other southern African beadwork pieces in the collection.

Bag

Raphia, plaited
27 cm x 16 cm, 10 in x 6½ in
c. 1850, Nigeria
Gift of Allison Abbott
A.2006.89.9

This bag sports an ingenious closure. The center strap extends down the back of the bag, allowing the top to open only as far as the bottom bobble permits. The fringe and other bobbles are purely decorative.

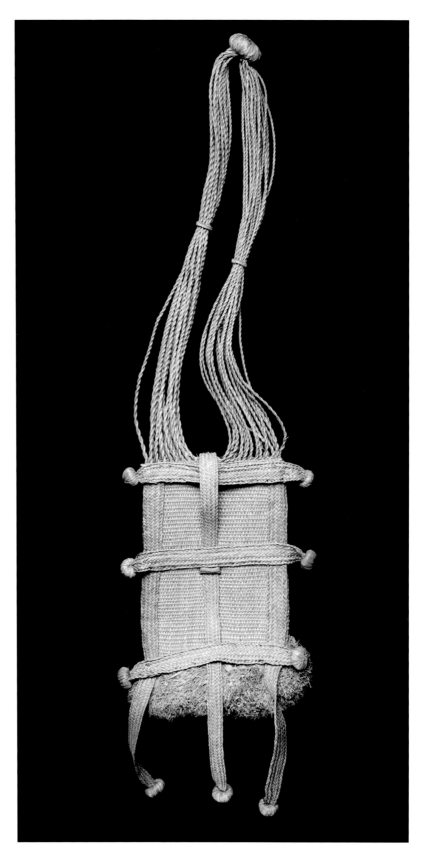

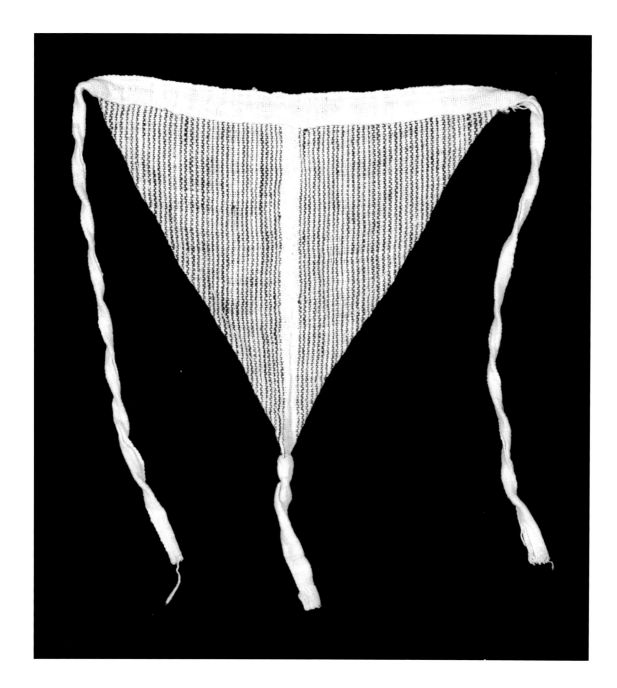

Undergarment

Cotton
25 cm x 27 cm, 9¹³⁄₁₆ in x 10⅝ in
Twentieth century, Nigeria
Gift of Sam C. Thornburg
A.1975.12.30

This type of undergarment is worn by northern Nigerian boys until puberty. Purchased new by the donor, it is a humble garment not found in many museums but is right in place in this collection. It is handwoven from hand-spun cotton yarn in a simple stripe pattern and made from two strips of cloth. The waistband and ties are a separate band. Called *bante* by the Hausa of northern Nigeria, the garment is also worn in Niger, Burkina Faso, and northern Ghana.

Fan

Feathers, leather, glass beads, cotton
78.5 cm, 30⅞ in length
c. 1910, Wyoming, Teton Sioux
Gift of Florence Dibell Bartlett
A.1955.1.901

Eagle feather fans, made from the entire wing or tail, were carried by Plains Indian men of age and status. The eagle was regarded as sacred, thus its feathers were particularly valued. A whole language of feather symbolism developed that expressed the exploits of a man in the realm of bravery in war. Specific groups had their own systems, though the concept was widespread.

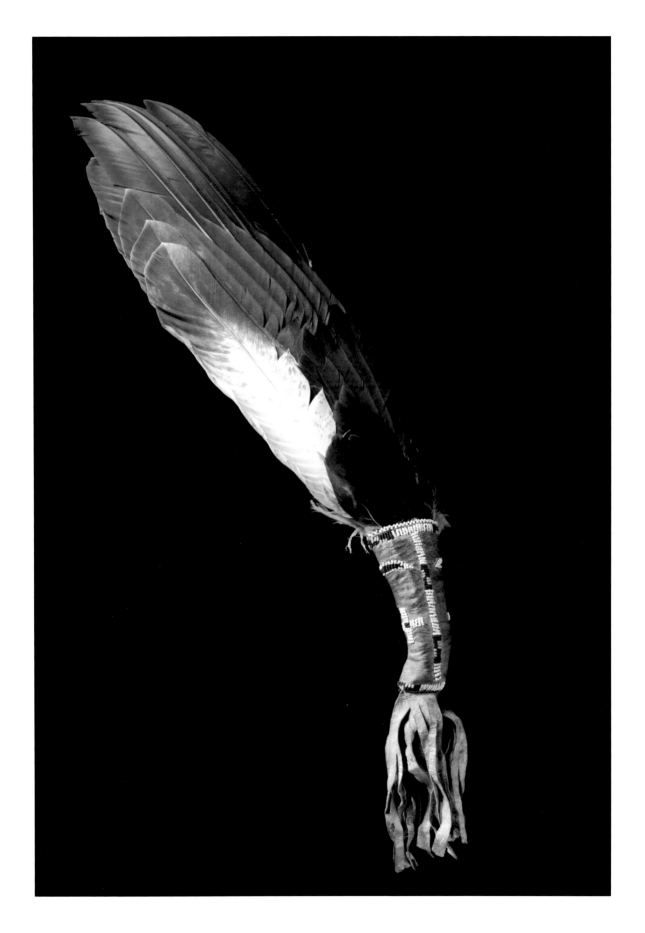

Above:

Sash (detail)

Wool, finger-woven
300 cm x 22 cm, 118¹/₈ in x 8¹¹/₁₆ in
c. 1850, Assomption, Canada
MNM
FA.1955.17.1

Finger-woven sashes, known as *ceintures fleches*, or more correctly as *ceinture à flames*, were commercially produced by female weavers in Assomption, Quebec, for the fur trappers, loggers, and porters of the eighteenth and nineteenth centuries. They used the sashes to keep their vital organs warm as well as to keep their heavy winter coats closed. Sashes could also be used as a tump line to carry burdens and were a mark of identity for the trappers. They were also worn by rural dwellers in Quebec to secure their winter coats and continued to be worn for weddings, as this one was last worn in 1955. The first loom-woven sashes made in England for the Canadian market appeared around 1875. The finger-woven sash industry waned when the cheaper alternative became widely available.

Right:

Mittens

Wool, knitted
26 cm x 11 cm, 10¹/₄ in x 4⁵/₁₆ in
c. 1850, Windsor, Ontario, Canada
Gift of David Lent
A.1978.88.3

Thick and very warm, these mittens were knitted with a very fine two-ply wool yarn. Short lengths of loosely spun yarn were inserted by needle to create the thick pile. Mittens made this way were often worn with the pile on the inside.

Above:

Sash (detail)
Cotton, wool, double weave
221.5 cm x 16 cm, 87 in x 6½ in
Early twentieth century, Mexico State, Mexico
IFAF
FA.1971.71.73b

Belts are used by indigenous women to hold up wrap skirts. In many cases, belts are not woven by the people who use them but are an item of trade coming from neighboring or even distant villages.

Below:

Sash (detail)
Cotton
139.5 cm x 6 cm, 54¹⁵⁄₁₆ in x 2³⁄₈ in
c. 1930, Cosoleacaque, Mexico, Nahua group
The Elizabeth Norman Collection
FA.1954.32.159

Above:

Belt (detail)

Wool, double weave
255 cm x 12.5 cm, 100⅜ in x 4¹⁵⁄₁₆ in
c. 1950, Nayarit or Jalisco, Mexico, Huichol group
Gift of the Girard Foundation
A.1979.6.116

Huichol women weave numerous belts for men's use. This wide belt is worn topped with several narrow belts of different colors. A string of small embroidered pouches are also worn about the hips.

Below:

Sash (detail)

Cotton, silk, supplementary weft patterning
214 cm x 7 cm, 84¼ in x 2¾ in
c. 1930, Totonicapan, Guatemala
IFAF
FA.1971.9.160

This type of belt is both woven and worn by women. A weaver needs to know how to make many different motifs to weave a fine belt on a back strap loom.

Above:

Woman's belt (detail)

Wool, attached fringe

24 cm x 4.5 cm, 88³/₁₆ in x 1³/₄ in

c. 1940, Santiago Sacatepequez, Guatemala

IFAF

FA.1971.9.68

Male weavers in Chichicastenango weave the plain black and white belt worn by women. It is sold all over the highlands of Guatemala without fringe or embroidery. Both are added in accordance with the woman's village. The embroidery is also done by men.

Below:

Woman's belt (detail)

Cotton, wool, embroidered

210.5 cm x 6.3 cm, 82⁷/₈ in x 2¹/₂ in

c. 1970, Chichicastenango, Guatemala

IFAF

FA.1973.22.5

The same belt (*above*) has been embroidered in cotton thread. Men both weave and embroider these women's belts.

Above:

Sash (detail)

Cotton
279 cm x 13 cm, 109¹³⁄₁₆ in x 5⅛ in
1959, Tecpan, Guatemala
IFAF
FA.1983.27.2

The seemingly diagonal white lines throughout the sash are the product of twisting adjacent warp yarns to achieve the candy cane stripe effect. Plain matte cotton yarn and shiny mercerized cotton yarns create contrast.

Below:

Sash (detail)

Cotton, supplementary weft patterning, weft twining
280 cm x 17.2 cm, 110¼ in x 6¾ in
c. 1960, Zacualpa, Guatemala
Gift of Norbert Sperlich
A.1979.52.68

Above:

Belt (detail)

Wool, double weave
128 cm x 5.5 cm, 50³⁄₈ in x 2³⁄₁₆ in
Twentieth century, Huancayo, Peru
Gift of Florence Dibell Bartlett
A.1955.86.223

The double weave technique produces
the same pattern with colors reversed on
the back.

Right:

Bag

Cotton, wool, double weave, braided
32 cm x 26.5 cm, 12⁵⁄₈ in x 10⁷⁄₁₆ in
c. 1930, Zimpan, Hidalgo State, Mexico,
Otomi group
The Elizabeth Norman Collection
FA.1954.32.170

Otomi men and women both carry finely woven bags.
The motif of the eagle with a snake in its mouth
perched on a nopal cactus is a symbol of the Mexican
nation. It is seen on the sampler on page 79 as well
as other weavings and embroideries from Mexico.

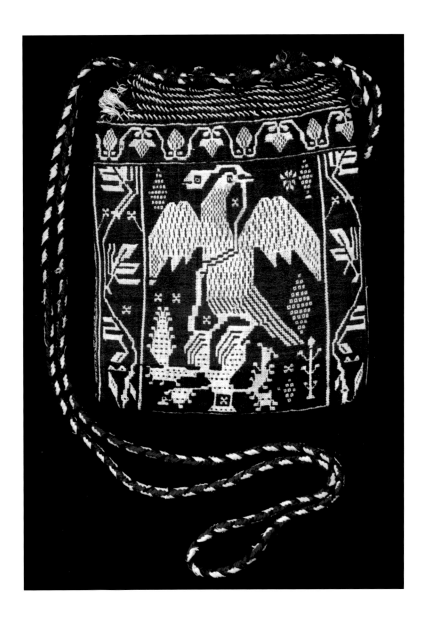

Above:

Belt (detail)
Cotton, wool
192.5 cm x 7 cm, 75¹³⁄₁₆ in x 2¾ in
Twentieth century, Ecuador
Gift of Florence Dibell Bartlett
A.1955.86.262

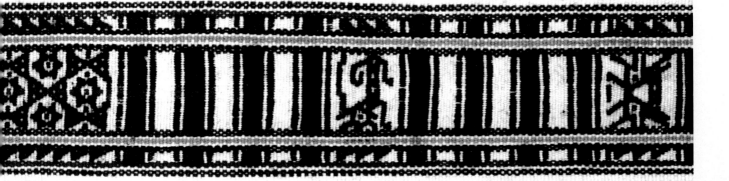

Below:

Belt (detail)
Wool, cotton, complementary warp patterning
292 cm x 5 cm, 114¹⁵⁄₁₆ in x 1¹⁵⁄₁₆ in
c. 1965, Cañar, Ecuador
MNM
A.1984.531.2

In Ecuador, women spin and men weave. Many different
width bands are made for use as belts and hair ties using
three different techniques on the back strap loom. The
inscription on this belt reads, "This belt is the property of
Juan Antonio Pichasaca." It was woven by Mr. Pichasaca
when he was in jail in Cañar, a traditional occupation of pris-
oners there.

Above:

Belt (detail)

Wool, complementary warp patterning
152 cm x 8.5 cm, 59^{13}/$_{16}$ in x 3^{3}/$_{8}$ in
Twentieth century, Tombabamba, Peru
Gift of Dr. and Mrs. John Rinehart
A.1998.35.4

These three belts are made using a technique that is common to many Andean textiles. The long warp ends on one end of the two wider belts are braided, sewn together, and finished with a narrow binding. The other end is squared off and also bound with a narrow edging. The narrower belt has braided fringe on both ends.

Center:

Belt (detail)

Wool, complementary warp patterning
165 cm x 6.5 cm, 64^{15}/$_{16}$ in x 2^{9}/$_{16}$ in
Twentieth century, Cuzco, Peru
IFAF
FA.1973.103.6

Newer ties, one pink and the other green, seem to have been added to this belt from earlier in the century. It was purchased used in Cuzco in 1973.

Below:

Belt (detail)

Wool
178 cm x 3 cm, 70^{1}/$_{16}$ in x 1^{3}/$_{16}$ in
1978, Peru
Gift of Dr. and Mrs. John Rinehart
A.1998.35.7

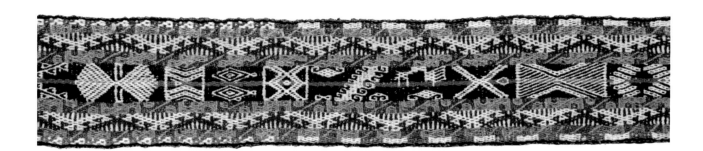

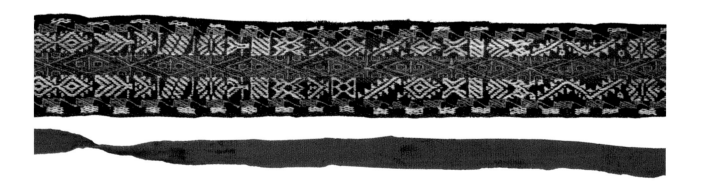

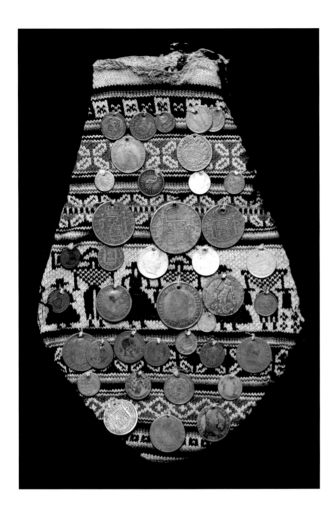

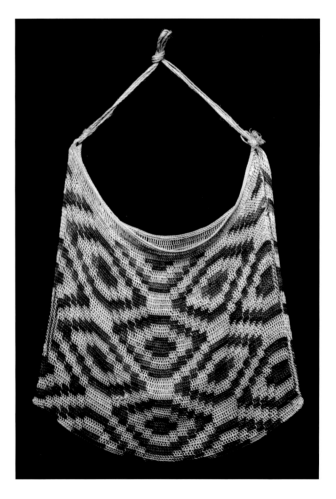

Below:

Bag

Carahuata fiber, looped

45.6 cm x 49.2 cm, 17¹⁵/₁₆ in x 19³/₈ in

c. 1970, Villamontes, Bolivia, Mataco group

IFAF

FA.1974.26.120

This carrying bag comes from the Gran Chaco region of southern Bolivia. Carahuata fiber comes from a plant of the *Bromeliaceae* family.

Above:

Bag

Wool, coins, knitted

30 cm x 20 cm, 11.8 in x 7.87 in

c. 1930, La Paz, Bolivia

Gift of Florence Dibell Bartlett

A.1955.86.279

Bags of all sizes were knitted by Bolivian women in the Andes for carrying money, coca leaves, and other personal belongings. The Spanish coins dating from 1758–1923 are attached to one side only.

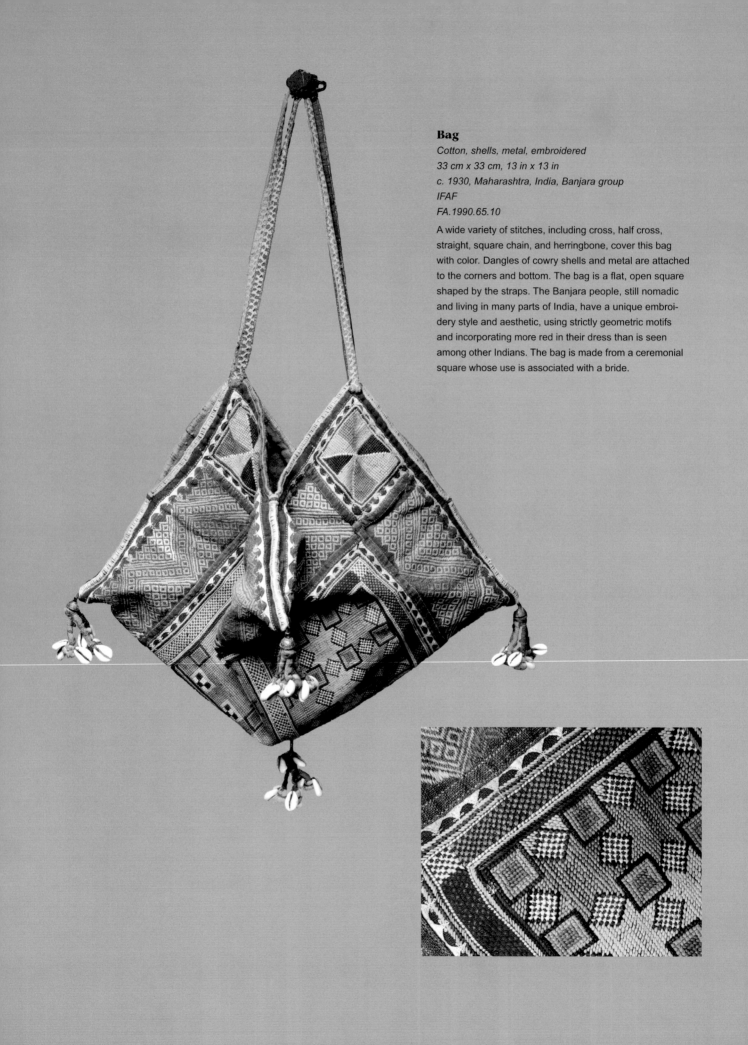

Bag
Cotton, shells, metal, embroidered
33 cm x 33 cm, 13 in x 13 in
c. 1930, Maharashtra, India, Banjara group
IFAF
FA.1990.65.10

A wide variety of stitches, including cross, half cross, straight, square chain, and herringbone, cover this bag with color. Dangles of cowry shells and metal are attached to the corners and bottom. The bag is a flat, open square shaped by the straps. The Banjara people, still nomadic and living in many parts of India, have a unique embroidery style and aesthetic, using strictly geometric motifs and incorporating more red in their dress than is seen among other Indians. The bag is made from a ceremonial square whose use is associated with a bride.

Above:

Belt

Wool, tie-dyed
392 cm x 14 cm, 154⁵⁄₁₆ in x 5¹⁄₂ in
Twentieth century, Manang Valley, Nepal/Tibet
border, Nyeshang group
IFAF
FA.1983.11.3

The Nyeshang or Manangi live at very high altitude in Nepal and still maintain their horse culture.

Right:

Bag, *kete whitau*

New Zealand flax, twined
16.5 cm x 18 cm, 6¹⁄₂ in x 7¹⁄₁₆ in
c. 1900, New Zealand
Gift of Mrs. Jack Stacy
A.1967.34.2

Small bags were not a part of Maori dress before European contact but developed as accessories to formal dress. This one is made from very fine and lustrous flax fiber warp whose ends form the fringe at the bottom of the bag. The fringe on the side is attached. The handle is made from two-ply flax yarn.

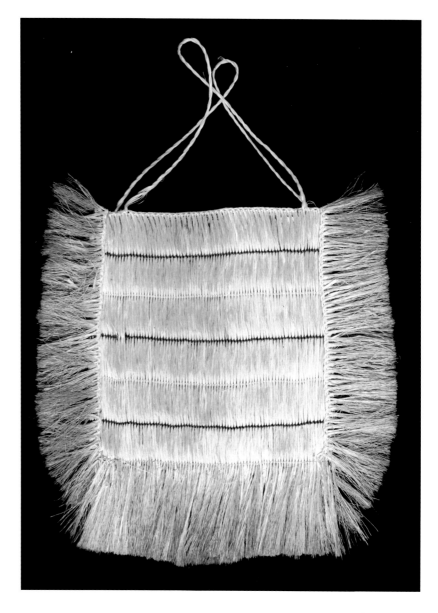

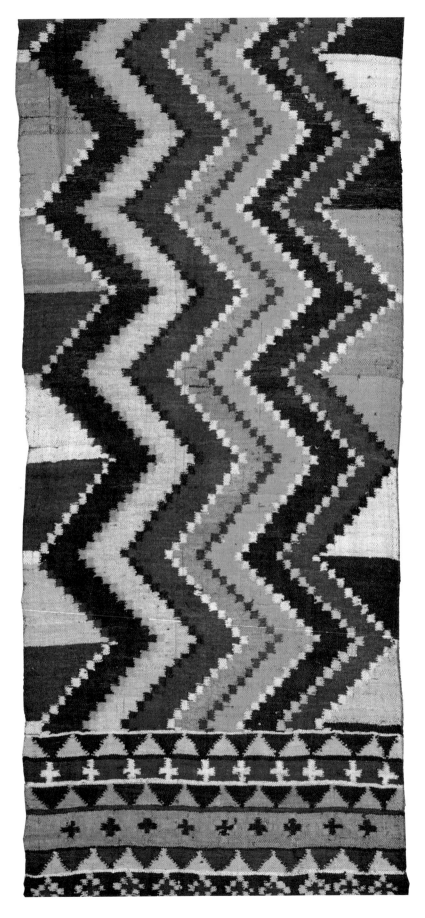

Sash, *kambut* (detail)
Silk, cotton, tapestry technique
288 cm x 28 cm, 113⅜ in x 11 in
c. 1920, Jolo Island, Philippines,
Tausug group
Gift of Mrs. Ward Gregg
A.1972.24.19

These finely woven sashes were worn by
Tausug men in the southern Philippines.
The same technique is still used by
Tausug female weavers today to create
the head cloths also worn by Tausug men.

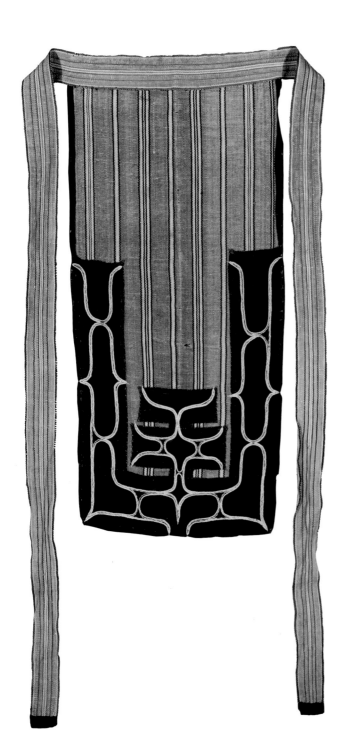

Apron

Elm bark, cotton, appliquéd, embroidered
65 cm x 31 cm, 25⁹⁄₁₆ in x 12³⁄₁₆ in
c. 1860, Hokkaido, Japan, Ainu group
Gift of Sallie Wagner
FA.1978.54.2

Aprons were worn every day by both Ainu men and women. Note the use of couching in contrast with the coat on page 148. Couching is an older technique than chain stitch among the Ainu.

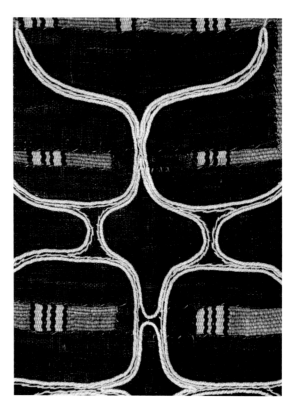

✿ Ceremonial ✿

CEREMONIAL DRESS HAS RESTRICTIONS AS TO WHO CAN WEAR IT AND when. Ecclesiastical garments are worn by the ordained and wedding garb by the bride and groom on their wedding day. Some ceremonial dress is prescribed by the culture or society where it originates; some is made ceremonial by deliberate individual use. A common funeral practice in parts of West Africa involves the use of a so-called uniform. When an old man or woman dies, the family gets together and, as part of the planning, picks a design of printed cloth as the commemorative cloth. Friends and family members can then purchase the designated cloth in the market and have it tailored into a garment that is worn to the funeral. When the same garment is worn afterward for any occasion, the wearer recalls the deceased and his feelings for him or her. The same practice is customary among a group of female friends when a child is born. Other words that are appropriate for things in this category are sacred, special occasion, magical, ritual, and religious.

Sacred and ceremonial dress is the dress of culture. Social and cultural values and beliefs as well as gender roles and age-related status are all made visible through ceremony, ritual, and religious practice. Senufo boys in northern Côte d'Ivoire undergoing an extensive initiation process into the Poro Society are dressed in small loincloths and white hoods, clothing that identifies them as apart from their families and society and warns passersby not to speak to them.[1] The white dress and veil worn by a Catholic girl receiving her first Communion symbolize the purity of soul achieved through her first confession. Small boys in Turkey are dressed in elaborate kingly robes as they make their way slowly through town, accompanied by parents and family, to their circumcision.

Dress associated with ceremony often incorporates iconography that relays these values. The birds on the Tajik wedding veil on page 221 are symbols of fertility, an important aspect of being a wife. On a magnificent robe worn by the Yoruba king of Akure, Nigeria, small beaded faces represent previous Yoruba kings, thus reinforcing the importance of the sacred

Mask, *aya uma*

Cotton, wool, embroidered, wrapped
63 cm x 31 cm, 24 13/16 in x 12 3/16 in
Twentieth century, Imbabura, Ecuador
Gift of Florence Dibell Bartlett
A.1955.86.258

This mask, made from commercial cotton cloth and hand-embroidered, is worn during the festivals of San Juan and San Pedro throughout Imbabura Province and around Cayambe in the far north of Ecuador. A stiff cap made of felted wool inside the mask acts as the support for the masker's head. Chain, herringbone, and buttonhole stitches create the floral motifs and outline the facial features. The stuffed "handles" on the sides of the face as well as the group of tasseled tufts sprouting from the top of the head are wrapped with thread and lightly embroidered. The mask is two-faced and is worn with garments made of cardboard and foil and sheepskin or goatskin chaps.

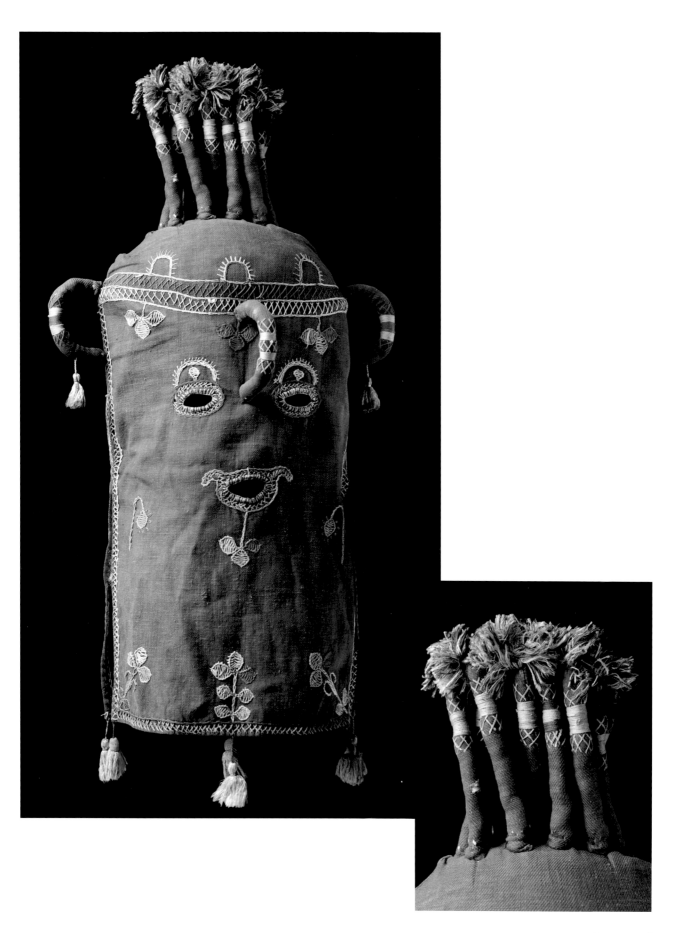

lineage of kings descended from Oduduwa, a Yoruba god and the first king.[2] A shaman's hat from Siberia is decorated with iron antlers to invoke the wild reindeer whose spirit protects the shaman.[3]

Pieces like these may seem strange or outlandish to someone in another culture, but the reasons they are worn or used are common to most cultures. People who officiate at services or events in most religions—whether Christian priest or Siberian shaman—show their position and authority by wearing special garments that distinguish them from the ordinary person. Royalty everywhere proclaim their exclusive right to something, a type of headwear, a textile material, a form of embellishment, or a color. Brides are universally celebrated and set apart on the special day, for instance by a white dress modeled on Elizabethan styles or an embroidered veil covering the face. How different are garments covered with writing and meant to protect the wearer from harm compared to vitamin pills, taken on faith to prolong life?

The museum has a large assortment of masquerade dress from Latin America and a smaller collection from Africa. Recent acquisitions include talismanic garments from Southeast Asia and shamanic dress from China. Wedding garments from Central Europe and the Balkans and huipils and head cloths used by *cofradia* members in Mexico and Guatemala during religious ceremonies are all represented.

Hat, *sikke*
Wool, felted
18 cm, 7 in diameter; 26 cm, 10¼ in height
Twentieth century, Konya, Turkey
Gift of Saz Richardson
A.1955.1.436

The felted wool *sikke* is given to a Mevlevi dervish when he has finished his 1001 days of training. It is the sign of his acceptance into the Sufi way. The hat, along with a white jacket and full skirt, is worn while performing the whirling prayer called *sema*. Sufi men who have achieved a certain level of holiness can wrap a cloth around the base of the sikke and thereby distinguish their status from other believers. Female Sufis wear a different hat and traditionally have not performed the sema. All aspects of dress worn for the sema are symbolic—the white garments are influenced by mourning clothes and the sikke represents a gravestone.

Masquerade costume

Cotton, painted
132 cm, 52 in length
Twentieth century, Korhogo, Côte d'Ivoire,
Senufo group
Gift of the Girard Foundation
A.1980.1.798

This type of masquerade dress is worn in
the far north of Côte d'Ivoire. It is made from
narrow strips of handwoven cotton cloth.
Interestingly enough, the dyeing process that
produces the figures is similar to a technique
used in India. First, a liquid mordant, or fixa-
tive, is painted on the cloth. This mordant is
a brew made from leaves and bark that pro-
duce the right chemical components to bond
with the dye. Then soupy mud is painted over
the mordant drawing to create the color.
Alternatively, the whole cloth is submersed
in liquid mud and later washed. The areas
of the cloth not painted with mordant wash
out white. This costume is typical of the body
garment worn for certain masked dances
associated with divination. Whether this
particular garment was made for use or for
sale to a tourist is a question. The form of
baggy body and short legs with drawstring
neck is standard for use, but the drawing
style is more typical of the flat cloths made
for sale as wall hangings, a nontraditional
product. Older masquerade costumes have
vertical stripes that create areas for geometric
and small figurative patterns.

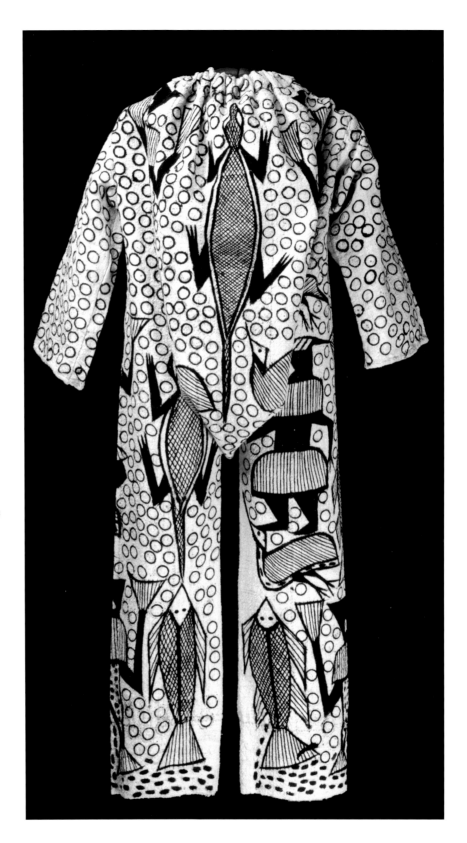

Right:

Wedding crown, *brurekrone*

Magnus Aase, silversmith
Silver, gilded silver, wool, silk, glass
18 cm, 7 1/8 in diameter
1899–1953, Bergen, Norway
Gift of Florence Dibell Bartlett
A.1955.1.958

Facing:

Plastron

Wool, cotton, linen, silver, mirrors, metallic
thread, bobbin lace, applied trim
58 cm x 43 cm, 22 13/16 in x 16 15/16 in
c. 1900, Norway
Gift of Florence Dibell Bartlett
A.1955.1.237

The wedding crown and plastron, or bib, have
been worn by Norwegian brides for centuries.
The use of special wedding headgear goes
back to early Christian times when the church
was attempting to gain dominance over
"pagan" religion. The earliest reference to
wedding crowns was in a manuscript dated
1723; they developed from simpler head-
dresses called *lad* and flower wreaths, sym-
bols of the bride's virginity. The crown is
composed of three parts—an inner padded
wool headband that supports the crown on
the head, the silver crown with its dangles
and glass paste jewels, and the cloth flower
wreath with silver lace trim and ribbons with
beads around the sides and back that covers
the base of the crown. Crowns were made by
silversmiths and were expensive. Very few
individual families owned crowns. A crown
might be owned by a wealthy family or
minister in a parish and rented out for each
wedding. This crown is stamped with the hall-
mark of the smith, MAASE, as well as the
hallmark of Bergen, where it was made.

(continued on facing)

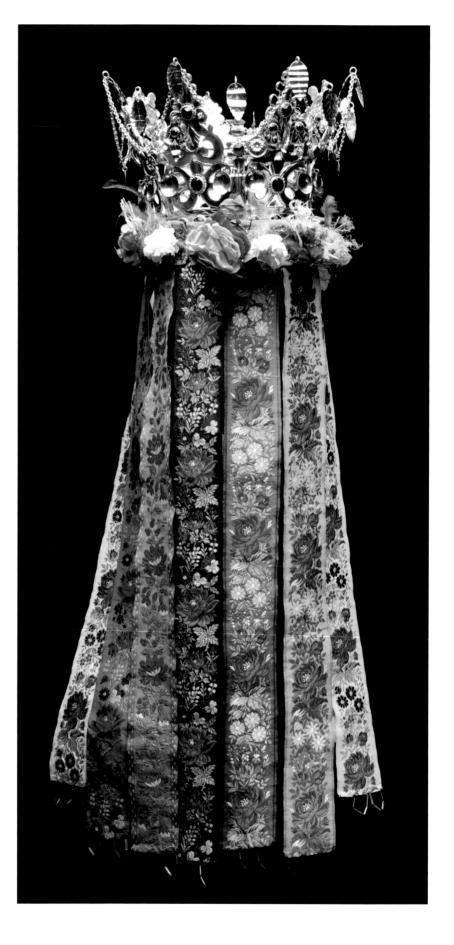

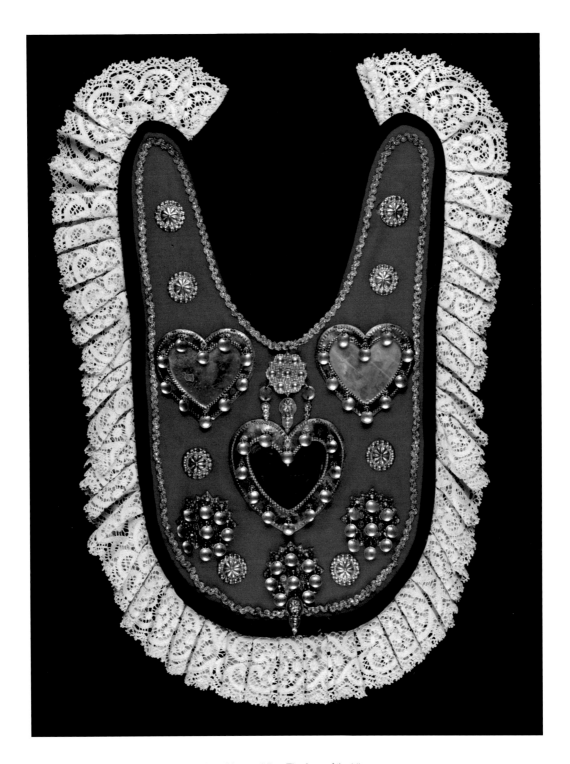

The bridal bib was also worn only on the day of the wedding. The form of the bib varied from place to place in Norway. In some areas it was a wide collar with silver ornaments attached. In others, it was like this one, a rigid plate that covered the chest. A bobbin lace ruffle surrounds the bib. The back is covered with red checked cotton fabric; red wool covers the front. Black wool binding and silver rickrack edge the bib. Mirrors, silver medallions, and shiny silver dangles all helped to distract the underworld creatures known as *huldrefolk* and protect the young woman at a vulnerable time of life. Other features of Norwegian wedding dress in the museum are two belts with brass plates and the special box for storing the crown, as well as several silver brooches.

Wearing blanket

Wool, silk
199 cm x 173 cm, 78⅜ in x 68⅛ in
c. 1915, Oklahoma, Osage group
Gift of Lloyd E. Cotsen and the Neutrogena Corporation
A.1995.93.1064

The peyote blanket is worn by male members of the Native
American Church during the peyote ceremony. The two colors
represent day and night, with the red half worn over the heart.
Some people say the colors also represent fire and water, two
important elements in the ceremony. The edges are bound in
green and purple ribbon work. Peyotism came to Oklahoma
from Mexico and the Southwest in the 1890s; the Native
American Church was established in 1920.

Upper garment, *huipil*

Cotton, supplementary weft patterning,
embroidered
103.5 cm x 128 cm, 40¾ in x 50⅜ in
c. 1925, Quetzaltenango, Guatemala, Quiche
Maya group
Cleves Weber Collection
A.1995.65.10

This three-panel ceremonial huipil was worn for weddings and for religious ceremonies associated with the Catholic Church in the city of Quetzaltenango. Two different supplementary weft techniques are used in this huipil of loosely woven white ground fabric. The white-on-white pattern at the bottom is woven with heavier yarn that extended all the way across the web, leaving floating lengths on the front of the cloth where the pattern didn't appear. After the cloth was taken off the loom, the floats were cut, creating a fringed effect outlining each motif. The colored supplementary weft was used only in the pattern area where it appears. Embroidery at the neck is done in blanket, chain, and straight stitch. Motifs include a sky band of diamonds, zigzags of lightning, and plants sprouting from jars topped with birds. These ceremonial huipils were worn as veils, with the neck hole surrounding the face of the wearer. The white-on-white area of another huipil of this type in the collection was made differently, with no cut ends.

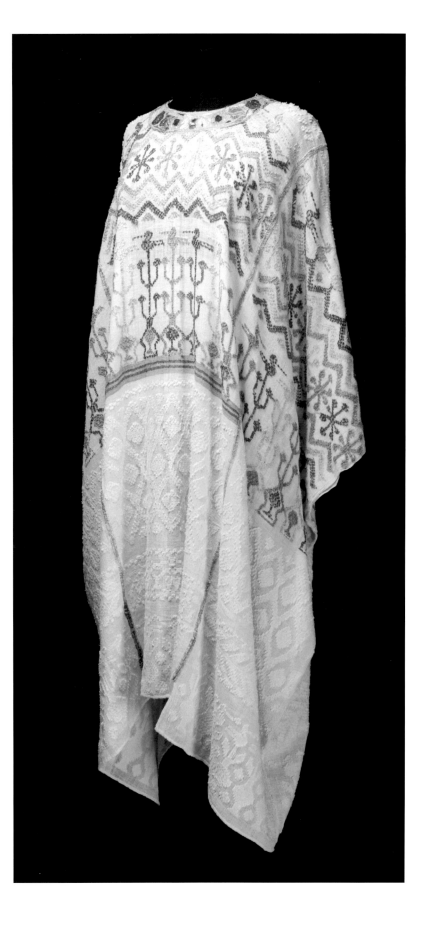

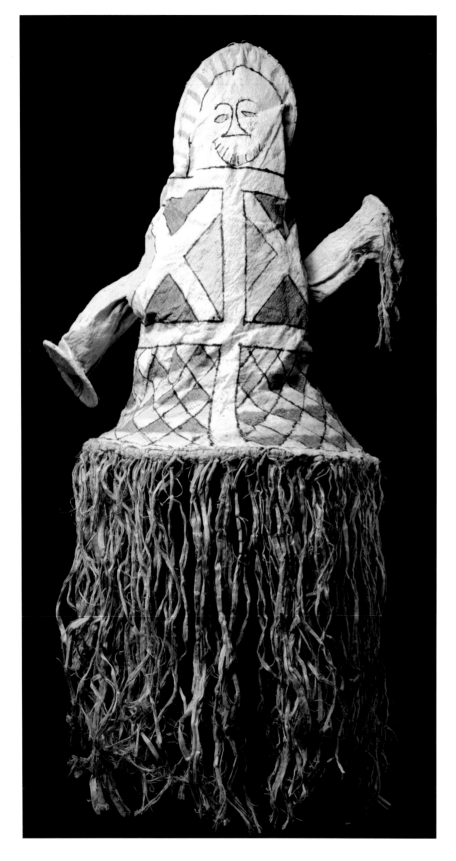

Masquerade costume, *tawu*

Bark cloth, plant fiber, painted
115 cm x 52 cm, 45¼ in x 20½ in
c. 1970, Amazon River, Colombia, Tukano
or Cubeo group
Gift of Charlotte and Bob Kornstein
A.1981.56.1

This masquerade costume is worn during a
funeral ceremony, or *ónye*. The *ónye*
celebrates the life of the deceased and is
a way to translate grief into joy. The knee-
length masks are made from white bark cloth
and painted with vegetable dyes. They are
worn by adult males during the *ónye* and
represent ogres, insects, animals, and forest
spirits. Shamanism is a major component of
the Cubeo belief system. The Cubeo people
believe that the masks contain the full sacred
character of the spirit depicted. After the
ceremony, the masks are usually burned,
though some are kept for other uses or sold.

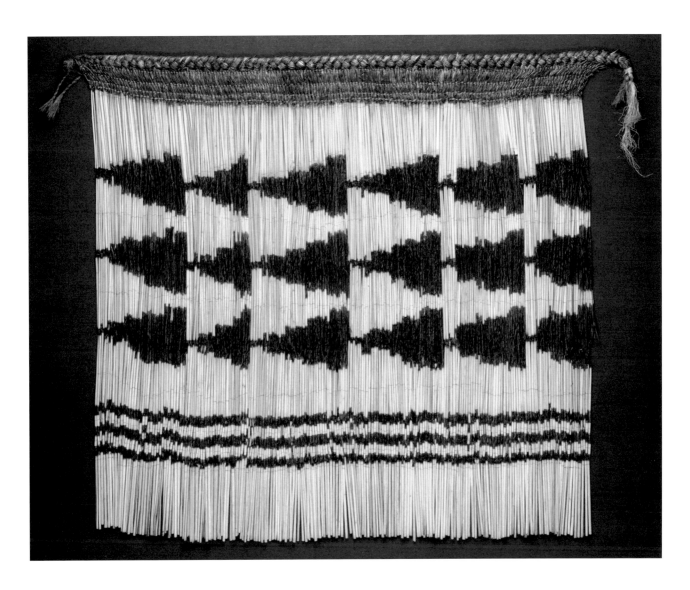

Dance apron, *piu piu*

New Zealand flax, plaited
76 cm x 91.5 cm, 30 in x 36 in
1860–1890, New Zealand, Maori
Gift of Lloyd E. Cotsen and the Neutrogena Corporation
A.1995.93.1159

The *piu piu* was a ceremonial garment developed from the kilt that was worn every day by both men and women. When European garments were introduced, they were rapidly adopted, and the Maori styles of cape and kilt were worn only on special occasions. The piu piu is made from the stalks of New Zealand flax that have been selectively scraped and dyed to make a pattern. The stalks are attached to a plaited waistband. The sound the stalks made as the dancer moved was an important aspect of the garment. Piu piu are still made and used in New Zealand.

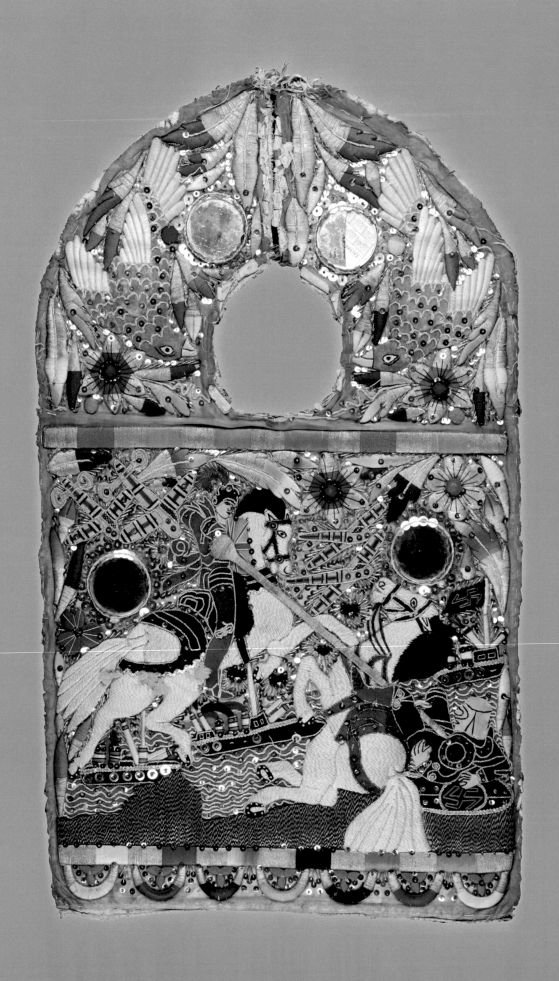

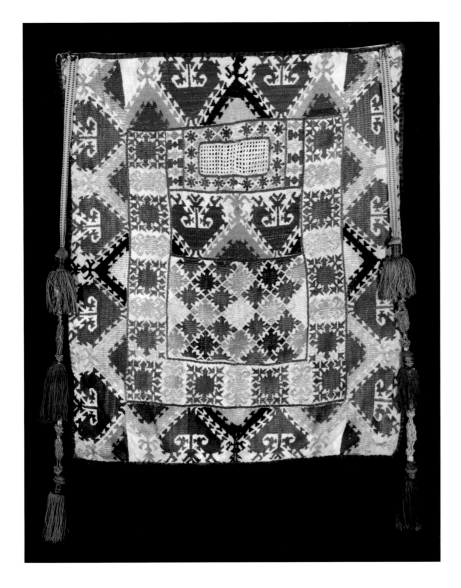

Dance collar

Cotton, silk, sequins, metallic thread, card-
board, newspaper, mirrors, embroidered
81 cm x 49.5 cm, 31⁷⁄₈ in x 19¹⁄₂ in
c. 1960, Junin, Peru
IFAF
FA.1977.9.1

Heavily decorated collars are worn by men
as part of the dance costume in Junin when
celebrating a saint's day. The stiffened bib
becomes a canvas for embroidery portraying
heroic themes. Here, the conflict between
horsemen on white horses dominates the
bottom of the bib; one rider has been dis-
mounted from his horse by the long lance of
the other rider. It's not known if these figures
represent anyone in particular, but it is interest-
ing that the victor has black hair and the
vanquished is blond. The background is filled
in with ships and yellow and pink airplanes
coming from all directions. All available space
is covered with sequins and metallic embroi-
dery. The figures are padded with cardboard,
and newspaper supplies some stiffening.

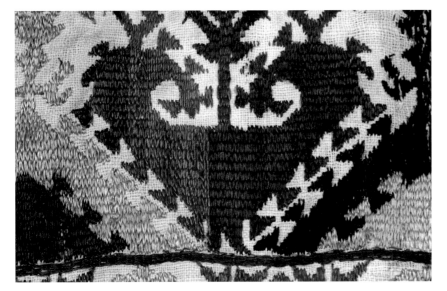

Left:

Wedding veil, *ruband*

Cotton, silk, metallic thread, embroidered,
needle lace, wrapped, knotted
77 cm x 54 cm, 30¹⁄₃ in x 21¹⁄₄ in
c. 1900, Tajikistan
IFAF
FA.2005.45.1

A *ruband* was used by generations of Tajik
brides in the mountain areas of Kara-Tegin
and Darvas, in what is now Tajikistan. The
veil covered the bride's face from the
moment she was taken to her future
husband's house until the final ceremonies
were over and she was a married woman.
Fine satin stitch in shades of red, green,
purple, and yellow cover the hand-spun
cotton fabric with stylized roosters, abstract
florals, and geometric patterns, all associ-
ated with natural energy and the life-giving
power of the sun and fire. The veil is backed
with commercially printed cotton and is
complete with ties and tassels to hold it on.
The use of the ruband disappeared in the
early twentieth century when the embroidery
skills were lost. It was replaced by kerchiefs
and shawls.

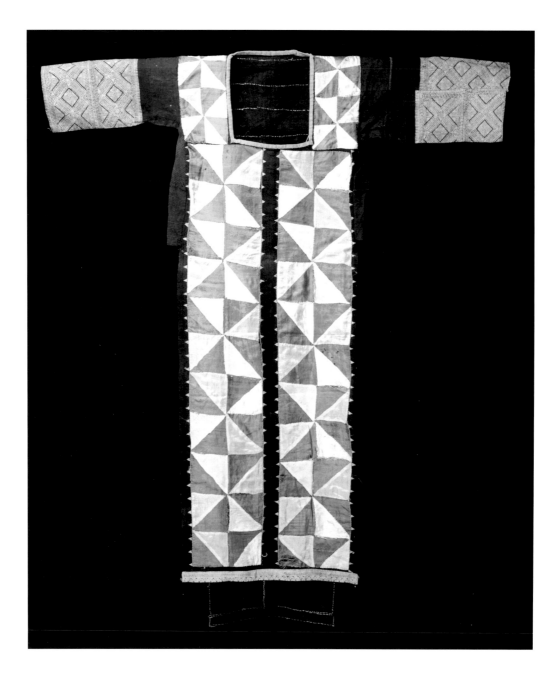

Tunic

Cotton, silk, appliquéd, batik, embroidered
139.5 cm x 118 cm, 55 in x 46½ in
Twentieth century, Yunnan, China, Yi group
Folk Art Committee purchase
A.2007.37.3

Female shamans of the Yi people living in Malipo County on the border with Vietnam wear this tunic during the Tiao Gong festival held once a year. Wax designs are drawn on handwoven cotton with a tiny metal blade inserted into a 2-inch-long wooden handle. The material is then dyed and put on the sleeves of the indigo-dyed tunic. The silk patchwork makes pinwheels, and small gold triangles are embroidered along the edge of the appliqué. The tunic is worn over a jacket and skirt.

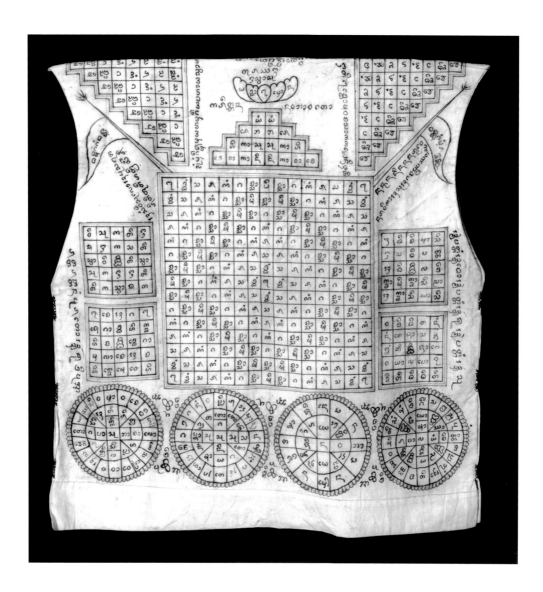

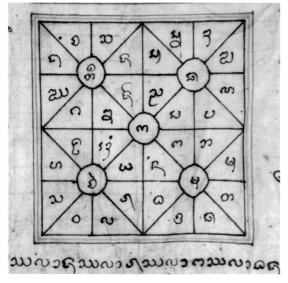

Talismanic vest

Cotton, drawing
43.5 cm x 41 cm, 17⅛ in x 16⅛ in
c. 1905, Lanna area, Thailand
IFAF
FA.2003.9.3

Garments covered with cabalistic drawing were worn for both spiritual and physical protection all over Southeast Asia. The practice of drawing on clothing grew from the ancient practice of tattooing that manifested in many ways in that area. Leg tattoos among the Shan of Burma, for instance, were associated with rites of passage and aesthetic decoration. Upper body tattoos were of a different type and intended to protect the wearer and provide him with supernatural power. Eventually, something worn over the skin was deemed as powerful as something under the skin, and tattoos were supplanted by vests and shirts prepared by specialists and activated by ritual. The sectioned circles at the bottom of the vest are aspects of an astrological chart. Magic squares made up of a grid with a letter or number in each square concentrate and intensify power. The sides of the vest are held closed by three groups of red stitches. The detail comes from the front of the garment.

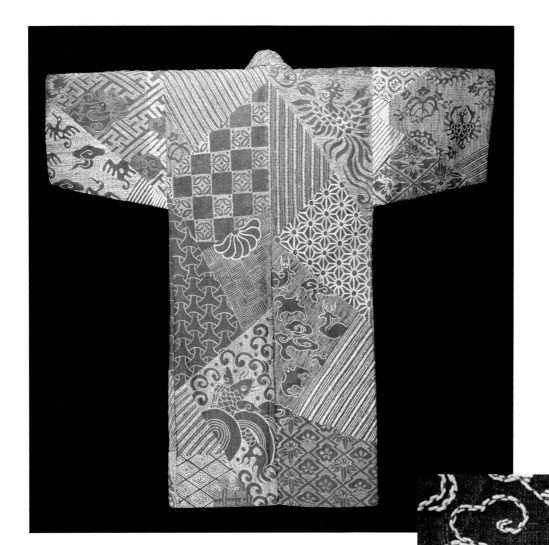

Festival coat

Cotton, embroidered

125.5 cm x 195.5 cm, 49⁷⁄₁₆ in x 76¹⁵⁄₁₆

c. 1780, Tohoku region, Japan

IFAF

FA.1955.6.2

This remarkable coat is a tour de force of the embroiderer's art. Using primarily long straight stitches to define negative space and occasional short stitches to outline figures, it was most likely made to look like the patchwork kimonos that were worn for the Obon festival. You can see patterns that from afar look like different types of dyed or woven cloth. The fish on the lower left is similar to designs made with rice paste resist (*tsutsugaki*). There are illusory woven stripes on the right, and other patterns that resemble those produced by stencils, all embroidered with hand-spun cotton yarn. The front of the coat is more of the same, with the addition of three cartouches with characters inside. The coat is lined with plain brown cotton fabric.

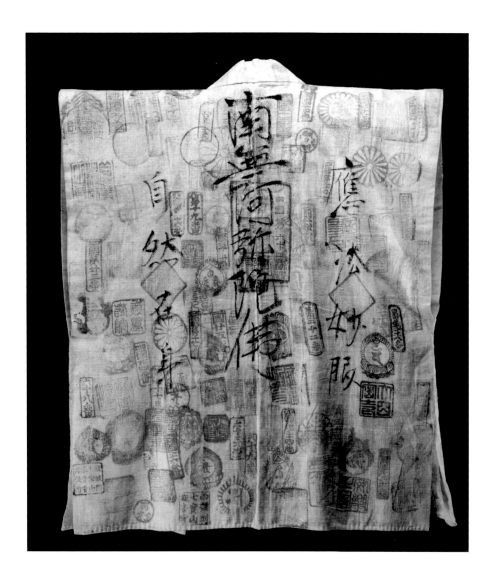

Pilgrimage vest
Cotton, stamped
63.5 cm x 55.25 cm, 25 in x 21¾ in
c. 1900, Japan
Gift of Ralph C. Altman
A.1952.14.42

Vests and jackets were worn by people making pilgrimages to shrines and temples in Japan. When a temple was visited, the garment was stamped. This piece was collected by Frederick Starr, anthropologist and professor at the University of Chicago, when he was in Japan from 1909–1910.

✿ Ensembles ✿

SOME DRESS COMES INTO THE MUSEUM COLLECTION AS COMPLETE or nearly complete ensembles. This is a somewhat unusual occurrence, since many collectors are interested in individual pieces or techniques and not in assembling all the parts necessary for a complete outfit. When ethnic dress is acquired directly from someone who previously wore it, the individual garments often represent different time periods. Some pieces are passed on as heirlooms and are worn as they are or modified to suit the fashion of the moment. Some are newly made for each generation, and as they wear out or become outmoded, garments are replaced. It has also been a common practice to remove embroidered parts such as cuffs and yokes and put them on a newer garment, preserving old techniques and styles. Thus, it's not unusual or inauthentic to have an ensemble dating from 1870 to 1950, for instance. It is important to distinguish the different ages of parts when this is the case.

On the other hand, garments from different time periods and places can be put together and sold as a complete ensemble by a shopkeeper or dealer. A collector or curator needs to be very knowledgeable about historical developments and subtle geographic differences in ethnic dress of the locality concerned to spot these potential problems.

Jewelry is often an essential component of an outfit but can be hard to display correctly on a mannequin. Undergarments are often neglected by collectors or simply not available on the market. This sometimes poses a problem in creating the right shape of the dressed mannequin or form. Appropriate foot- and legwear can be difficult both to procure and to display or photograph in the museum setting. None of the photographs in this section include shoes, even when we have them in the collection.

A fully dressed mannequin presents a more realistic picture of dress traditions than individual garments shown flat or isolated from other components. Yet for those individuals who want to see each part of an ensemble for the details of its shape and decoration, full ensembles are frustrating.

Man's wedding outfit
c. 1910, Mesokovesd, Hungary, Matyo group
Gift of Florence Dibell Bartlett
Exuberantly embellished with embroidery, this apron and wide-sleeved shirt were made by the prospective bride for her prospective groom. Other garments worn by the groom are tall black leather boots, voluminous trousers with ruffles, a vest, neck tie, and flower-adorned hat. The apron shown here is a little newer than the rest of the pieces, made after 1924. This is known by looking at the band of yellow embroidery above the long black fringe at the bottom. In 1924, wearing clothing embellished with gold or silver lace and fringe was banned by the Catholic priests of Mesokovesd. People had to remove the trims from their garments and bring the trims to the church, where they were thrown on a bonfire. A few weeks later, young women had replaced those trims with black silk fringe and yellow embroidery that mimicked the lace, as seen on this apron. The detail shows the metallic trim and fringe of an older apron in the collection, one too fragile to put on the mannequin. From about 1870, Matyo embroidery went through a creative florescence stimulated by economic growth, resulting in the brilliantly colored large motifs seen here. Earlier embroidery used red and blue threads only; motifs tended to be single and symmetrical. It's said that women devised new patterns each year to put on men's sleeves; thus a shirt could be dated by someone who knew how to read it.

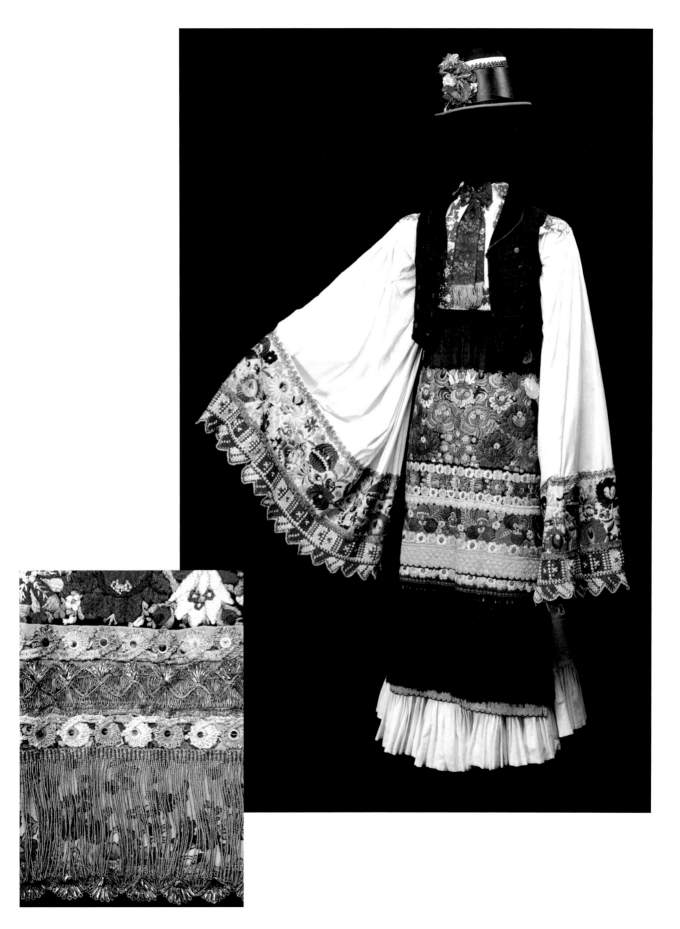

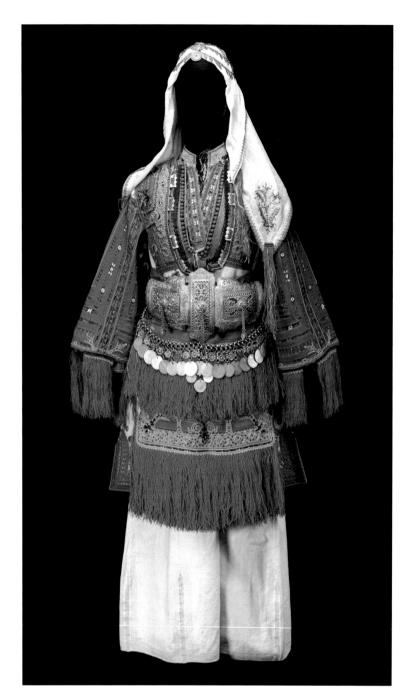

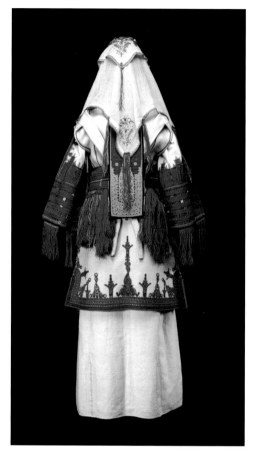

Wedding ensemble

c. 1900, Smilevo, Macedonia, Miyak group
The Ronald Wixman/Stephen Glaser Collection
of Macedonian Folk Costume

Macedonia, formerly part of Yugoslavia, has a rich textile tradition that incorporates original Slavic elements as well as influences from the diversity of the Ottoman Empire. Well into the twentieth century, a young woman made all the parts of her wedding ensemble and the textiles that composed her dowry, except for jewelry and some purchased pieces. Untold hours were spent on spinning, weaving, and embroidering these elaborate garments so essential to the identity of the individual and community. This

outfit from the southwestern part of the country has twelve pieces, including knitted socks that aren't shown. The white chemise is worn over a blouse with green velvet sleeves and front embroidered in gold. A short velvet vest is worn over the chemise. Decorative gold thread buttons with a tiny white heart bead on each line both sides. Most visible from the back, a white wool sleeveless coat with red embroidery and vestigial sleeves makes the outermost layer of garments. A wool apron with couching and embroidery is topped by a woven belt with fringe and a large goldwashed *pafta,* or buckle. Wearing pounds and pounds of clothing in multiple layers shows not only the wealth of the bride's family, but also her physical strength and her skill with needle and loom.

Unmarried woman's ensemble

1846 to early twentieth century, Delsbo,
Halsingland, Sweden
Gift of Florence Dibell Bartlett

Many of the full costumes purchased by Ms.
Bartlett came from Europe, where they were
fast disappearing in her time. She bought a
number of full ensembles from Sweden, where
the textiles seem to have inspired her. We
have no information as to when or where she
bought this ensemble. As is common, some
parts are older than others, but it does seem to
have all the right components. The Delsbo
skirt is black wool pleated into a waistband; the
pleats are sewn into place on the back at the
top and a red band is attached at the bottom.
The apron is patterned with narrow stripes and
attached to a woven red and white waistband
with long ties and tassels. A red wool bodice
with narrow black stripes is lined with linen and
has the initials HKOD and the date 1846 3/4
written inside. The embroidered pocket is
made from wool with a leather back; couched
pewter thread outlines the red patches, and
the pocket is attached to a metal frame with a
hook for hanging it on the apron. The outfit is
completed by a blouse, silk scarf, two silver
brooches, a frame cap made from printed cot-
ton, and embroidered leather gloves and black
over-mitts that are not shown. Although the
woolen and linen fabrics used to make the
clothing were made at home, the construction
was probably done by a professional tailor.

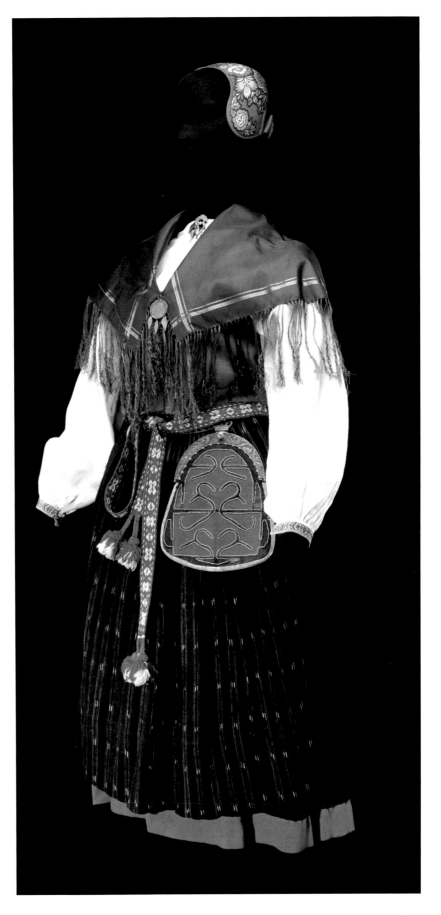

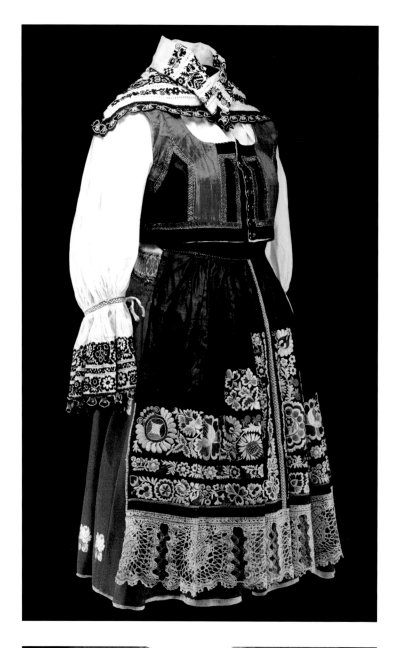

Woman's ensemble

c. 1920, Kyjov, Moravia
Gift of Francelle Metzenberg

The village of Kyjov in South Moravia, now in the Czech Republic, is famous for its local dress consisting of a short gathered skirt worn with petticoats, a full-sleeved blouse, short bodice or vest, apron, and scarf about the neck. In actual wear, the sleeves would be puffed out, as would the skirt with more petticoats. The sleeves and neck cloth are decorated with black cotton embroidery around cut-work holes. Drawn thread work creates borders between areas of embroidery. A narrow tape of bobbin lace finishes the edges of the sleeve cuffs and neck cloth. A narrow red and white tape holds the sleeve gathers in place. It would be tied at the elbow when worn. The vest is made in an interesting way; black silk is cut to shape and bands of red silk are tucked and sewn to make the curves of the neck and armholes. The three red medallions on the back are pleated from ribbon with couching added and are said to symbolize the Holy Trinity. The metallic trim is formed from serpentine gold-wrapped strands threaded through with narrow metal strips. Satin stitch embroidery finishes the piece. The aprons of the Kyjov area are the most famous part of the ensemble. Elaborate embroidery on glazed cotton shows many kinds of stitches by this expert needlewoman. Satin, knot, seed, and trellis variations are just a few of the stitches used. Homemade bobbin lace from linen thread in characteristic sinuous patterns completes the apron. Both married and unmarried women wore the same style of dress; the only distinguishing feature was a cap or scarf worn by married women. Girls wore flowers in their hair or went bareheaded. Kyjov dress is still worn for festivals and special occasions in the area.

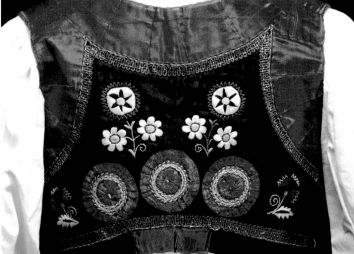

Unmarried woman's ensemble

1775–1800, Skyros, Greece
Gift of Florence Dibell Bartlett

This nine-piece ensemble was highly prized by Skyros girls and
passed on from mother to daughter to be worn only on the wed-
ding day or on great feast days. The expensive materials and the
work involved in these garments are a testament to the value it
was given. The embroiderers of Skyros are known for their use of
distinctive motifs such as birds and animals with human heads,
and sphinxes. The cotton chemise, visible only at the sleeves
and as a line of color at the hem of the dress, is embroidered in
silk and metallic thread with two-headed birds on the sleeves and
hem. A narrow band of gold lace is attached to the sleeve. Over
the chemise is a dress consisting of a pleated silk brocade skirt
attached to a sleeveless bodice, like a jumper. The skirt is deco-
rated with two strips of silver tape made with wrapped thread and
wire. On top of the dress, a red silk blouse is worn. The embroi-
dery uses metal-wrapped thread, as does the lace inset on the
sleeves; seams are joined with silk thread needlework. The fur-
trimmed vest of silk brocade is typical of Skyros and creates tex-
tural contrast with the metal and silk. The cotton belt has the date
1796 woven in as well as the words "Holy City, Jerusalem," and
"Jesus Christ" in Greek. The belt buckle is similar to those worn
all over the Ottoman world. The dark blue and yellow veil is fairly
heavy cotton with some silk weft in parts. It is normally worn far-
ther forward on the forehead with the jewelry attached, not pos-
sible to display on a mannequin. Both the skirt and the chemise
were shortened by taking up a large fold, evidence that it was
worn by more than one woman. The entire ensemble was pur-
chased at the American Women's Hospital in Athens at an
unknown date. There are two more blouses as well as some
embroidered bedding from Skyros in the collection.

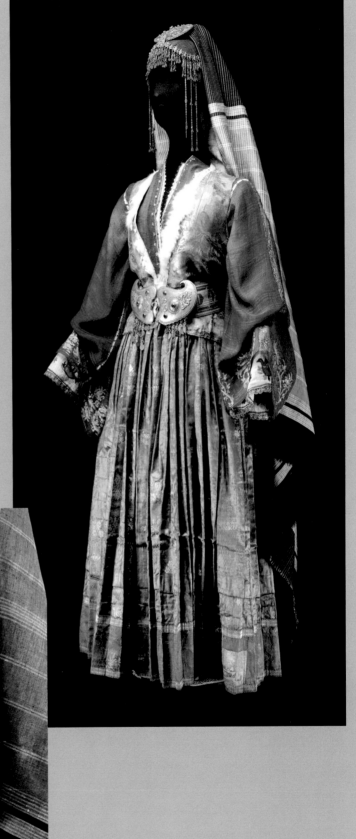

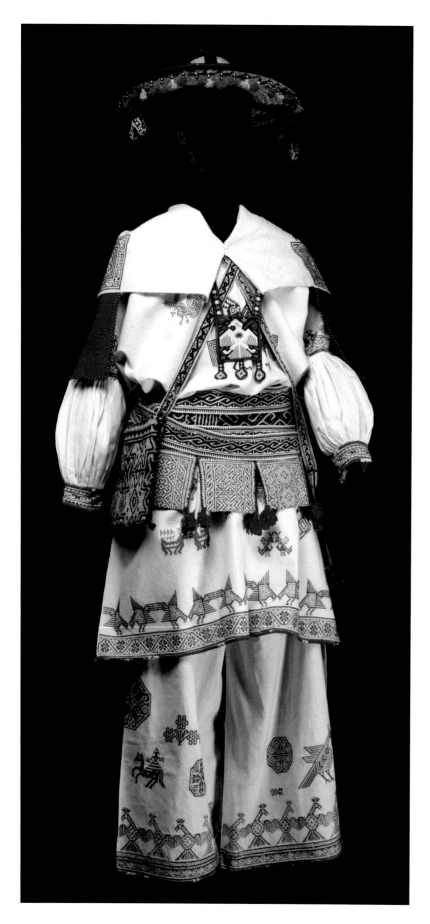

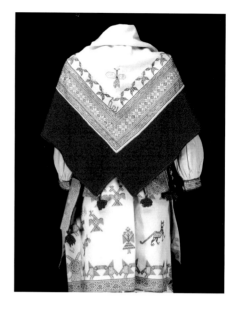

Man's festival ensemble

Twentieth century, Nayarit, Mexico, Huichol group, IFAF

The Huichol live in the remote mountains of Nayarit and Jalisco in west-central Mexico. Due to their self-imposed isolation from outside influences, they have retained their religion and many of their dress traditions. Men's ceremonial dress is more elaborate than women's, a most unusual situation. Change over time is seen in materials and the amount of embroidery on garments. Before commercial cotton fabric, called manta, was available, sheep's wool was used. Men wore a long wool shirt with little embroidery and no pants. Early in the twentieth century, trousers were adopted and decorated with a band of embroidery on each leg. The trousers shown here, collected in 1967, have several spot motifs, a later development, in addition to the border at the bottom of each leg. The belt and wool bag were woven in double weave. The cross-stitch embroidery on all the pieces as well as the weaving were done by the wife of the owner of the clothing. The motifs all represent the deep reverence the Huichol have for the natural world and all its inhabitants. The eight-part medallion on the front of the trousers is the *toto* flower; it blooms during the rainy season when the corn is growing and thus represents corn. The toto flower is usually represented as eight-petaled but is also embroidered with four and six petals. Earrings and necklaces made from glass beads have been made and worn since the beginning of the twentieth century, if not earlier. Huichol women dress more simply, wearing a blouse, skirt, and quechquemitl only. Everyday clothing takes the same form as festival dress but with less decoration.

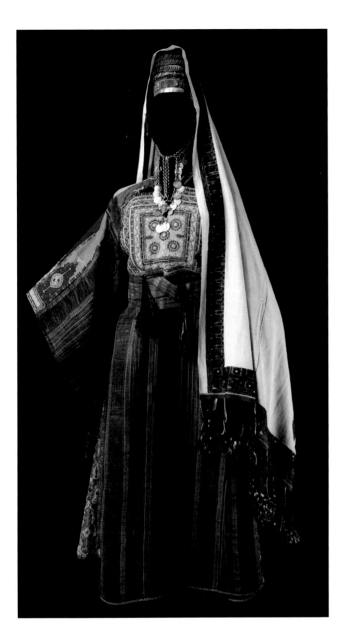

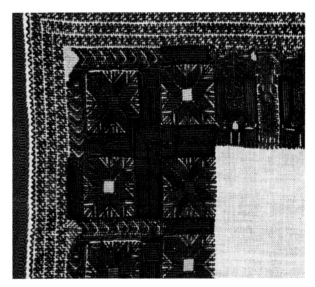

Women's ensemble

c. 1890, Bethlehem, Palestine
Gift of Florence Dibell Bartlett

The Bethlehem style of *thob*, or dress, is characterized by long pointed sleeves with a panel of silk taffeta, embroidered with couching known as "Bethlehem work," from the shoulder to the hem. The same taffeta panels are also inserted on the sides of the dress and embroidered (detail). The front of the dress always bears a large rectangular panel that here is fully covered with couching in metallic and silk thread. The dress is made from a silk and linen blend woven in Mejdel near the coast and called "royal with flowers," *malak abu wardeh*, the most expensive of the locally woven dress fabrics. Cotton and wool were locally produced, but silk and linen yarns were imported from Lebanon and Egypt. Narrow strips of silver metal are woven into the fabric of the back of the dress. Small pieces of imported velvet, highly prized as an exotic luxury, are sewn on the shoulders. The dress is caught round the waist by a long sash of silk fabric woven in Syria.

On the head is worn the *shatweh* (see page 106) with a chin chain of silver links and coins. The beautifully embroidered veil is made from two lengths of fine linen, embroidered with silk. A silk band with twisted and knotted fringe is attached to the two short ends. The type of embroidery is unique to these veils and thought to be related to Greek Island embroidery. Many of the inhabitants of Bethlehem and the two villages associated with the Bethlehem style were Christian. Greek women came to Bethlehem on pilgrimage and also as brides and brought either their embroidery skills or embroidered textiles with them, exposing Bethlehem embroiderers to a new style. The veil is special occasion wear; for everyday wear a plain white cloth was pulled over the hat and fastened under the chin when a woman left the house. A short-sleeve jacket was worn over the dress at times. There are more than seventy-five embroidered dresses, several jackets, many veils, hats, shoes, pieces of jewelry, and other accessories as well as men's clothing from Palestine in the museum.

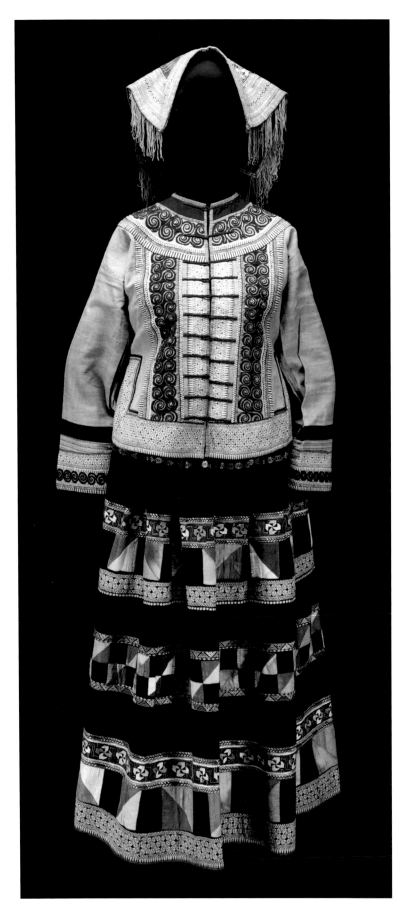

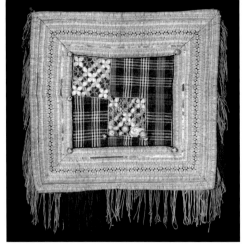

Woman's ensemble

Twentieth century, Yunnan, China, Yi group
IFAF

Worn in the villages of Malipo County near the
Vietnam border to this day, this outfit demonstrates
the multiple skills girls need to master to make
everyday clothing. The jacket or blouse is made
from all handwoven cloth with the exception of a
pale green strip. Some is woven in narrow warp
stripes against a brown ground; the rest starts out
white. The finished cloth is dyed light blue for the
sleeves and part of the body of the jacket. For the
strips of cloth on the front, the cuffs, and around the
hem, small patterns were drawn with wax before
dying, creating the blue and white patterns. This
technique of wax resist is known as batik. The deep
blue spirals are made by appliqué, the edges raised
by the stitching used to secure the cloth shapes. Then
many pieces, both narrow strips and wider bands, are
sewn together to make the garment. In some places,
a line of tiny stitches in fuchsia silk defines an edge. In
others, a slight strip of gold-painted leather is couched
with thread. In newer examples from this area, the
leather is replaced by gold-colored synthetic material.
In this one garment we have six techniques repre-
sented—weaving, batik, embroidery, appliqué, piec-
ing, and hand-sewing of complex shapes. A garment
of this quality would have silver buttons, made by a
professional, down the front. The full skirt of hand-
woven cotton, meanwhile, has silk appliqué patches
and two sections of batik. The remaining patterns
are embroidered with silk thread in satin stitch. The
square head cloth is composed of handwoven cotton
plaid and batik fabric with a very narrow band of
red-and-pink printed cotton all the way around.
Two squares in the center of the cloth have been
appliquéd with ovals and edged with couched metal
strips, then appliquéd onto the plaid. Chains with
dangles and bells and purchased tape fringe around
three sides completes the covering.

Woman's ensemble

c. 1970
Chin Hills, Burma, Haka Chin group
MNMF

These three pieces of beautifully woven silk aptly show the continuation of local dress and weaving skills among the Haka Chin people in Burma. There are several related groups of Chin living in the Chin Hills of Burma and neighboring Assam state in India. The textiles of the Haka Chin require the most complex weaving of any of the groups. Cotton, flax, and hemp are locally produced, but silk has always been imported to this area. It is woven on a body tensioned loom. Two 11-inch strips are sewn together for the tunic or blouse, with areas left unsewn for the neck and arms. Weaving alternates between areas of plain weave, where it is all red, and areas of twill, where the cloth appears paler. Warp stripes of green, coral, and pale blue are decorated with small diamonds and chevrons. There are horizontal bands of small pattern as well, all made with supplementary weft technique. The shawl is made in the same way, the twilled bands showing as yellow. The warp fringe is twisted and knotted. The tube skirt is entirely patterned with small designs and is composed of two 22-inch panels sewn together. The small diamond pattern is known as *tial*, which means "spotted" in Chin. Women's clothing style of short tunic and skirt probably originated in the nineteenth century. The shawl over the shoulder is a smaller form of blanket or mantle, worn by both men and women as an everyday garment, and in earlier times significant as a prestige garment. Certain colors and types of decoration could only be worn by a man who had sponsored a certain number of feasts of merit. The detail shows a portion of the skirt and the tial pattern. The museum's collection has several other Chin garments as well as numerous blankets and bags, some said to have been made before 1890.

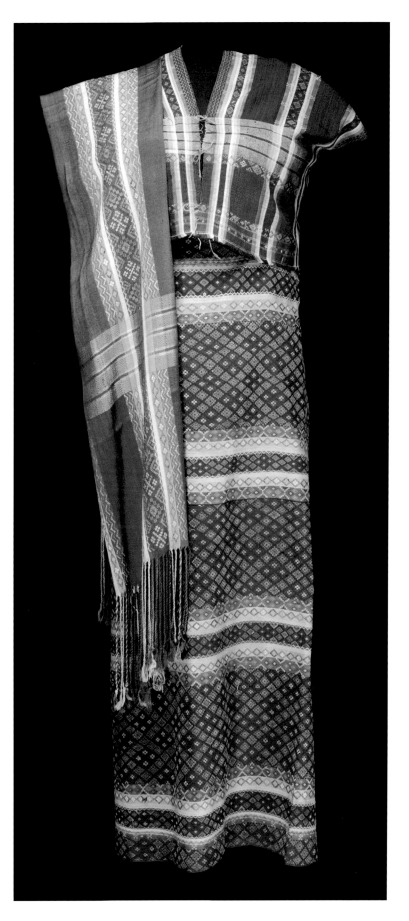

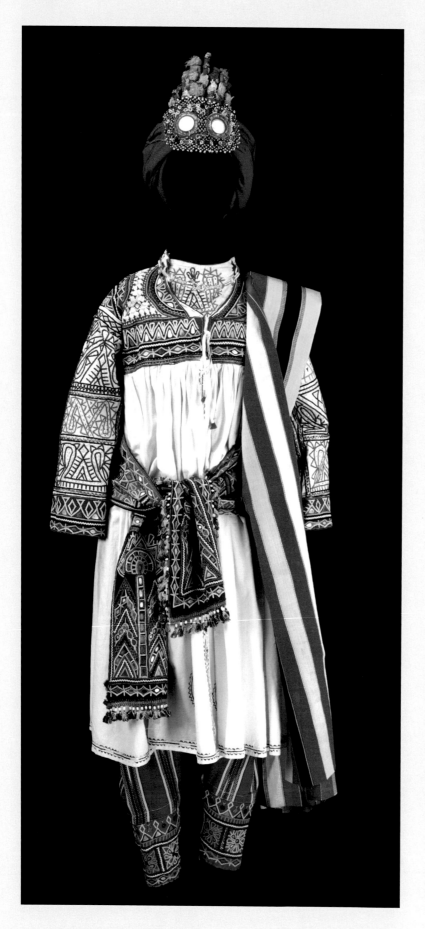

Man's wedding ensemble

c. 1980 and 1965, Bhujodi, India, Kachi Rabari group
IFAF

The Kachi Rabari live in Kutch, a desert region in the far northwest of Gujarat. They are pastoral nomads, herding sheep, goats, or cows in a seasonal migration, as well as being Hindus. Rabari men wear entirely different clothing for everyday use, usually a wrapped lower garment and a loose shirt called a *camiz*. For weddings, garments like these are worn. The jacket, pants, and sash of this outfit were all made by a Kachi Rabari woman named Ranakiben for her brother to wear at his wedding. The *angadi* upper garment is a short bodice with full gathered skirt attached. The bodice and sleeves are fully embroidered with square chain stitch and interlacing. The garment is influenced by the dress of Rajput royalty in Rajasthan and worn only at weddings. Trousers, also worn only at weddings by Kachi Rabaris, are made from a silk and cotton fabric called *mashru*. Unlike the tight-fitting trousers worn by other Rabari groups, these are full with fitted cuffs and suggest Muslim influence. The cuffs are embroidered with square chain stitch. The sash is called *bukani* and was traditionally worn over the turban and under the chin. It is also worn as a sash. It is fully embroidered with beaded fringe. The detail shows the square chain stitch, mirrors, and small glass beads that replace the cowry shells used at an earlier time. The mashru shawl and red cotton turban cloth were commercially made. The turban ornament *mors* was made by Ranakiben's mother, Lassuben, in the 1960s. Glass beads, mirrors, and cotton thread tassels decorate the piece. Wooden slats between layers of cotton cloth maintain the shape and stiffness of the mors so it can be attached to the turban cloth. Mors have rarely been made since the 1960s, as the right beads are hard to find. They are kept and handed down to be used by the males in a family.

Notes

Introduction

1. Barbara Sumberg, *A History of Cloth Production and Use in the Gouro Region of Côte d'Ivoire* (Minneapolis: University of Minnesota, 2001).

2. Paul E. Rivard, *A New Order of Things: How the Textile Industry Transformed New England* (Hanover, NH: University Press of New England, 2002).

3. E. J. W. Barber, *Prehistoric Textiles: The Development of Cloth in the Neolithic and Bronze Ages, with Special Reference to the Aegean* (Princeton, NJ: Princeton, 1990).

4. Mary Schoeser, *World Textiles: A Concise History* (London: Thames and Hudson, 2003).

5. Witnessed by the author in June 2008.

6. Although there was trade between inland and coastal people before the Portuguese arrived, it is uncertain how much cloth was traded and what it was used for. See Bobbie Sumberg, "Dress and Ethnic Differentiation in the Niger Delta" in Joanne B. Eicher (ed.) *Dress and Ethnicity* (Oxford: Berg, 1995) and Lisa Aronson, "Ijebu Yoruba Aso Olona: A Contextual and Historical Overview" in *African Arts* 25, no. 3 1992: 52–64, 101–102.

Bedding

1. Annie Carlano and Bobbie Sumberg, *Sleeping Around: The Bed from Antiquity to Now* (Seattle: University of Washington, 2006), 36.

Home

1. Anna-Maja Nyland, *Swedish Handcraft* (Stockholm: Hakan Ohlssons, 1976).

2. *Goddesses and their Offspring: 19th and 20th Century Eastern European Embroideries* (Binghamton, NY: Roberson Center for the Arts & Sciences, 1986).

Church & Temple

1. Rebecca Green, *Divine Worth: Weaving and the Ancestors in Highland Madagascar in Sacred and Ceremonial Textiles* (Proceedings of the Fifth Biennial Symposium of the Textile Society of America, 1996), 239–248.

Dress

1. Nicholas Wade, *In Lice, Clues to Human Origin and Attire* (New York Times, March 8, 2007).

Outerwear

1. William Wroth, *The Mexican Sarape: A History* (The Saint Louis Art Museum: 1999).

Ceremonial

1. Till Förster, "Senufo Masking and the Art of the Poro," *African Arts*, 26 no. 1 (1993): 30–41, 101.

2. Christa Clarke, *Power Dressing: Men's Fashion and Prestige in Africa* (Newark: The Newark Museum, 2005), 6.

3. William Fitzhugh and Aron Crowell (eds.), *Crossroads of Continents: Cultures of Siberia and Alaska* (Washington, D.C.: Smithsonian, 1988), 247.

Further Reading

Museum of International Folk Art collections:

Carlano, Annie, and Sumberg, Bobbie. *Sleeping Around: The Bed from Antiquity to Now*. Seattle: University of Washington, 2006.

Fisher, Nora (ed.). *Mud, Mirror, and Thread: Folk Traditions of Rural India*. Ahmedabad: Mapin Publishing Pvt. Ltd. In association with Museum of New Mexico Press, 1993.

Fisher, Nora (ed.). *Rio Grande Textiles*. Santa Fe: Museum of New Mexico Press, 1994.

Glassie, Henry. *The Spirit of Folk Art: The Girard Collection at the Museum of International Folk Art*. New York: Harry N. Abrams Inc., 1989.

Kahlenberg, Mary Hunt (ed.). *The Extraordinary in the Ordinary: Textiles and Objects from the Collections of Lloyd Cotsen and the Neutrogena Collection*. New York: Harry N. Abrams Inc., 1998.

Stillman, Yedida K. *Palestinian Costume and Jewelry*. Albuquerque: University of New Mexico, 1979.

General:

Barnes, Ruth and Eicher, Joanne B. (eds.). *Dress and Gender: Making and Meaning*, Oxford: Berg, 1993.

Eicher, Joanne B. (ed.). *Dress and Ethnicity: Change Across Space and Time*. Oxford: Berg, 1999.

Schoeser, Mary. *World Textiles: A Concise History*. London: Thames and Hudson, 2003.

Weir, Shelagh. *Palestinian Costume*. Austin: University of Texas in cooperation with British Museum Publications, 1989.

Index